Praise for Cine

"A wonderful book full of my favorite kinds of stories. Entertaining and insightful for fans of cinema, sports, or (ideally) both."

—**J. K. Simmons**, Academy Award-winning actor

"From one Eagles fan to another, buy this book. Go Birds!"

—**Miles Teller**, actor

"I always thought Adnan was an expert in sports, but after spending some time with him, he's one of the most knowledgeable fans of cinema that I've ever met. Love this guy and love this book."

—**Josh Duhamel**, actor

"Adnan Virk's zest for life is infectious, and his debut book is as enthusiastically refreshing and entertaining as any I've ever read."

—**John Ortiz**, actor

"I have always contended Adnan is something of a polymath, and Cinephile confirms my belief. I just wish his erudition had extended to my classic films Pootie Tang and BASEketball."

—**Bob Costas**, Emmy Award-winning sportscaster

"Adnan Virk is ill. Sick. Troubled. Diagnosed with acute Scorsese. His addiction to film is neither healthy nor sane. He really thinks the world needs more of his thoughts on movies. I hate that he's right."

—**Dan Le Batard**, Incredibly Successful Podcast Host

"Adnan Virk is the only person on this planet I have never stumped with one of my obscure movie references. If this doesn't confirm his knowledge of The Cinema, I don't know what could. Buy this book."

—**Keith Olbermann**, ESPN and MSNBC broadcaster

"Having covered several Academy Awards ceremonies with Adnan by my side, let me be the first to say that there is nobody who loves the movies quite like he does, and nobody I'd rather work with on the red carpet. *Cinephile* provides a glimpse into the mind of a man obsessed with cinema, whose passion for the art of filmmaking is palpable and inspiring. Well done, my friend!"

—**Ben Lyons**, broadcaster and producer

"From De Niro and Paul Giamatti to Billy Bob Thornton and Al Pacino, Virk rounds out these famous actors into real people, revealing aspects of their work you may have overlooked. He gives insight into what drives their work and takes the reader along on a swift journey you won't soon forget."

—**Jeffrey Lyons**, film critic

"I met Adnan through our shared love of baseball, but we connected over the movies. What a surprise—and a joy—to learn Adnan would rather talk Robert Mitchum than Bobby Meacham."

—**Ben Mankiewicz**, Turner Classic Movies

"Adnan Virk's knowledge and appreciation of film is on par with any human being who has ever analyzed the medium."

—**Nick Khan**, president of WWE

"Finally, all the names Adnan has dropped over a lifetime of Hollywood sycophancy—all in one convenient place! Whether listening to *Cinephile* with Adnan Virk or reading *Cinephile* by Adnan Virk, I count myself a proud member of the world's greatest AV Club."

—**Scott Rogowsky**, the Quiz Daddy a.k.a. the Kosher Kershaw

CINEPHILE

CINEPHILE

INTERVIEWS, ESSAYS, AND TALES FROM THE RED CARPET

ADNAN VIRK

MIAMI

Copyright © 2025 by Adnan Virk.
Published by Mango Publishing, a division of Mango Publishing Group, Inc.

Cover Design: Elina Diaz
Cover Photo/illustration: stock.adobe.com/blackbvrds
Author Photo: Brandon Moyé (@moyevisuals)
Layout & Design: Elina Diaz

Mango is an active supporter of authors' rights to free speech and artistic expression in their books. The purpose of copyright is to encourage authors to produce exceptional works that enrich our culture and our open society.

Uploading or distributing photos, scans or any content from this book without prior permission is theft of the author's intellectual property. Please honor the author's work as you would your own. Thank you in advance for respecting our author's rights.

For permission requests, please contact the publisher at:
Mango Publishing Group
5966 South Dixie Highway, Suite 300
Miami, FL 33143
info@mango.bz

For special orders, quantity sales, course adoptions and corporate sales, please email the publisher at sales@mango.bz. For trade and wholesale sales, please contact Ingram Publisher Services at customer.service@ingramcontent.com or +1.800.509.4887.

Cinephile: Interviews, Essays, and Tales from the Red Carpet

Library of Congress Cataloging-in-Publication number: 2025938462
ISBN: (print) 978-1-68481-854-9, (ebook) 978-1-68481-855-6
BISAC category code: PER004030 PERFORMING ARTS / Film / History & Criticism

To my dad, for taking me to the library where I discovered
a rich treasure trove of movies.

To my mom, for all the popcorn...and all the laughs.

And to the filmmakers who inspired me and gave me
solace in my time of need.

TABLE OF CONTENTS

Introduction **Why *Cinephile*?** ... **11**

Chapter 1 ***Moonlight* Won Best Picture! In the Eye of the Storm at the Oscars** ... **15**

Chapter 2 **Can I Call You Bob? On Meeting De Niro** ... **24**

Chapter 3 **He Just Glides: On Loving Al Pacino** ... **32**

Chapter 4 **Paul Giamatti: Movie Star** ... **42**

Chapter 5 **Ready for My Close-Up: Big George Foreman** ... **50**

Chapter 6 **Some Folks Call It a Kaiser Blade: The Legend of Billy Bob** ... **54**

Chapter 7 **I, Margot: Before *Barbie*, Robbie Became a Star** ... **64**

Chapter 8 **J. K. Simmons: Master Conductor** ... **72**

Chapter 9 **Monica Bellucci: Bellissima** ... **80**

Chapter 10 **Michael Shannon: Master of Malevolence** ... **84**

Chapter 11 **Nicolas Cage: King of Cool** ... **90**

Chapter 12 **Ethan Hawke: Versatile Heartthrob** ... **94**

Chapter 13 **Will Arnett: Canada's Funnyman** ... **97**

Chapter 14 **Kevin Hart: Little Big Man** ... **109**

Chapter 15 **Mahershala Ali: Dignity Personified** ... **115**

Chapter 16 **Willem Dafoe: Virtuoso** ... **125**

Chapter 17 **Barry Jenkins: Auteur of *Moonlight*** 136

Chapter 18 **Barry Jenkins: Part 2** 143

Chapter 19 **Matthew McConaughey: From Texan Hunk to Oscar Winner** 145

Chapter 20 **Miles Teller: *Whiplash*** 152

Chapter 21 **Josh Duhamel: Human Ken Doll** 158

Chapter 22 **John Ortiz: The Actor's Actor** 167

Chapter 23 **Scorsese Stories: Il Maestro** 176

Chapter 24 **Scene Study: Random Thoughts for an Aspiring Film Critic** 227

Conclusion **The Future Is Now: What's Next for Cinema** 243

Acknowledgments 246

About the Author 248

INTRODUCTION

Why Cinephile?

My deepest desire is to start this book like the opening of Billy Wilder's *Sunset Boulevard*, as a dead guy narrates what happened to him. But alas, there is no Gloria Swanson in my life. So, I'll begin by quoting Gene Wilder in *Young Frankenstein*: "It's alive!"

Why not learn to pick up fly fishing?

Why not learn to speak Russian?

Why not learn to drive a really cool car as fast as you can while pretending you're blind?

Whenever I think of all the things I'd rather be doing, of course, they are always related to the movies.

Fly fishing? Well, that's because of Robert Redford's *A River Runs Through It*.

Speaking Russian? I'd like to see if it would work the same magic in my life as on Jamie Lee Curtis that John Cleese demonstrated in *A Fish Called Wanda*.

And driving a sports car blind? The idea is inspired by Al Pacino hoo-ahing his way to an Oscar. Cue Pacino voice: "Charlie, you're riding with one very happy man!"

Blame the fact that from ages eleven to seventeen, I lived in Morven, Ontario, with a population of five hundred. Even the cows were lonely.

Blame the fact that I lived on top of a convenience store/gas station and my dad would allow me to pick the VHS videos we'd rent. "Be Kind, Rewind." I can't imagine how many people in 1993 wanted to go get some gas, milk, and watch Martin Scorsese's 1973 classic *Mean Streets*, but I sure did. Of course, I'd also watch *Total Recall* with my brother and laugh at the guy's eyes bulging out of his head, but there were only so many popcorn movies I could digest. I viewed movies as fuel, as oxygen, as nourishment.

Where does the lifelong love of movies stem from for this sportscaster? As with so many of my virtues, it comes from my loving parents.

One of my fondest memories of my childhood is my mom making a big batch of popcorn and watching an old movie with her. Her stipulations were clear cut: no swearing, no nudity, no swearing, and no violence (okay, maybe a little bit of fireworks wasn't a complete write-off). I couldn't very well recommend watching *The Little Mermaid* every Saturday night, so enter my dad.

He wasn't a huge movie geek, but he *was* a voracious reader, so I would tag along with him to the library and behold the treasure chest of movies there: everything from Ingmar Bergman's *The Seventh Seal* to Akira Kurosawa's *Seven Samurai*. The VHS copies were twenty-five cents apiece. Thus began my true cinematic education, courtesy of the Kingston Public Library.

The summer after I graduated high school and before I went away to college at Ryerson University, I made a list of all the movies I watched, and it was fifty in sixty days. Almost like a multivitamin,

I had to have one a day. When I came home that summer, I really got down to business and watched one hundred movies from the library in four months. (I've been accused of being *a bit* of an obsessive.) True classics and art house cinema is what I watched, so no one could deny I wasn't truly serious about cinema.

Later, I finished one of the great achievements of my life, which was watching every single movie in a marvelous book called *The A-List*, flagging the one hundred "best of the best" as chosen by a consensus of the National Society of Film Critics. Some of the movies were challenges (1934's *L'Atalante*), some were trifles (did I really need to sit through Elvis Presley's *Jailhouse Rock* to be legit?), and some were downright disturbing (Luis Buñuel's *Los Olvidados*, anyone?).

But I'm so glad I completed my mission. Charles Burnett's *Killer of Sheep* was probably the hardest to track down, but an amazing experience. I'll never forget the Czechoslovakian film *Closely Watched Trains* by director Jiří Menzel and the easy, goofy humor mixed with a profound ending. Speaking of profound, was there anything better for a twenty-year-old than fighting back tears after first watching Yasujirō Ozu's *Tokyo Story*? For a forty-six-year-old, there is still nothing better than watching *Tokyo Story*, a timeless film about a Japanese family and among my all-time favorites.

I could do my own list of essential films or rank the movies you must see before you die. But these ideas have been done to death, and besides, none of us have that kind of time. So, I'll tell you about my life as a Cinephile and how I hosted a podcast of that name for 336 glorious episodes over eight years. I'll tell you how I got to work for the Academy and hosted the Oscars for Facebook Live and Oscar. com two years in a row, 2016 and 2017, thanks to my incomparable friend Ben Lyons. I'll tell you about meeting one of my heroes,

Robert De Niro, how funny Kevin Hart really is, and who the most glamorous people were when I walked the red carpet at the Oscars.

And I'll try to explain to you why, despite being the social creature that I am, there's still nothing I like better than being awake in the dark, watching these images that allow my mind to contemplate, my imagination to roam, and my heart to soar.

CHAPTER 1

Moonlight Won Best Picture! In the Eye of the Storm at the Oscars

April 3, 2017

I began *Cinephile* because I wanted to have my own slice of real estate. I was always a pinch-hitter for the big ESPN radio shows like *Mike & Mike*, *The Herd with Colin Cowherd*, and *SVP & Russillo*, but yearned to be something more than just a substitute teacher. Thankfully, I had an ally and a wonderful friend in Dan Stanczyk, who was willing to be my producer for free.

"I love it," he said. "We'll do a podcast: movies, baseball, tennis, Canada—all the stuff that you're into."

I mulled it over. "I was just thinking about a podcast about movies. We can call it *Movie Geek*."

Over email, we fleshed out what the pod would be: reviews, guest interviews, top five lists, streaming suggestions, Scorsese stories. But he wasn't crazy about the title.

"How about *Cinephile*?" I offered.

"Bam," he wrote back. "That's the one."

We debuted in June 2016 and I was elated to finally have a home for my movie bloviating. All these years, my friends and family had to put up with my nonsense. Now, there were thousands listening, eager to hear the thoughts of this self-indulgent gasbag on movies!

Dan was a wonderfully attentive audience member: sarcastic, knowledgeable in his own right, armed with good questions, and more than willing to offer a good-natured jab when I needed one.

Sucking off the teat of ESPN, we were also able to land some terrific guests; you will read some of their interviews in this book. Lisa Stokes and her team, including Katie Miervaldis, were invaluable. And then I got a DM on Twitter (now X) from Ben Lyons.

Ben is a much better version of me; he loves sports and movies in equal measure. His father, Jeffrey, is one of the finest film critics of all time (and one of the biggest Boston Red Sox fans ever).

Ben's message to me was straightforward. Essentially, *I'm a big fan of your work, love what you're doing.* But he also added that he hosted a live stream for the Academy Awards and was trying to get me involved. I thanked him for the kind words and didn't think much of it.

Two weeks later, I received a call from my friend and agent Nick Khan at CAA.

"Sitting down?" he deadpanned.

He proceeded to read to me what he had received. It was an offer from the Academy of Motion Picture Arts and Sciences to be a host for the Academy Awards live stream, to be broadcast on Facebook Live and Oscar.com.

Moonlight Won Best Picture! In the Eye of the Storm at the Oscars

"It was all a dream, I used to read *Word Up* magazine..."

I couldn't believe my good fortune! This was truly a dream come true.

When I met Ben at the get-to-know-you dinner the Friday night before the Oscars, it was as if I had been reunited with a long-lost friend. He was funny, gracious, kind, and welcoming. Like I said earlier, a better version of me, as well as taller and skinnier.

We had a brief rehearsal the night before. We would be set up in the room where the winners would enter to get their photographs taken, and the adjacent media room where they would be interviewed by all the press. I never got to see the actual Kodak Theater, but I wasn't complaining. I remember walking the red carpet the night before, which was dirty and littered with lighting and camera equipment.

The next day, I was so hyped. *Alright, Mr. DeMille, I'm ready for my close-up.* I was being paid $4,000 and had a small clothing budget for a tuxedo. I wasn't sure if I should rent one or buy one, but Ben, the optimist that he is, convinced me to splurge. "You could be wearing this for the next ten years!"

The Loews hotel where they put us up was right next to the Kodak Theater. I was amped on the way over, excited for what lay ahead. I'll never forget that moment of being backstage, seeing where I'd be positioned, and then walking down the steps to the red carpet. While most people describe heaven with pearly gates, this is what I think of. There were blinding white lights everywhere and the carpet, which looked grimy the night before, was now positively shining. It looked pristine.

I saw Ben and our colleague Sofia Carson set up and conduct interviews as part of our "live from the red carpet" show. I loitered on the red carpet for the next hour, intercepting celebrities for a brief handshake or small word. My college friend Andrew Liszewski emailed a video to all of my college buddies of Guillermo Rodriguez from *Jimmy Kimmel Live!* interviewing Jeff Bridges and ridiculous little me, just strolling by in the background, nonchalantly taking it all in.

All the stars looked fabulous, glammed up to the nines. Taraji P. Henson and Brie Larson were particularly striking. The only celebrity who gave me a slight cold shoulder was Samuel L. Jackson, but he struck me as the type who didn't want to be bothered by anyone. Nothing personal.

Judd Apatow, on the other hand, was very friendly when I told him how much I loved his work on *The Larry Sanders Show*.

"Oh, who are you with?" he politely asked.

"ESPN."

"Did you like my 30 for 30?"

I didn't realize he had codirected *Doc & Darryl*, a documentary about his beloved New York Mets starring Dwight Gooden and Darryl Strawberry.

"Yeah, it was great!" I was merely one of many in a long line of Hollywood liars and sycophants.

I didn't miss a chance to say hello to Jeff Bridges and told him how much I loved the movie *Fearless*.

Moonlight Won Best Picture! In the Eye of the Storm at the Oscars

"Oh, thanks so much," he said graciously. "That's one of my favorites, too."

There were two people in particular I had to meet, since I had interviewed them for my podcast *Cinephile*: Mahershala Ali, first-time Oscar nominee for Best Supporting Actor for *Moonlight*, and the director of *Moonlight*, Barry Jenkins.

Mahershala was a close friend of my cousin Saleem Qadir and had been a fantastic guest on *Cinephile*. His publicist had assured me he would find me on the red carpet. I gave him a big hug when I saw him, wished him luck, and took a picture, which I immediately tweeted out.

Same thing with Barry. I had been messaging his publicist and she promised me I'd get a minute with Barry after I had been such a vocal supporter of *Moonlight*.

When I saw him on the red carpet, we hugged and I told him I had an odd feeling about tonight.

"I think you've got a puncher's chance," I said, knowing that, as a sports guy himself, he'd appreciate the analogy.

He smiled. "I hope you're right."

Then I went backstage, where I was with Ben, Sofia, and Troy Gentile, costar of *The Goldbergs* and a hilarious, friendly guy. I told him how much I loved that his character wore the apparel of Philly's sports teams on the show, being a lifelong Flyers and Eagles fan myself.

Our show was a second-screen experience. We would give our opinions on what was happening without actually seeing the live broadcast. For example, our producer would tell us that Best

Supporting Actor was the next category, and then we would talk about each of the nominees and their performances that year, their filmography, and any other cool tidbits we wanted to share about them until the winner was announced. Then, we'd go on to celebrate their achievement and put into context what it would mean to them.

It might sound like a lot to talk for three-and-a-half hours, but we had a couple of ten-minute breaks, and honestly, talking about movies is something I could do, and have literally done, in my sleep. It's not the first time I've been accused of being garrulous when it comes to film. It was such a joy to share the stage with each of my cohosts and then try to stay focused when we'd hear the buzz of an Oscar winner walking in behind us, taking pictures, before going to the media room.

And then came the moment none of us will ever forget.

La La Land was expected to win Best Picture. A rapturous love letter to Hollywood, it was impeccably directed by wunderkind Damien Chazelle and featured plenty of razzle-dazzle, along with swoon-worthy chemistry between its leads, Ryan Gosling and Emma Stone. Stone won Best Actress, Chazelle won Best Director, and the coronation was almost complete...

We were told by our producer that *La La Land* had indeed won Best Picture. Ben started talking about what a success it was for the producers and for Chazelle himself, who he had interviewed hours earlier on the red carpet.

And then, the oddest thing happened. Our stage manager Denny, who had a slight resemblance to gruff character actor Brian Dennehy, was frantically pointing at the monitor to my right. This monitor was airing what the public was seeing at the Academy Awards hosted by Jimmy Kimmel.

I could see what appeared to be confusion on the stage and a man showing an envelope to the camera which clearly listed *Moonlight*. The camera cut to a shot of my buddy Barry Jenkins and company exulting in the crowd.

"Wait, wait. *Moonlight*'s won Best Picture. *Moonlight* won Best Picture." I was trying to keep up with what was happening.

"Whoa, we have a little..." Ben began.

"Oh my goodness. This is incredible. *Moonlight* won Best Picture!" I repeated.

"We have drama here at the Academy Awards," finished Ben.

"This is like Steve Harvey, remember that?" I cracked a reference to Harvey reading the wrong winner at the Miss Universe pageant.

The emotion was building in my voice. I had returned to my usual vocation as a sportscaster. This was my Al Michaels "Do you believe in miracles" moment.

"We said earlier tonight, Ben, we were going to see a shocker. This is the shocker!" I exclaimed. "*Moonlight* won Best Picture!"

And it really was a seismic upset. All award season, *Moonlight* was the little movie that could, slowly gaining steam from critics and audiences who were taken with this beautifully layered coming-of-age story by a gifted filmmaker making just his second film out of Miami. Now, they had captured the biggest prize of all, and we had no idea what happened.

In the days and weeks to come, I discovered what I had originally surmised—that Warren Beatty had read the wrong name—was

correct. He and Faye Dunaway had been given the wrong envelope. Rather than the correct one for Best Picture, they had been given the envelope for Best Actress. So, when Beatty opened the envelope and saw "Best Actress" and "Emma Stone," he was utterly flabbergasted. However, after only a brief glance at the name of the corresponding film, *La La Land*, he gave the joyous declaration and eventually all hell broke loose.

We finished the show amidst a very confused backstage crew of photographers and journalists. Ben had an invite to an after party where we saw Academy Award winner Kenneth Lonergan (for *Manchester by the Sea*) brandishing his Oscar proudly. (I had chatted with him briefly on the red carpet as well, since I was a big fan of that film and his writing.) We also hilariously saw Regis Philbin get into a limo going to *another* Oscar party—oh, to have his energy and stamina!

Ben had the perfect idea for how to wrap up the night: In-N-Out. I had eaten it before, since my wife is from California, and we loved to crush late night burgers and shakes like a scene out of *Pulp Fiction*. We were Ben and Adnan, playing the roles of Jules and Vincent, dining on a tasty burger. Instead of the Big Kahuna, it was In-N-Out. It was a note-perfect capper to a momentous night.

I DMed Barry Jenkins on X with heartfelt congratulations and he messaged me the next day, still in disbelief with all that had transpired, telling me he was having an adult beverage with his lovely lady, soaking it all in. Barry returned to *Cinephile* when promoting *If Beale Street Could Talk* and I played for him my call of his unlikely Oscars triumph. He was laughing during it, and I had to ask if he was aware of my call before that moment.

Barry happily said he was. He said he had made a return to Florida State University, where he had graduated in film studies, and they had played the call for him there.

"Man, my guy Adnan was hyped!" he laughed.

Indeed I was, and still am. *Moonlight* won Best Picture! I was a part of Oscars history.

CHAPTER 2

Can I Call You Bob?
On Meeting De Niro

August 30, 2016

It wasn't as I had planned it. I didn't think I'd be on the third floor of a hotel in Williamsport, Pennsylvania, with my wife and two kids, when finding out that I had an opportunity to interview one of my heroes.

Katie Miervaldis, our wonderful talent producer who always looked out for *Cinephile*, had sent me the email explaining that the one and only Robert De Niro would be on the ESPN campus in Bristol on the following Monday, August 25, 2016, and she could slot me in for fifteen minutes for *Cinephile*. He was promoting his new boxing drama, *Hands of Stone*, a biopic of Roberto Durán, and I was delirious with joy.

So, after we finished *Baseball Tonight* at 11:00 p.m., we loaded up the Buick Enclave to make the five-hour drive back to West Hartford, Connecticut. I'd interview this living legend at 10:00 a.m. and then drive back solo since I was hosting the *Baseball Tonight* Monday evening show.

On the drive back, my wife and I were both giddy (the kids slightly less so). I asked my friend Tim Kurkjian for advice.

"No one calls him Robert, and Mr. De Niro is too formal, but I don't know about just calling him Bob out of the gate."

"Just ask him," Tim said. "It's polite and disarming."

I asked my dad for advice and he agreed with Tim. We got home safely that night, and the next day, our sitter didn't show up, which led to momentary soul-crippling panic before we dropped the boys off with our lovely neighbor who understood what was at stake here.

We waited in the radio studio: me, my wife Eamon, and producer Dan Stanczyk. I had a basic approach: I wanted to ask De Niro about things most people probably didn't delve into too much and then hopefully get into the essence of why, for many, he's been America's greatest actor since Marlon Brando.

And then I looked and saw Robert freaking De Niro turn the corner and exclaimed, "Here he comes!" It almost felt like it was a surprise birthday party and we should all duck and hide.

But instead, in strode one of my favorite actors. I'll never forget that moment: his thick head of hair brushed back, a full white beard, the warmest of smiles, and an outstretched hand. The only word I can use to describe how he looked is avuncular. *Here he is, ladies and gentlemen: everyone's favorite uncle, Robert De Niro.*

He shook my wife's hand and she told him, "I've been watching you since I was eleven. You're the reason I love movies." He politely smiled and I told him this interview was for a podcast.

"Not on camera?"

"Nope," I said, and he seemed to be a little more relaxed. I was well aware of his reputation and had seen him on countless interviews where many joked about how taciturn he was. But I got over my awe and got down to business.

<p style="text-align:center">★ ★ ★</p>

Adnan Virk (AV): On June 3 of this year, I met Al Pacino. And now on August 23, I'm meeting Robert De Niro. So now I can die in peace, meeting my two favorite actors in a three-month span. First and foremost, can I call you Bob?

Robert De Niro (RDN): Sure.

AV: Thank you, sir. I'm wearing my Tribeca Film Festival shirt because I saw *Taxi Driver* earlier this year, and it was an extraordinary experience to see that film again on a big screen. But I'm always curious about personal passion projects, and I think about actors and festivals [they founded]. And it's really you and Tribeca and it's [Robert] Redford and Sundance. And I think about Tribeca and the fact that you and Jane Rosenthal put this together to try to build up New York post-9/11. And it's become this roaring success. Where do you rank Tribeca as far as your personal accomplishments?

RDN: Well, we started it after 9/11 and I'm very proud of it. It's doing well. It's been well-received by people. And I'm happy that it'll hopefully be a real traditional part of the city—[the] fabric of the city—for years to come.

AV: And I think that's the beauty of it, because it's enriching film culture, but it's also giving back to the city. And no matter what, people always associate De Niro with Tribeca.

RDN: Yeah. Well, as I say, I'm very proud of it. And, you know, Jane Rosenthal has been really the driving force behind it. And we started it together, but she and our whole team, they're really the ones who make it happen.

AV: Speaking of passion projects: the documentary you did about your father.

RDN: Yeah.

AV: Because the public perception of Robert De Niro is very generous, loving, and caring to those in his circle but outwardly shy, quiet, [and] keeps to himself. So, to [make] a very personal film about your father—who, for those that don't know, was a brilliant painter, and if you see Bob's film, he makes the point [that] his dad probably didn't receive the recognition he should have—and put it on a very public format on HBO, what was the impetus for that?

RDN: I always wanted to just document his life with the films that I had. There was a guy that used to follow him around—and we used some of it in the movie—with a Super 8 camera, I guess in the '70s. And then he finally got in touch with me. I was aware of him going around with my father from time to time. But then he got in touch with me, as I say, after my father passed away and wanted to see if I wanted the stuff, which I did. I think that I bought it from him. I thought he gave it to me, but someone reminded me that I did pay for it. That's okay. So anyway, although we didn't use as much as I thought we would, I just wanted to [do it] for my kids... [who] did not know—don't know—anything about him... So, I kept his studio. I've taken them over to the studio to see it...

I've always thought of doing a documentary and finally I said, let me just do it. At the prodding of, actually, Jane Rosenthal's saying, "Let's finally do this," because there were contemporaries of my

father who are in the documentary that we were concerned would not be around at one point and it would be essential that they're in it, and they are. So, that's how it started. I didn't know how long it would be. I didn't know [if] it would be an hour, two hours. It wasn't intended to be on HBO. Then they came and saw it and they said, "Would you be interested?" I said "Okay." And then it became what it became.

AV: You think of the great combos in film history: [Marcello] Mastroianni and [Federico] Fellini, [Akira] Kurosawa and [Toshiro] Mifune, Sydney Pollack and Robert Redford, and you and Marty [Martin Scorsese]. Eight films that you've made together. And each one, to me, has such strong power. And the stories behind it are great. What is it about you and Marty that connected so well initially with a film like *Mean Streets*?

RDN: Well, you know, when I was a kid, I'd see Marty around with his group on one side of the street, and then we'd be here. We had a few, maybe one or two, who would go between the two groups and hang with both groups.

But then I was told he's at NYU. Over the years, I saw his *Who's That Knocking* [*at My Door*] with Harvey [Keitel] and his *It's Not Just You, Murray!* and some other things that he had done.

And then a mutual friend of ours, a film critic, got us together at a dinner one time, and we were talking, and I told him how much I liked the movies and so on and da-da-da. And then, he was doing *Mean Streets*. Well, then we started talking.

That was kind of after this dinner, but he had offered me one of the parts—other than Harvey's, that was set. And I was trying to decide. I talked to him from time to time: "Should I play this part, should I play that part?" So finally, I settled on the part that I played, Johnny Boy.

AV: *Taxi Driver* is a movie for young men, particularly angry young men, that you can really relate to: feeling jilted and feeling upset by what Betsy does to him and the lack of connection Travis has in this world. It's extraordinary how the movie is so universal. I'm Pakistani-Canadian, from Toronto and am not raised in this quintessential New York story, but I can relate to it. It was Paul Schrader's story. But what was it for you?

RDN: We all liked the script. I forget when I read it. I read it sometime after I did *Mean Streets*, and we all just liked the script. I thought it was a terrific script. That was there. And so, it was easier to get it made after [The] *Godfather* [Part] *II.*

Who can tell what a reaction to a film will be? That, nobody knows. But there was something. I could even identify with being from New York, [with] people all around in a city, and being sort of disconnected as a young man. So, as you say, you're from where you're from, I'm from where I'm from—I'm *from* New York. Still, you know, it's about a guy from out of New York who comes in, disconnected—you can feel that being [from] anywhere or being right from that place. That just struck a chord with everyone.

AV: A film that I think is so underlooked in your career with Marty [is] *The King of Comedy*. That was ahead of its time, showing how celebrity-obsessed [our] culture was. And Rupert Pupkin, Marty said he thinks it might be your best role ever.

RDN: Okay, well, no, I had a lot of fun doing that. Again, [with] Marty and I, there's some movies that I wanted to do more than he would and there are other movies that he'd want to do that I'm not crazy about, but I'll do them because it's for him. So, that was one that Marty—I remember trying to get him to do that...and going over the script with him. I haven't seen the movie for a long time, but Jerry [Lewis] told us that story where he was about to go on in Vegas, and

he was just getting off the phone. He was outside, a woman was there, [asking] "Please just say hello to my son, my son." She was on a payphone. And then he said, "I can't, I gotta go, I gotta go." So, he goes off, and she says, "You should get cancer or something."

AV: This is the way some people are. As we close up, we usually do a segment on here called "three words." Can you describe Martin Scorsese in three words for me?

RDN: Lover of film.

<p style="text-align:center">★ ★ ★</p>

The interview wrapped and Bob turned to me and said, "Pakistan?" and I said, "Yeah, I'm Canadian but that's where my parents are from." And he said, "There's a great article about the Hindu Kush in Pakistan, you'd enjoy it. Look it up or let us know if you have trouble finding it."

I asked for a picture together but before we took the picture, I reminded him of Don Rickles's killer line, "I had dinner with De Niro once. It was like eating alone."

Bob gave a good-natured laugh and eye roll and we took a wonderful picture. His friend Stan complimented me on the terrific interview and I graciously thanked him. Bob gave my wife, Eamon, a peck on the cheek and she didn't wash her face for a month.

Adrenaline pumping, I dropped Eamon off at home and sped back to Williamsport, Pennsylvania, to resume my duties for ESPN, hosting the Little League World Series. On the five-hour drive, I saw an email pop up and the subject heading was simply "From RDN's Office."

This was 2:37 p.m. and it read:

Hi. Bob wanted to say how much he enjoyed the time today. Here is the article he was talking to you about, the lost tribes of the Hindu Kush.

And I sat there just dumbfounded on the side of the road. Perhaps the greatest actor of the last fifty years went home in his chopper and then, while working his way through the rest of the day, was thoughtful enough to tell his assistant, "Hey, find that kid's email and send him this article."

I was and remain blown away by the gesture. So many actors simply answer the questions and move on with their day. But, clearly, I had made a connection with Bob. What a guy.

Perhaps a year later, I got a request from his office for college basketball tickets. I had no free hookup, but in hindsight, I should have just bought them off StubHub to keep the connection alive a little while longer.

Robert De Niro has given me memories to last a lifetime with his work, but his kindness is something I'll never forget. He has been vociferously voluble in his attack on Trump and has made some less-than-ideal movie choices this century. I understand he may not be everyone's cup of tea. But for me, he will always be the epitome of the profession as an actor's actor and a deeply considerate man who gave me one of the thrills of my life.

CHAPTER 3

He Just Glides: On Loving Al Pacino

June 3, 2016

I don't just love Al Pacino. To use a word Alec Baldwin once used in describing his adoration for Al, I *worship* him. To worship at the altar of Pacino is to readily accept the incontrovertible evidence that there's never been a more staggering four-year run of excellence than what Al churned out from 1972 to 1975.

Director Sidney Lumet used to call him "Alfonse," but he was born Alfredo James Pacino on April 25 in the south Bronx, raised by a single mother and his maternal grandparents. A wayward youth marred by mischief and childhood indiscretions led to him finding his calling, dedicating himself to studying literature, and finding his voice on the stage. Acclaim soon followed for young Pacino with the likes of *Does a Tiger Wear a Necktie?* and *The Indian Wants the Bronx*.

Al became a star as the brooding character Michael Corleone opposite everyone's acting hero Marlon Brando, who was stuffing his cheeks with cotton balls and mumbling his way to an Oscar. The stories from *The Godfather* are legion: how Francis Ford Coppola fought for Al even though Pacino thought he'd be better suited to play the hotheaded Sonny; how Paramount wanted to fire him and replace him with Robert Redford or Ryan O'Neal; or how Al and Diane Keaton would get drunk together and laugh about what a horrible movie they thought they were making. Pacino earned his

stripes (and kept his job) with the Sollozzo scene when he killed the Turk and Police Chief McCluskey before fleeing to Sicily. Slowly and fascinatingly, Al evolved from war hero to the head of a Mafia family. Against considerable adversity, Coppola turned a bestseller into an instant classic, made everyone at Paramount giddy with joy, and Pacino's life would never be the same again.

Pacino became a leading man with his streetwise turn as the one honest cop in the rotten police force. The poster alone for *Serpico* is iconic: bearded, shaggy-haired Al, sunglasses on his head, with those soulful, sad eyes. Men wanted to be him and women wanted to be with him. In interviews, whenever Al has been asked what he thinks are his best movies or performances, he invariably cites *The Godfather* and *Serpico*. With his characteristic humility, Al is succinct on Sidney Lumet's storytelling, melded with his own method acting: "I thought it was pretty good." In the picture, Pacino vacillates between broad comedy when he enters the police house dressed as a Hasidic Jew, and then flips to righteous fury when he erupts on a superior, screaming, "This is my life, you fuck!"

The gift of Pacino's performance is that he doesn't make Frank Serpico a particularly good hang, but he also isn't holier-than-thou about his stance. He just doesn't take money, period. He isn't corrupt and wants to do the right thing. When researching the role, Pacino said it was so valuable that he got to hang with and spend as much time as he wanted with the real-life subject. He once asked the real-life Serpico why he didn't just take bribes like the other cops and then give the money away to charity. Frank responded, "If I'd done that, what kind of person would I be when I listen to Beethoven?" Exquisite.

The 1973 film *Scarecrow* is an under-seen gem starring Pacino and Gene Hackman. In more recent times, director Quentin Tarantino once showed Pacino a print of the film, discussing how much he

enjoyed it, while courting him to appear in *Once Upon a Time... in Hollywood*. Then followed *The Godfather Part II*, as Michael Corleone truly showed us an offer we couldn't refuse. With a true "heart of darkness," he orders the death of his brother, Fredo, but not until their mother passes away. Pacino is ruthlessly efficient, clinically cold, and altogether mesmerizing every time he's on screen. It might be the single greatest miscarriage of Oscar justice that he didn't win an Academy Award for Best Actor for this performance, instead losing to, not Jack Nicholson for *Chinatown* (which would have been understandable) but Art Carney in *Harry and Tonto* (which was criminal). To witness the scene where Diane Keaton's character, Kay, mercilessly shreds Michael's soul ("It was an abortion, Michael!"), is to see Pacino's simmering cauldron finally pop up, his eyes almost bulging out of their sockets, as he strikes her.

But to see Pacino as a true powder keg of emotion, you have to see Lumet's *Dog Day Afternoon*, one of the very best films of the 1970s, the decade most accepted as the richest for auteur-driven cinema. Al is Sonny Wortzik, an inept bank robber, aided by his dimwitted friend Sal (Pacino's close friend, the always pitch-perfect John Cazale) into a foolish plan to rob a bank to (wait for it) pay for his lover's sex change operation. That later nugget isn't dropped until well into the movie, but *Dog Day Afternoon* functions as a showcase for Pacino at his most fiery and most compelling. Seeing him with his unkempt hair and sweaty face, prowling the front of the bank like a lion, screaming at Charles Durning's equally incendiary police chief—well, it's the closest one could imagine to seeing Al on stage. Indeed, the movie is like a play, set almost entirely inside the bank, and Lumet is wise to let his leading man carry the show and then some.

No matter the role, Pacino's gritty intensity shines through. He lost his way a little after *Dog Day Afternoon*, with misfires like *Bobby*

Deerfield and *Author! Author!* His 1980 crime thriller *Cruising* was reviled at the time of its release, with even director William Friedkin deriding Pacino for being late to the set and not as committed as he should have been. It is the story of an undercover cop who's investigating a series of slayings in gay neighborhoods and had, to quote my friend Scott Rogowsky, "More leather than the Rawlings factory." The movie didn't really work, but certainly earned points for audacity. Pacino received an Oscar nomination for Norman Jewison's *And Justice for All*, although that seemed to be primarily recognition for the final riveting scene in the courtroom ("I'm out of order? You're out of order!").

Scarface was trashed by the critics in 1983, but along with Michael Corleone, Tony Montana is now Pacino's most famous creation. Al's bravura turn, cocksure, arrogant, and sneering his way at the opposition as he climbs to the top, culminates in a ridiculous but splendiferous coked-up finale. Brian De Palma made sure the entire film, working from an eminently quotable script by Oliver Stone, had an operatic, larger-than-life feel to it. In the final scene, Tony invites us to say hello to his little friend—and shattered audience expectations with its ultraviolent send-off. Pacino suffered third-degree burns while shooting the eye-catching climax and while he recovered in the hospital, De Palma kept on shooting more people—even inviting his friend Steven Spielberg, who dropped by the set, to call "action" on some of the carnage.

So, say goodnight to the bad guy. Hugh Hudson's *Revolution* in 1985 was so viciously trashed, Pacino took a break from it all. Disappearing from movies for four years, he enjoyed his life with Diane Keaton, did some plays including *The Local Stigmatic*, and read his beloved Shakespeare. Then, realizing he needed some money, Pacino went back to work and gave us a stunning career renaissance.

Sea of Love featured Pacino back where audiences loved him most, as a cop investigating a raft of murders, and being stalked by a leonine Ellen Barkin like a tigress in heat. *The Godfather Part III* couldn't match its predecessors, but did feature wonderful pathos from Pacino as a guilt-stricken, aging criminal in search of redemption. It was King Lear Corleone, and despite seven Oscar nominations, the movie couldn't match *Part I* and *Part II*, through no fault of Al's. Pacino himself reflected that audiences didn't want to see him as frail and weak—they loved Michael to be strong and ruthless, the ultimate bad guy.

So, more bad guys followed. A riotous turn as Big Boy Caprice in Warren Beatty's *Dick Tracy* landed him another Oscar nomination, with Pacino veering into satire, playing a criminal who was the world's largest dwarf. Then came 1992, and the resurgence was complete. He received two Oscar nominations: one as Best Supporting Actor in David Mamet's *Glengarry Glen Ross* as the smooth-talking and devilishly deceitful Ricky Roma, which he played with equal parts lubricity and electricity; the second a long overdue Academy Award for Best Actor as Pacino hoo-ahed his way to the golden guy. *Scent of a Woman* is a guilty pleasure for me; at times, it's borderline foolish, but it's also highly entertaining, never more so than when Pacino is grandstanding literally on stage with Chris O'Donnell, chiding the administration about what it means to be a bard man.

A reunion with De Palma followed with *Carlito's Way*, featuring a more passionate Pacino, although a scene-stealing Sean Penn as Dave Kleinfeld and De Palma's Hitchcockian final ten minutes are what leave the most lasting memories from that movie. Michael Mann's *Heat* is an all-time great film, but Pacino's character Vincent Hanna, while memorable, suffers from overacting—which has dogged him the last twenty-five years. (It should be noted that Al was not helped by Mann, who excised the small detail in

the script that Hanna was a recovering cocaine addict, which is why Pacino gave him those spontaneous outbursts.) An Oscar nomination should have come Pacino's way for Mike Newell's *Donnie Brasco*, with his star finding a new way to tell a gangster story in the tragicomic rendering of the mafioso character Lefty Ruggiero. So many gangsters are glorified on the big screen, but Pacino's Lefty was dumber than a bag of hammers and easily duped by Johnny Depp's titular character. The haunting final scene, when Pacino, knowing what dark fate awaited him, says, "Tell Donnie, if it had to be anybody...I'm glad it was him," showed us that, when need be, Al Pacino could still make us cry.

More roaring followed: as a bellowing, beleaguered football coach in Oliver Stone's amped up *Any Given Sunday*, and as the sociopathic Roy Cohn in *Angels in America*. Pacino was underappreciated playing the character Will Dormer opposite the sad clown turned quiet killer Robert Finch, played by Robin Williams, in Christopher Nolan's *Insomnia*. In this film, Pacino, the great actor, who had previously sleepwalked through generic thrillers, was wide awake, battling a sleep deficit and a devastating conscience in equal measure. There was an occasional spark amidst the insipid mediocrity of the 2000s, including when he played a long-past-his-prime singer trying to reconnect with his son, played by Bobby Cannavale, in *Danny Collins*. But it wasn't until Pacino's first time working with the legendary Martin Scorsese that the old Al was back. His first Oscar nomination in twenty-seven long years was well-earned for his volcanic turn as Jimmy Hoffa, a teamster turned gangster leading his life with puffed-up pride and damning the consequences, in *The Irishman*. The scene featuring his longtime friend Robert De Niro, warning Pacino of the dangers of his hubris, is one of the best scenes both actors have showcased in the latter stages of their careers.

But before *The Irishman*, I got to meet my hero on June 3, 2016. A date I will never forget because, devastatingly, on the way home after the event, I heard the news that one of my other heroes, Muhammad Ali, had died after a long battle with Parkinson's.

But back to the night itself. Maybe it was just a cash grab, but I couldn't care less. It was "An Evening with Al Pacino" hosted by Joy Behar. It was $500 for a pair of tickets for my wife Eamon and me, along with a picture with the star after the show. The picture alone would be priceless.

The event took place about an hour from our home at the Mohegan Sun in Connecticut. Joy wasn't exactly Roger Ebert on stage, but Al seemed to like her, and he told his usual stories with elan, many of which I had heard before, but still never tired of hearing. Where did the famous shout of "Attica! Attica! Attica!" in *Dog Day Afternoon* come from? Who was his favorite costar to kiss? How did he come up with "hoo-ah" in *Scent of a Woman* and how did he play blind? The crowd, naturally, ate it all up.

Then, it came time for picture-taking. Those who had paid for just the lecture dutifully trudged out while the rest of us gathered single-file for the moment to meet our hero.

While I was rehearsing what to say with my wife, the woman in front of me, who looked to be in her mid-fifties, with spiky blonde hair and glasses, seemed to be visibly nervous.

"Are you alright?" I inquired.

"Oh my god, yeah," she breathlessly said. "I'm just so excited. You have no idea how much I love Al Pacino."

I find, in moments like these, I have to resist the desire to be competitive and point out, "One of my boys' middle names is Pacino; see if you can top that!" Instead, I played along.

"We're all huge fans. It's gonna be great for all of us."

"I don't think you understand," she continued. "Look."

She lifted up her pants to reveal an incredible tattoo of Al Pacino as Tony Montana on her calf. I'm not one for ink myself, but had to admit that Scarface himself staring back at me was pretty damn cool.

She wouldn't shut up about what a fan she was and how nervous she was, and she was worried she might hyperventilate. She was from Nebraska and had flown all this way for this once-in-a-lifetime experience, and now she was making me nervous. I mean, she was probably going to faint once she saw Al—how the hell was I supposed to top that opening number?

When she walked in, I heard the burst of tears and what sounded like Al consoling her. One of America's greatest actors could also handle bawling fans like a total pro.

Thankfully, waterworks were not an issue when I strode into the room.

"Hey, Al," I said confidently. "I saw *Looking for Richard* at the Toronto International Film Festival."

I thought a specific reference to a film, one of only three movies he had directed, might resonate a little more than the usual *Godfather/Scarface* fan.

"Oh, sure, I remember you," Al said. Always the charmer.

I stood next to him; the long-simmering debate of who was taller, me or Al Pacino, would have to be settled another time, since he was sitting. We took the picture and then I turned to him.

"Al, I work for ESPN, you should come visit us sometime here in Connecticut."

"Ah, sports, sports, I love sports."

"Yeah," I added, "you grew up a huge Yankees fan in the Bronx."

"And basketball right now."

"Yeah, the Warriors. They're loaded."

"Oh, that guy, man, that guy."

"Steph Curry. Yeah, he's special."

"Yeah," Al said. His eyes glazed over, almost as if he was hypnotized and was watching Steph Curry launch a three-pointer, beautiful parabolas before his very eyes.

"He just, he just *gliiiides*."

I thanked him, walked away, and afterward I told my wife that I was incredulous that, of all the topics I thought I would cover with my favorite actor, the greatest shooter in NBA history was not the one I was expecting.

Al Pacino, to me, represents the very best of us. His memoir *Sonny Boy*, released in 2024, is surprisingly poignant, revelatory,

and nothing short of inspiring. If a little kid from the Bronx can overcome a neglectful father, a mother who suffered from mental illness, and significant poverty to become one of the most cherished actors of all time, then clearly there is hope for us all.

Every time I see Steph Curry dropping threes, all I think of is Pacino in that inimitable voice. It struck me that he could've been speaking of himself, the way he moves on screen. Think of him in *Scent of a Woman*, dancing the tango with Gabrielle Anwar as the blind, self-loathing Lieutenant Colonel Frank Slade. Long after he's gone, we'll see Pacino on the screen and think to ourselves, "Man, he just *gliiiiides...*"

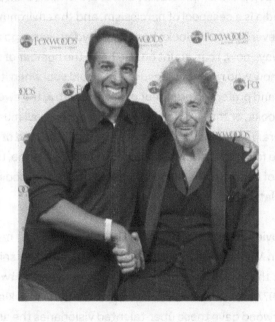

CHAPTER 4

Paul Giamatti: Movie Star

January 16, 2024

I would generally describe myself as an optimist, but I don't have much faith in the human race moving forward. I don't mean to be cynical, but it's the simple truth. Politics are a maelstrom of hate, social media is a cesspool of narcissism, and the environment is facing irreversible ruin. Books had their heyday years ago with Hemingway—now, I can count on one hand the number of adult males I know who read for pleasure. I'm an old soul when it comes to music and prefer the grandeur of Frank Sinatra, the sweet sound of Sam Cooke, or the sax blowing of John Coltrane—all music from a bygone era. Technology has improved a lot of lives, and of course, I would be feckless without Google Maps and my iPhone, but I miss the days of being genuinely bored, spending hours brooding and contemplating life.

As for movies, they don't make 'em like they used to. As my friend Ben Mankiewicz once said—correcting me after I said the '70s were the finest decade of cinema—the ten years between 1967 to 1977 were the best. That's when the auteur was king and Hollywood gave these über-talented visionaries the arsenal to fulfill their vision. Scorsese, Spielberg, Coppola, Lucas, Friedkin, Bogdanovich, et al., stormed the barricade and gave us groundbreaking cinema that reaped grand returns at the box office. One of the best books I've ever read is Peter Biskind's *Easy Riders, Raging Bulls*, which is chock-full of movie nerd trivia and

salacious movie gossip about these men and their entourages being ultimately undone by ego and avarice. And all the drugs.

Another decade which boasted many remarkable movies is the 1990s, which for me represented a critical time in my life, spanning my ages of twelve to twenty-two. Disgraced criminal and depraved former mogul that he may be, there's no denying that Harvey Weinstein and Miramax were a big part of why that decade churned out so many special movies as part of that legendary indie boom.

So, amidst the incontrovertible belief that I'm not just bathed in nostalgia and life really was better in the past, I have one thought that I cling to with obstinate hope that perhaps all is not yet lost in this crazy world of ours: Paul Giamatti is a movie star.

PG doesn't have the matinee idol looks that you would associate with someone of that label, but make no mistake: he is one. And Giamatti's done it the right way: by churning out brilliant work either as a character actor or a leading man for decades.

Giamatti was born in New Haven, Connecticut. His father A. Bartlett Giamatti was the president of Yale and eventually rose to the rank of National League President, and finally was commissioner of Major League Baseball for a scant five months in 1989. Bart's most famous decision was to ban the hit king Pete Rose for life, after it was discovered that Rose had bet on baseball, the game's cardinal sin. I attended an event where Giamatti was interviewed by Stephen Colbert for an hour about his career in July 2024 in Newark, New Jersey. I paid $400 for a front-row seat, and one of the last questions was from an audience member who asked about his dad banning Rose. Giamatti answered, "It's not something I talk about a lot, but I will. I don't think he loved doing it.

I think it was a really tough spot for my dad and it obviously had a huge impact on all of us."

Bart Giamatti died of a massive heart attack at the age of just fifty-one, shortly after making his fateful decree on Rose. But his impact was keenly felt on his son, Paul, since Bart was a professor of English literature. To this day, Giamatti the son remains a voracious reader who, in his prime, admitted he'd read a book a day, but now prefers spy thrillers and mystery novels that he finds in secondhand bookstores which he adores visiting. His apartment in Brooklyn has thousands of books, and he has readily admitted on his podcast *Chinwag* that he has a serious compulsion when it comes to buying them. For those not well-steeped in science fiction, he once recommended *The Lathe of Heaven* by Ursula K. Le Guin, which I immediately picked up from the library and found to be a deeply rewarding read that mixed the brainy and the beautiful.

Giamatti first made his mark as the scene-stealing executive in the Howard Stern movie *Private Parts*. Two moments still stand out from his performance: him teaching Howard how to enunciate and pronounce the call letters WNBC and later, apoplectic, shrieking to Stern, "You are the Antichrist!"

Giamatti had shown up in passing on episodes of my favorite cop shows like *Homicide: Life on the Street* and *NYPD Blue* and had one amusing scene in Mike Newell's *Donnie Brasco*, asking Johnny Depp about the ubiquitous phrase "fuhgedaboudit."

Giamatti didn't have any scenes with Al Pacino in that film, but later worked with him on stage. He has laughed about his penchant for whistling and being promptly scolded by the legendary actor to cease and desist such an annoyance.

A. A. Dowd did an outstanding job summarizing Giamatti's career for *Vulture* magazine:

> Because of his talent for playing unglamorous slobs and schlubs, Giamatti is an easy actor to typecast. But the truth is he has plenty of range. He's convincing as both sharp-witted intellectuals and dullards, the wealthy and the downtrodden, erudite fine-dining enthusiasts and bellowing supervillains. He can seem harmless or intimidating, can disappear into the wallpaper of a room or dominate it with his intensity. Few of his contemporaries seem as equally comfortable turning the volume down to a low dramatic hum as they do reddening their features and abusing their vocal cords. Which is to say, Giamatti can go as big or small as you need him to go.

For years, Giamatti was my great white whale. I thought I was going to interview him right before his Showtime series *Billions* was about to debut. We were all set up for 4:30 p.m. on a Friday afternoon in the studio, but as the minutes ticked by and his publicist told our talent representative Josh Drew that Giamatti was running late, the pessimism started to seep into the room. Eventually, his publicist promised to reschedule, but despite Josh's best efforts haranguing her, the interview never materialized and I was frustrated beyond measure.

Fast-forward to 2024, and Giamatti is embarking upon the campaign trail for a long overdue Academy Award for Best Actor for *The Holdovers*. He was unjustly snubbed for his finest performance as the lead in Alexander Payne's *Sideways*, and after reuniting with Payne and playing a teacher from a family of teachers himself, the public thought perhaps twenty years later the Academy would right its wrong.

I still couldn't land an interview with Giamatti for my podcast *Cinephile* as his publicists didn't get back to me, so I took matters into my own hands. I flew to the Critics' Choice Awards, to which, as a member of the CCA, I was lucky enough to gain admittance. I was accompanied by the great Ben Lyons and his friend, the equally great Josh Horowitz of MTV and the excellent podcast *Happy Sad Confused*, on which Michael Shannon has been a hilarious recurring guest.

From experience, I can tell you that at the Critics' Choice Awards (and I would assume this goes for all awards shows), the best place to chat with a celebrity is outside the bathroom or the smoking area. I once accosted Paul Schrader coming out of the restroom years earlier, thanking him for appearing on *Cinephile*. At the 2024 CCAs, while Giamatti was the golden goose, I also had the pleasure of saying hello and grabbing quick selfies with Seth Rogen, Jon Hamm, Will Ferrell (who pleasantly recognized me from my college football coverage on ESPN), Ramy Youssef (who I commended for being such an inspiration to our fellow Muslims), Kiefer Sutherland (who, when I told him I hailed from Kingston, Ontario, smiled and said, "They make 'em tough in Kingston"), and Matthew Macfadyen, and they were all friendly and gracious. I told Macfadyen he had the single funniest line on *Succession*, which was, "Soon, I'll be sucking off ogres for phone cards." He gave a great belly laugh and confessed, "I had trouble saying some of those lines with a straight face."

As for Giamatti, I waited outside near the bathrooms as he was in a rather extended conversation with an animator, while Jeremy Allen White was having the first of many cigarettes in the designated smoking area. PG was explaining that his goal was once to be an animator, which was one of the direct reasons he was so happy to play the misanthropic Harvey Pekar in the brilliant indie movie *American Splendor*. Giamatti was being polite, but I could tell

the woman was wearing him out and eventually, mercifully, she asked for a picture. I jumped in and offered to take it for her and her coterie of friends, and then asked them to return the favor. As I put my arm around Giamatti for the picture, I mumbled, "I've got a story for you."

He had a wary mien about him and said, "Okay."

I said, "I've heard you on my friend Josh's podcast *Happy Sad Confused*, on *WTF with Marc Maron*, on Scott Feinberg's *Awards Chatter*, and *The Hollywood Reporter* pod, and I love *American Splendor*, *Sideways*, *Cinderella Man*, all of it. But none of them asked you about the movie of yours I really love, which is *Barney's Version*."

He smiled immediately and said, "You're right, that's a great fucking movie, and nobody asks me about it!"

I told him I was Canadian and was a fan of Mordecai Richler, who wrote the book upon which the movie was based, and I remember how complimentary he was of Montreal and Canada when he had won the Golden Globe for Best Actor.

He nodded and said, "Yeah, Canadians love that movie, and so do Italians for some reason. I don't know why."

"How great was Dustin Hoffman as your dad? Dying in the massage parlor."

Giamatti chuckled. "Hilarious. We got along great."

I continued. "You know another movie of yours people don't mention enough is *Win Win*."

Giamatti said it this time with even more conviction: "That's another great fucking movie nobody asks me about! Tom McCarthy, yeah." (McCarthy wrote and directed the movie and later helmed the Oscar winner for Best Picture, *Spotlight*.)

"Cannavale, Jeffrey Tambor, so good," I said.

Giamatti then told me that rather than listening to him on all these podcasts, I should be listening to his podcast *Chinwag*, and I promised I would add it to my rotation. (I did listen and it was as strange and irreverent as I hoped it would be during its one-hundred-episode run. Giamatti eventually pulled the plug on the pod with Stephen Asma, blaming his lousy multitasking and needing to turn his attention to his day job.)

"Last thing," I continued, "and I promise I'll leave you alone. Everyone always mentions the Merlot line from *Sideways*, but the funniest part is when you go in the store and ask for a copy of *Barely Legal*. The guy goes to get it and you interrupt and you say 'No, no, the new one.'"

To this, Giamatti gave another good-hearted laugh and said, "Yep, that's a good one."

I asked him if he still had the same publicists and if he'd come on *Cinephile*.

"For sure," he said. "We can talk about *Barney's Version*."

And with that, he walked away. His publicists still did not respond to my request for an interview with this marvelous, sui generis actor, but I was satisfied. Later that night, Giamatti deservedly won the Critics' Choice Award for Best Actor, announced with gusto by Oprah Winfrey. Like a member of the paparazzi, I had

my iPhone out in anticipation. I was hunched down right in front of his table and recorded his humble reaction when he won and subsequent excellent speech. In the speech, Giamatti specifically thanked In-N-Out Burger for his viral post-Golden Globes sighting and mentioned his son, his late father, the cast of *The Holdovers*, and his girlfriend, Clara Wong. He also gave a pointed shoutout to the profession which has dominated his family, saying, "Teachers are good people. We've got to respect them."

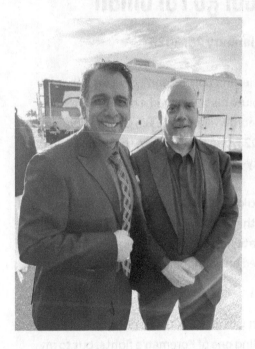

Giamatti may have lost the Oscar to Cillian Murphy for *Oppenheimer*, but the true cinephiles know what a talent and genius of an actor he really is. He can nail a persnickety crank like Harvey Pekar in *American Splendor*, ham it up as the villain with Clive Owen and Monica Bellucci in *Shoot 'Em Up*, carry a period piece like *John Adams* on HBO, give hope to wannabe authors and schlubs in *Sideways*, play the role of a true supporting actor with energy and pep for Ron Howard's *Cinderella Man*, portray a virulent racist in *Twelve Years a Slave*, and finally, pay tribute to the long line of teachers he comes from in *The Holdovers*. Try not to be overcome in that final touching scene—I dare ya.

CHAPTER 5

Ready for My Close-Up: Big George Foreman

January 26, 2023

I've only been in one movie, and no, you don't get to glimpse my visage, but I had an absolute blast. I played a boxing announcer (I know, big stretch) in George Tillman Jr.'s *Big George Foreman*, which was released in 2023, two years before the boxing champ died at the age of seventy-six.

I went to a recording studio in Montclair, New Jersey, and was thrilled I'd be working with my former ESPN colleague and current MLB Network running mate Robert Flores. Ro Flo is an incredibly talented guy, quick-witted and congenial, and a genuine boxing fan as well.

My agent and friend Matt Olson at CAA, who got the deal done for me, told me I'd be calling one of Foreman's fights, but to my delight, once I saw the script, I realized it wasn't just a fight. It was the granddaddy of them all: the Rumble in the Jungle. It was a pivotal fight in Foreman's career. At the time, George was a physically imposing, brooding, and brutish hunk of granite, a dour and sullen guy—a stark contrast to the lovable image he cultivated later on in his career when he was hawking the highly successful Foreman Grill.

There were two announcer roles, simply named Announcer 1 and Announcer 2, so Ro Flo and I determined I'd be the play-by-play guy and he'd do the color commentary. Our director, George Tillman Jr., joined us via Zoom and was a friendly, guiding hand. His previous films included *Soul Food* and *Men of Honor* and I made a mental note to ask him later about directing Robert De Niro in the latter.

Ro Flo and I put on our headphones and went to work. We were seeing edited footage from the movie and it was, as always with moviemaking, amazingly meticulous. We would hear three beeps in our ears, seconds apart, which was our cue to start speaking our lines rather than George having to say action every time. We had a total of about twenty to twenty-five lines, but we would only record in couplets: a line from me, a line from Robert, and then do it again.

George was always unequivocally positive in his reactions and pragmatic in his approach. "Okay, that was great," he'd say. "Let's just try it again."

I'm the type who truly takes it seriously when taking direction. If I'm not given any feedback, I like to deliver the lines the exact same way, since I realize directors have various reasons for asking you to do it again. If they want specifics, they'll tell you, and George would. After a few takes, George noted that Robert and I sounded a little too similar, so Ro Flo made the gracious decision to take his delivery down a notch.

After an hour or so, George seemingly pleased with our performance, I heard what I had been waiting for.

"Alright, you guys do this for a living, right? You want guys who know what they're doing and you guys are authentic. So, forget about the script; just say whatever comes naturally and we'll do the whole thing."

Now, I had license to ham it up as much as possible and get hysterical in the biggest moment of the fight. Muhammad Ali was Foreman's opponent and took an astonishing amount of abuse in the fight, but his strategy was the famed rope-a-dope. The blows clearly hurt, but Ali, playing possum, waited for Foreman to tire himself out. Finally, when Ali knew George was bone-weary and depleted, he pounced on him and unloaded on the stunned Foreman, sending him tumbling to the canvas and winning an unlikely fight as an underdog.

The crowd in Zaire was rabidly cheering for Ali, and even though I was aware this was a Foreman biopic, as an announcer without any bias, I was intent on selling the finale as hard as I could, my voice even cracking a few times in the big moments with Robert and I sharing a laugh about it.

It was a wonderful collaborative process, and I loved how George allowed us to ad-lib and change the script to whatever felt more natural or realistic. He didn't just desire ersatz emotion. He confessed he had a real problem with the line: "Foreman's lines are rubbery and Ali's legs are strong." We changed it to "Foreman looks gassed and Ali is still rolling," and he was so grateful. After ninety minutes, we were done, and I asked George for a De Niro story before we said goodbye.

"Oh, Bob's amazing. He likes to do multiple takes, multiple lines right after each other. So, if the line is 'Hey, how you doing?' then it's 'Hey, how you doing? Hey, how you doing?' I went to him and I said, 'Bob, I don't think you're giving me enough space in between the two lines, you know?' My editor was saying that. And he was like, 'Really?' He said, 'I think you should go back to your editor and take a look at that.' I went back to my editor and he said, 'Don't ever talk to Robert De Niro again about what you're not doing, right?'" We all laughed.

"And he's such a great supporter, man. I learned a lot from him because he's a director too, you know, he directs it. We would talk about the pacing of the movie and how we could fit all that we wanted in two hours and eight minutes, how all of it fit together. He would always show up early, do the job, and then afterwards game plan how we could be better tomorrow."

Invigorated by the entire experience, I couldn't wait to see the finished product. They sent me a rough cut of the film two months later and after an hour into the movie, we got to the gargantuan set piece, the Rumble in the Jungle.

There weren't as many lines as I expected. Less is more, I told myself. But I could clearly tell it was my voice on screen and I liked the energy of me and Ro Flo together.

And then the big moment, the fateful blow from Ali to the redoubtable Foreman. Here's where I would shine...except I didn't.

George made the appropriate artistic choice to shut us up, swell the music higher, and shoot Foreman tumbling to the canvas in slow-motion. It was impactful and completely the right call, but I couldn't help but think, *So much for my Howard Cosell moment that would launch me into many more acting gigs.*

I later interviewed George on *Cinephile* and on MLB Network and he was enthusiastic and gracious, even if he did cut out my best stuff! But again, I was just elated that now on IMDb, I actually had my very own appearance in a major motion picture.

By the way, the paycheck was $2,300 for ninety minutes of "work," if you can call it that. I really should've bought a Foreman grill in gratitude.

CHAPTER 6

Some Folks Call It a Kaiser Blade: The Legend of Billy Bob

November 22, 2016

It helps when you have a cool moniker. Billy Bob Thornton. Proudly from Arkansas and yet so much more than a celebrated Academy Award-winning actor and musician with the Boxmasters. He's also peculiar, eccentric, refreshingly candid, and a man of probity about everything from his profession to his phobias.

When he was first trying to make a name for himself in Hollywood, Billy Bob was working as a server at "a famous person's party," as he puts it. There, he was given indispensable advice from a famed director, who told him to write a part for himself if Hollywood couldn't cast him. He explained Billy Bob's problem: "You're not handsome enough to be a leading man, but you're too handsome to be a character actor." That director was the nonpareil Billy Wilder, who directed masterpieces like *Double Indemnity*, *Sunset Boulevard*, and *Some Like It Hot*.

Billy Bob came to ESPN on November 22, 2016 to promote *Bad Santa 2*. As he was coming into our studio, he was intercepted by my friend, former NFL defensive star Booger McFarland, who was a genuine fan and wanted to tell Billy Bob how much his work meant to him since they were both from the South. After a couple of minutes, Booger formally introduced himself and Billy Bob said, "I

Some Folks Call It a Kaiser Blade: The Legend of Billy Bob

know who you are," and then turned to me, gave me a big grin, and said, "And I know who you are, too."

I was flush with pride and overjoyed. And away we went.

★ ★ ★

Adnan Virk (AV): I wanted to start with, first and foremost, *One False Move*, because that was the film that introduced you to me. You wrote the script with Tom Epperson. And I remember the movie critics Gene Siskel and [Roger] Ebert's review. They were like, "You got to see this film." And the greatness of that movie is it's not only a thriller, it's a commentary on race. It's a commentary on city versus country. It's about family. It's an extraordinary movie. When you have memories of *One False Move*, what stands out to you?

Billy Bob Thornton (BBT): People didn't want us to use that title because there were several movies in the catalog, over the years called *Hurricane*. And then it was called *Star City*. And then finally, one of the studio guys named it *One False Move*. We didn't even title it. And at the time, we thought it sounded kind of like a B movie title.

AV: Right, it sounds like a generic thriller.

BBT: Exactly, and we weren't crazy about the title. And yeah, it worked out okay. But, you know, Carl Franklin, who directed the movie—Carl is a terrific actor's director. And so, I was really happy to be with a good actor's director early on like that. Because, you know, some people get with the wrong people and develop bad habits. And I think he did a great job on it. And you're right, the movie's about a lot of different things. And it's the kind of movie— because the independent film business is pretty much done for right now. It's all on TV. You either do event movies for the studios,

or you do Amazon, Netflix, whatever. And that movie, along with *Some Folks Call It a Sling Blade* and *Monster's Ball*, man, it's no longer there. A lot of movies that I've done over the years probably either wouldn't get made now, or would get made for a couple of million dollars and nobody would ever see them.

AV: You dovetailed perfectly to my next point, which is the twentieth anniversary of *Sling Blade* this month. People forget and think you won the Oscar for acting, but it was for the screenplay. Because you had come up with the story; some folks call it a kaiser blade, I call it a sling blade. But how were you able to make that movie in 1996 and have it transcend, like you said, beyond just this independent bubble?

BBT: Right. Well, you know, from the late '80s through the late '90s, there was a sort of an independent film renaissance period. It was a really rich time for independent film. And, you know, Miramax had a lot to do with that. And it was a time when those were sought-after. You know, somebody wanted the next real edgy, sort of literal anti-hero, indie-feeling, rough-edged kind of movie.

And I sold that movie to the first people I talked to, really my agent over at William Morris. He just said, "Hey, there's this guy," like they were production assistants, and now their parents, you know, gave them some money to make movies with. They had made one movie, I think, before *Sling Blade* for like $60,000.

And I'll share something that I don't even know if I've ever said publicly, but I've told friends of mine—one of the things about *Sling Blade* is that they didn't have all the money. They said, "This is gonna be our first million-dollar movie. We can't pay you as a director or anything, we have to pay you as an actor because of the union stuff," but I wasn't in the DGA [Director's Guild of America] yet.

Some Folks Call It a Kaiser Blade: The Legend of Billy Bob

"But what we were doing is looking for people with a script who want to direct their own movie because we can't afford directors, but we'll let you direct it and we'll give you fifty percent of it, of the gross." And I said "Yeah, okay," because I thought my mom and a few friends would see it, you know. And so, one way or the other, what they didn't tell me at the time was that they didn't have the money. They were getting the money as we were making the movie. They had $30,000 when we started. I mean, if I had known that, I would have been a nervous wreck, you know, but I had no idea.

AV: And that's a fortune, a million dollars for an independent film at that time, it's a fortune. You're thinking, "We're good, we got this." I love J. T. Walsh in the movie.

BBT: Oh yeah, I know, right? J. T. was great.

AV: The only flaw of the movie is every damn person that sees it does an impression of Karl.

BBT: They always mention french fried potatoes. You know, I don't care if people love your movie, they can love it for whatever reason, but it is a little disconcerting to me that, you know, people will come up to me sometimes and say "Man, I love *Sling Blade*, man, that scene where he said 'french fried potaters' was hilarious." And I'm like, "Really? So, you didn't get the whole religion part and, you know, all the underlying themes? I guess that's at the top of your list."

AV: I read Martin Scorsese gave you editing tips on *Sling Blade*, is that true?

BBT: Well, you know, what happened was the studio wanted me to cut it. Once we sold it to the distributor for more than I ever dreamed of, they wanted me to cut the movie down—they always

want you to cut things to an hour. And so, I sent it to Martin Scorsese on video cassette. And because he was a fan of *One False Move* and I'd met him at something once, and he said, "If you're needing anything, let me know. You know you're going to do okay in this business. Whatever you know, kid," that kind of thing. And so, I took him up on it, and I don't think he remembered even meeting me, and probably doesn't remember *this*, but I sent it off to him. I called him up and I said, "If you could ever help... They want me to cut this movie. It's my first movie, I'd done a documentary before, but that was it. Would you watch this and tell me if you think it needs to be cut? Because I would listen to you." It had no music or anything yet. It was two hours and seventeen minutes. And I sent it to him, and I heard back from him a couple of weeks later.

He said, "Don't cut a frame, aside from anything creative. I personally happen to think this is a great movie, and I think you're going to do very well with it. You may even collect an award for this movie, you know. The reason I'm telling you this is because right now you're under the radar, you're starting out and everything. This is probably the only time, the only chance you'll ever have in your career, to do a movie exactly the way you want to do it. Once you become a big deal, they'll never leave you alone again." And he was right. You'd think it's the other way around. But in fact, when they don't care about you yet, that's when they'll let you get by with stuff. And see, the original company, The Shooting Gallery, that gave me the money to make the movie, they gave me the final cut. So, when we sold it to the distributor, our distributor already had the final cut. So, they couldn't make me cut it. And that's why I sent it to Scorsese.

AV: I think *The Man Who Wasn't There*, which you did with the Coen brothers, is extraordinary. Great film noir, beautifully shot by Roger Deakins, the dialogue's amazing. That character you play, the barber, is so detached and so taciturn. How were you able to do that?

BBT: Well, the hardest thing, or at least the thing that was most concerning before doing the movie was figuring out, how do you do a whole movie where you're really talking in voiceover the whole movie, and you don't have a lot of dialogue, you're just sitting there smoking and looking at people?

And one of the things that I do when I'm playing a character that's that inside themselves is, on the set, I'm not that way all the time. In other words, if you're just sitting there, Robert Duvall told me years ago, there's a thin line between subtle and boring. And I think that, first of all, you have to hold the camera. And there has to be an intensity inside you in order to do that. And so, on the set, I would talk to people right up to the time we said action. I didn't sit in the corner and sulk. That would just keep me in the same spot. So, in other words, if it's almost like when somebody dies and you see something go out of them or whatever, you know. It's like, if I've just been sitting around joking with you and we've been talking about football or whatever it is, and then I sit down and they say, "Roll," there's still life going on there, see.

AV: I watched some behind the scenes stuff on *Monster's Ball* and you're already in conversation with Halle Berry before they call action and you're reading what's scripted.

BBT: Well, the point of good acting is that you're supposed to be real. I've always looked at acting classes like this—they take you through *all* these steps to get to this "place." And maybe it works for some people, not for me. But I always say this to young actors.

I say, if you're in Santa Monica and you want to go to the airport, you don't go from Santa Monica to Glendale to the airport. Just go to the airport. It's right over there. And so, I believe that if you have life experience, you should just talk to people like you talk to them without going out in the hallway and yodeling and stuff first.

AV: I think some would say, "So, you mean method acting?" but it's not like you're staying in character the whole time.

BBT: No.

AV: You're being you.

BBT: Yeah, I'm me in every role I play.

AV: So, it's not like Karl is inhabiting the set, as pretentious as that sounds.

BBT: Yeah, I don't even call characters by their other name. It's like, "Who is William?" "Well, you know, William is the kind of guy..." because you're automatically separating yourself from them. You're making them a mountain you have to climb. And I just don't believe that. I mean, my dad was like the guy in *The Man Who Wasn't There*, which, by the way, is my favorite performance I ever did.

AV: Oh, it's extraordinary.

BBT: And when you're doing these things, you have to kind of keep your life in it, you know? It's like, I always tell people my method started when I was born. They ask if I have a method or a process— my process was from the time I was born 'til now. You know, it's not something I concocted.

And it's like, if an actor is playing a street person, let's say a homeless guy, and he goes downtown in LA and he gets in a cardboard box on Fifth Street, and his security guard is right there in the car, and you know, his publicist is on the phone with him and stuff, and he spends the night in a cardboard box, you're still not going to know what it's like to be a homeless guy. If you know that

you're going back to Beverly Hills tomorrow, you're not going to know what it's like to be homeless, you know?

AV: The guys that get caught in concepts end up missing the real substance of the art.

BBT: Well, people want to believe. Like, if you do a Q&A with a group of young filmmakers or whatever, or critics or whatever you are, it's interesting to them to hear about the process. And it's interesting to hear all the tricks of the trade. People desperately want to believe that there's a formula for everything. And sometimes there's just not. And I believe for actors, you can either do it or you can't. I've never seen an acting coach make a bad actor good. I've seen them make good actors worse. (Laughs)

AV: You see some young actors and say, "I just don't see it."

BBT: Yeah, that's not your deal. See, for instance, people assume that actors can do any other kind of entertainment thing. Not true. I'm not a good public speaker, I could never...I'm the wrong guy to host something. For instance, I'm too scattered. I have ADD. I'm dyslexic. There's all kinds of reasons for me to not be a host.

AV: *Bad Santa* is one of the funniest movies of the century. I've read that when you got the script, you were like, "Okay, either this is going to be a gigantic hit or this is it. I'm packing my bags and going back to Arkansas."

BBT: Exactly.

AV: Why do you think it was able to connect with audiences?

BBT: I think it's an alternative to the usual overly sentimental kind of movies. People who watch *It's a Wonderful Life* will watch *Bad*

Santa 2. I think it's almost like an antidote to all the Christmas syrup. And also, I think Willie says a lot of things to people that we want to in the grocery store at the time but we can't do it. I think everyone wants to do that now and then, and I think people can live vicariously through Willie that way. And also, something that profane—you just got to...you watch it like a train wreck. It's like, "Wow, they did this."

AV: You mentioned Duvall, your relationship with him. How did that happen? He's in *Sling Blade*, you're in *The Apostle*, which I think is Duvall's masterpiece.

BBT: I love that movie, yeah.

AV: And your character plays this racist who ends up coming to the church and has an awakening, so to speak. How did that develop with Duvall? He's one of the greats, obviously.

BBT: I knew Duvall before we did *Sling Blade*. We had the same agent, and my agent knew that he was my hero and he hooked us up a few years before that. And Duvall came to me one time, to Tom Epperson and myself, and he said he liked our writing. And Duvall loves Southern literature—Texas and Faulkner and Steinbeck, any of that stuff. And he said, "I want you guys to write me a movie where I play a Black man." I swear. And I said, "Well, Bobby, that's kind of a tall order." And he goes, "When I was a kid, there was a Black man who had red hair. I swear to god. And I remembered that in my town." And he wanted to play a Black man. So, we wrote this movie that he and James Earl Jones starred in called *A Family Thing*. And that was kind of how our relationship started right there.

AV: That's really cool. Speaking of projects that went against the grain, you were nominated for an Oscar for Best Supporting Actor for *A Simple Plan*. I think of the scene when Jacob, your character,

says, "Listen, man, I've never even kissed a girl before. If being rich changes that, I'm all for it." How do you know those characters? It seems like those outcasts, those guys from the South, you know those people better than anybody.

BBT: I was one, more than people know. I was raised in the woods. And when we moved into a town that was a bigger town, I was kind of an outcast, and teased as a hillbilly and all this kind of stuff. So, I went through all that, and I was just this buck-toothed kid who never figured I'd amount to anything, and I was pretty insecure. Those characters are actually probably closer to me than anything else. And the character, that scene you're talking about with Jacob in the car about the girl, that wasn't in the script. That was mine. And that was an actual story.

AV: It's a rich filmography you have put together. I could talk to you for hours. I'm glad we were able to be nostalgic about it all.

BBT: Me too, man.

★ ★ ★

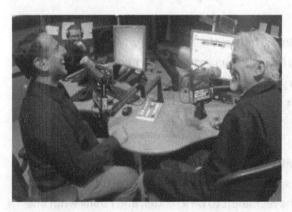

The interview ended and he gave me a big smile and said, "Man, I knew you liked movies, but I didn't know you knew that much!"

For a guy who was a total neophyte when it came to navigating Hollywood, Billy Bob Thornton is as sagacious as they come.

CHAPTER 7

I, Margot: Before *Barbie*, Robbie Became a Star

November 28, 2017

Margot Robbie first burst onto the scene as Leonardo DiCaprio's sultry and sensational love interest in Martin Scorsese's diabolically funny *The Wolf of Wall Street*. She is now a brand unto herself after the smashing global phenomenon that was *Barbie*. When I interviewed her, it was when she was promoting her first starring vehicle, *I, Tonya*, where she played disgraced figure skater Tonya Harding. Robbie is empirically pulchritudinous yet also fearless in the roles she tackles.

* * *

Adnan Virk (AV): In the movie, they refer to Tonya as short or dumpy and not as beautiful or pretty in the images of Nancy Kerrigan, and you yourself, of course, are a tall and beautiful actress. I wouldn't expect you to play Tonya Harding. What was it like for you?

Margot Robbie (MR): No, I mean, first and foremost, Tonya I think was very unfairly spoken about in the looks department. She's an athlete. She was never meant to be a model, and I think what she did kind of got left on the wayside in light of the whole incident, but she was a tremendous athlete. I guess I was most worried

about convincing audience members that I could also seem like an Olympic-level athlete. I did months and months of training, of course, but even if I had ten years to train, I could never possibly skate like an Olympic-level athlete. So, that was my biggest fear on the physical side. The rest of it, like with any character, you have amazing people to work with, amazing people who can do crazy things with hair and makeup and costumes. And the idea was more to embody the spirit of Tonya. That's what was important to the fact that we handmade all the costumes, the way her costumes were handmade. All the makeup that our makeup designer used, she bought really cheap at a strip mall. Nothing was, you know, high design and makeup. It had to be something that Tonya could have physically bought herself in the '80s. The hair, the '80s perm, was amazing and great fun. And we adjusted the hairline with the wig so that, you know, my face shape changed slightly. So, there's a lot of tricks you can do like that, and a lot of it did help me feel more like the character and definitely embody the spirit of Tonya and also, you know, the '80s, the '90s, a different time period.

AV: No question. It's a very physical role. I'm Canadian and am probably one of the few that can actually discern the difference between a salchow and a triple axel. That whole world, Margot, is different, isn't it?

MR: Totally, I mean, it's such a hard sport, and I think I even underestimated how difficult it would be. When I started training, I said, "Okay. I'll need like a couple months for sure, but I'll pick it up quickly." And I mean, it's *such* a hard sport. It's really painful. I played ice hockey a little bit when I first came to America, and this was way more painful than that because you've got no padding on. You've got the toe pick there to trip you up. But falling on the ice with no padding, it's brutal. And the sheer raw power and strength it takes to pull off these moves is unbelievable. I mean, what these athletes do is incredible, and that's why it was so important to us

to film these skating sequences on the ice. I mean, a lot of the time when you see it on TV competitions and things, it's, you know, through a long lens or a static shot from a camera on the side of the rink. And in that way, it's seen as being very graceful, and it's a real art to make it look so effortless. But when you're on the ice, like a few feet away from a raised sharp blade flying towards the camera, it's exhilarating to watch and you understand the raw power and how tough this sport is.

AV: I understand you talked to Tonya Harding before the filming started. How did that conversation go?

MR: It was great. She was incredibly understanding about what we set out to do. I mean, I didn't want to meet her until right before we started shooting because I wanted to have prepped my character and decided exactly how I was going to play the character before meeting her. She wasn't a consultant on set. She didn't get any say in the script or anything like that. So, all things considered, she was very understanding that we were setting off to make a movie. And obviously, seeing it must have been a weird experience for her, to see the most triumphant and tragic moments of your life whittled down to two hours on a screen told in someone else's hands. It must be incredibly difficult, but she was always very understanding. She understood that she needed to let go and let us do our thing. We told her, "This isn't a traditional biopic. It's not a documentary. It's a feature film." And I just wanted to let her know, "I'm playing a character. I'm not trying to replicate you." We need the liberty on set to kind of let these characters grow in their own way as we're filming. And we can't sugarcoat anything, which we didn't. So, you know, when she eventually saw it, once we finished, right before we premiered at Toronto, she said she laughed and she cried. And there's obviously moments she doesn't agree with, primarily the moments that's told from Jeff Gillooly's point of view

in our film, who's played by Sebastian Stan. So yeah, but overall, I think she's grateful that her side of the story was finally told.

AV: Your scenes together with Allison Janney are the heart of the movie. I would be laughing because it was so droll, dry, deadpan. Janney's the mother from hell, but then I'm laughing because she's so blunt and so ruthless. I thought you two both knocked it out of the park.

MR: Yeah, Allison described it well. Allison says doing our characters is like laughing in church, where you can't help but laugh, but then you feel bad about it. Straight after it, there's a lot of those moments in our film where you find yourself laughing, but moments later, you're kind of hit with the reality of the situation and it is really confronting. Suddenly, the room goes dead silent. You can hear a pin drop. It's amazing what Craig, our director, did to manage to pull off a tone so specific, one that dances between the drama and the comedy. It's a very entertaining film.

The violent moments are not entertaining. They are confronting. We didn't want to sugarcoat that and make it seem like an issue as serious as this is by any means easy for someone to deal with. So, those moments, yeah, it's quite confronting, I think, for an audience to watch. But then, you know, moments later, you find yourself laughing at something else entirely. And it's just a wild ride, this film. It really, it's hard to give it a specific genre. It just encompasses the richness of Tonya's life. There's tragedy. There's hilarity. There's absurdity, there's harsh realism. I think people will be very surprised when they walk out of the theater.

AV: And I love the breaking of the fourth wall. I don't know if I laughed harder than the scene where Allison says, "Well, I've kind of disappeared from the storyline, what the hell?" I started laughing.

MR: With the bird on her shoulder.

AV: It's just so self-aware. And I guess part of that was because, when researching, the writer spoke to Tonya and Jeff Gillooly; they both had such conflicting stories. So, you have this unreliable narrator, which is true to life. I definitely noticed the influence of GoodFellas from the jump cuts and then the moving camera and the music. Did Craig talk about it? Did he screen GoodFellas with you?

MR: No, I mean, I think Craig had a lot of touchstones, David O. Russell, Scorsese, of course, Coen brothers. There's a lot of touchstones in this film. And at the end of the day, it wasn't about replicating any specific moment from any other specific film, but knowing that we didn't have the boundaries to hold back and try to be one specific thing. It was a very fluid set. Things would grow organically in the moment. Things would get kind of...they would escalate and scenes would get bigger and bigger, or small moments would be very quick and quiet. I think Craig was a genius that he didn't hold back or let himself be boxed into any specific thing. But yes, I'm sure he's thrilled that people are likening it to GoodFellas, because that's kind of everyone's favorite movie.

AV: When you first auditioned for Scorsese, Ellen Lewis gave you the call and said Marty is interested. You're like, "Who's Marty?" And then what happened with you and DiCaprio?

MR: Yes, I didn't know that everyone referred to Marty as Marty and not Martin Scorsese, so that took me a minute. And then I quickly gathered that Leo was Leonardo DiCaprio. Here I was, using everyone's full name up until that point. But it was a crazy, crazy experience. I mean, I jumped off a plane and was suddenly in New York City in Ellen Lewis's office and she took one look at what I was wearing, and was like, "Why are you wearing that?" And I was like,

I, Margot: Before *Barbie*, Robbie Became a Star 69

"I didn't know this was going to happen." I didn't pack accordingly. I had jeans and flat shoes on. She was like, "Please try and look a bit like the character. You're going to go to SoHo, get the tightest dress and the highest heels, and then you're going to come back and do this audition." I was like, "Got it." So, I came back, and yeah, to be in the room with Ellen Lewis, Martin Scorsese, and Leonardo DiCaprio all at once was incredibly overwhelming. But yes, I guess my nerves bled into my performance a little bit and maybe I got a little overzealous with a particular scene and I smacked Leo in the face, which was not scripted at all. And I had a moment of terror where I thought I was going to be arrested for assault, and instead they gave me the role, so it turned out well in the end.

AV: Who was laughing harder after you slapped Leo, him or Scorsese?

MR: I don't know, they were cackling. They thought it was hilarious. They were like, "Do that again. Let's do the scene again and hit him again!"

AV: How about the fact that in *The Wolf of Wall Street*, the way Terence Winter wrote the script, the Duchess is referred to as the most beautiful girl in the world. No pressure, right?

MR: Yeah, hottest blonde ever, I think, was the quote. Yeah, everyone says, "Oh, when you transform for a role..." I was like, "I can't look like this. This is impossible." But really, it really is about just embodying the character and the attitude of the character. You can do anything if you say it with conviction.

AV: Yeah, and I know that obviously you've acted in soaps before, but what was it like being directed by Scorsese on set, as you said, not being overwhelmed by the moment, working with Leo and all those other great actors?

MR: I just never presumed anyone would take notice of my role, so I kind of just went for it and did whatever felt right in the moment. No one knew who I was at the time, and no one was expecting me to do anything particularly amazing. So, I thought, well, why not really go for it? When am I ever going to get an opportunity like this before? I don't know if I'll ever even get to be in another movie after this. So yeah, Scorsese—like Craig and *I, Tonya*—kind of created one of those atmospheres on set where there's no boundaries. It's your character and you do whatever your character would do in this moment. And if that means doing something really crazy or doing something exceptionally subtle, that's your choice to make. And I love working with directors who don't give you boundaries like that. They create a safe space and then they let you go wild. It's amazing.

AV: Now, those scenes with you and Leo, I mean, you could tell what kind of relationship the Duchess had with Jordan and she wasn't going to take any crap no matter what. That was the best thing about your character. I just read what David Ayer was saying about *Suicide Squad*. He said he regrets the fact he should have made the Joker the main villain in the movie. I know that movie got mixed reviews, Margot, but everybody was unanimous that you were the best part of the film, that you were outstanding as Harley Quinn. This is somebody who relishes her homicidal tendencies. Seems like a fun character to play; what was it like for you?

MR: Oh, she's so much fun to play. I love playing Harley. I kind of never wanted it to end, but yeah, again, another brilliant director to work with, and I love that David never directed me differently to any of the guys on set. If he was pushing them to a really dark or uncomfortable place, he'd be giving me the exact same piece of direction. He never sugarcoated anything just because I was a girl on the set. You know, these characters are wild, and he kind of let them go wild. But I loved playing Harley. She's definitely got a lot

of attitude as well. I think a lot of the characters I play have a lot of attitude. But that's why it's so fun. You get to do and say all the stuff that you can't do in real life. It's the best part of the job.

I wasn't as enamored as the rest of the world was with Greta Gerwig's *Barbie*. Robbie, with those limpid blue eyes, is always irresistible on screen, and Ryan Gosling was amusing as Ken, but while subversive at times, I did find the second half of the film rather heavy-handed and obvious. But I have been thrilled to see Robbie's ascension from stunning ingénue to one of the biggest, most bankable movie stars in the world. I hope she takes more chances like *I, Tonya*, an indie film that broke through and stands as a vital movie in her burgeoning filmography.

CHAPTER 8

J. K. Simmons: Master Conductor

October 12, 2016

I was mesmerized the first time I saw J. K. Simmons on Tom Fontana's Oz, a prison drama which aired on Showcase in Canada, where I saw it, and originated from HBO in the US. The show was highly influential in proving HBO's mantra: "It's not TV. It's HBO." The entire cast was uniformly excellent but no one was more powerful than Simmons as Schillinger, a neo-Nazi who tortures a new inmate named Beecher who is woefully out of his depth. Simmons was charming and terrifying in equal measure, and I became a fan of his for life after being enraptured by his work.

J. K. is beloved in the industry and is a consummate professional with over two hundred stage and screen credits. He won the Academy Award for his iconic performance in Damien Chazelle's Sundance breakout Whiplash (2014) and was also nominated for playing William Frawley in Being the Ricardos (2021). He has also won a British Academy Film Award, a Golden Globe, and a Screen Actors Guild Award. For mainstream audiences, he is unmistakably J. Jonah Jameson in Sam Raimi's Spider-Man trilogy, and if you want to see his comedic side, I thought he was hysterical in Palm Springs (2020) alongside Andy Samberg and Cristin Milioti.

So, it was a genuine thrill when, through being the voice of Celebrity Softball on ESPN, I got to interview J. K. and tell him what a fan I was of his work on Oz and in general. He was kind and

gracious in person, just as he was when I interviewed him for the *Cinephile* podcast.

★ ★ ★

Adnan Virk (AV): Joined now by J. K. Simmons; you can see his new film *The Accountant* opening this Friday. J. K. and I go back to Celebrity Softball in San Diego, which I call with Eduardo Pérez. I don't have the box score in front of me, J. K., but I'm pretty sure you went two for two with a couple of singles. I still can't believe Terry Crews struck out—which, we had him on the podcast recently. He swears that it was no accident, but I don't know.

J. K. Simmons (JKS): I walked up to him after that and I said, "Are you sure you're left-handed?" Because, you know, [he] look[ed] like one of those kids I coached in Little League, like in T-ball, where they get up and they're so uncoordinated that you go, "Put the glove on the other hand," and they go, "Oh, yeah, no, I actually throw with this hand!" Because his left-handed swings were not pretty.

AV: That's a great call. He took his shirt off and my call was, he looks like a Greek god when he took his shirt off, and then he just embarrassed himself when he struck out. It was awful.

JKS: Yeah, yeah, no, he's got the go-to move, you know, with the flexing pecs and you know, which of course I'm trying to compete now with my biceps photo that's breaking the internet currently.

AV: All anybody wants to talk to you about now—you're a talented Oscar-winning actor, everybody wants to talk to you about is the picture of the biceps. That's it.

JKS: I know, and it's so terrible to be perceived as a piece of meat like that. You know, I'm a human being, I'm not just a piece of sexy muscular man flesh.

AV: (laughing) As I had mentioned to you when I met you in San Diego, I just adored the show Oz, and I want to do a deep dive if we can. You're a theater actor who then plays this role. Tom Fontana writes this role for you. You're a member of the Aryan Brotherhood. And your character, Vern Schillinger, I thought it was so well done by you, like one of the greatest villains ever in TV history. And to me, what's so amazing about your career, J. K., and the fact you won the Oscar for *Whiplash* and you've gone on to make so many great films since this show, to me, I thought you'd be eternally typecast because you were so good as Schillinger. I'm thinking, every time I look at this guy, I'm going to picture this Nazi. And I know that for you, you were taking the role home with you a little bit because your wife was a Broadway dancer and she was in *Beauty and the Beast* and you were really kind of immersing yourself in the character. But how did you approach playing this guy who was so vile and yet so entertaining?

JKS: Well, it was, first of all, to address that, you know, the fear of being typecast. I mean, I was, like you said, I was a theater actor. I was, you know, nobody gets rich doing theater. Well, maybe Nathan Lane now, but I had this opportunity to be on this new groundbreaking HBO show and I'm meeting Tom Fontana, this, you know, big-time writer-producer. And I found myself sitting there almost talking my way out of the job because I was aware of the impact it could have and I was aware of, you know, how I could be typecast playing a Nazi for the rest of my life, and I knew that's not what I wanted my career or my life to be. So, he kind of pitched me this whole thing about how the character is going to start out as, maybe we think he's going to be a, you know, befriend our everyman character, the Lee Tergesen character Beecher. And as it

develops, then we're going to find out what a vile SOB he is and this and that, and, you know, kind of pitched the arc of the character.

Of course, the arc of the character ended up being like the first half of the first episode before suddenly I was tattooing my cellmates' asses and we found out what a bad guy I was going to be. So, yeah, I know there was a very real fear that I was going to be typecast and then, you know, like one of the many blessings that's landed in my lap in my career, just when *Oz* was hitting the airwaves, the folks at *Law & Order* called and asked me to play the shrink on *Law & Order*. So, I had this real yin-yang thing going on in the public eye, you know, very early on in my, I mean, I was, you know, forty years old, but in my camera acting career. That was kind of the beginning of it.

AV: Well, it was amazing seeing the way, like you said, Schillinger, once you knew who he was, once his cards were revealed, how bad can he be? How much can he torture Beecher? And then finally, Beecher gets his comeuppance. The end of season one, he defecates on your face. What was your reaction when Fontana showed you that script or when you shot the scene? What was going through your head there?

JKS: Here's my perspective on that scene, because, like, it was a year or two later, I get a call at home; this is late '90s, so we all have our answering machines at home. I get home and there's a message on my answering machine from Tom. "J. K., it's Tom calling, and listen, I had this script idea for Schillinger," but he said, "I just, you know, I want to make sure you're cool with it because I don't wanna..." and I'm thinking, "Okay, you have had me rape people, kill people, tattoo people, you have had a guy poop on my face." I was so terrified...and he never okayed any of those. It wasn't like, "Hey, is it okay if you're, you know, lying semi-conscious on the floor and a guy squats over you and takes a big dump on

your mouth?" So, I was terrified of what the hell this was going to be. (pause) Turns out he wanted me to sing.

AV: Oh yeah, that episode was amazing! I'm glad you mentioned that musical episode, because you got Rita Moreno, who of course, *West Side Story*, she's going to belt it out, she's phenomenal. But the scene of you and Beecher singing together, that was so audacious. And it was amazing. It worked.

JKS: Yeah, Beecher and Schillinger are singing a Barry Manilow duet. Yeah. So, no, yeah, he never asked me about would I mind being naked or, you know, anally violating someone or having a guy crap in my face. But he did ask me if it would be okay for me to sing a song. And Fontana took great pride in sort of, you know, not just the great cast that he assembled—and I always used to brag about how that show was so good because of all the New York actors, but now that I'm an LA actor, I can't brag about that anymore. But Tom was always proud of just the sheer boldness, just the, you know, the audacity of what he was doing and what these actors were willing to go along with.

AV: And I think it was a critical show and established what HBO was all about, which was, you know, no-holds-barred television. And like you said, that may get headlines. I remember reading, in fact, there was a huge gay audience because they were like, oh, all these guys are really fit. You see them walking around naked and having all these scenes. You actually had people, right, different audiences who were attracted for different reasons to the show.

JKS: Absolutely. Yeah, I mean, there was a big audience with that, you know, naked dudes on TV. I mean, you know, there's a lot of demographics that are going to find that appealing.

AV: I know you're seeing Harold Perrineau tonight and [The] Cherry Orchard. I loved Eamonn Walker as Kareem Saïd. I thought he was so good. I remember years later being shocked that he was British! I was like, oh my god, that guy, that was Kareem. He played Othello.

JKS: I was actually just texting with Eamonn two days ago. We were, you know, we met on that show and he's a Brit and I took him during that first season, took him to his first American baseball game. The Tigers were in town. That's my team. So, we go up to Yankee Stadium. No, it was during the second season because the show had been on the air. So, you know, Eamonn's got his Yankees cap on, I got my Tigers cap on, and we're there at Yankee Stadium in the, you know, in the semi-cheap seats at the time because, you know, it was the early days of HBO. And people, you know, you'd see people do double takes at us for a variety of reasons because, you know, they'd kind of look and they'd go, "Oh, I kind of know who that guy is and I know who that—wait a minute, you know what's wrong with this picture? We got the head of the Black Muslims and the head of the Aryan Brotherhood here, you know, having a beer and chatting together. Something's wrong."

AV: Oh, that's classic. Credit to you for offering so many rich roles beyond that. And it's funny, though, even when watching Whiplash, the scene where you kind of befriend Miles Teller: "Hey, what do your parents do? Oh, your dad's an English teacher, oh, that's pretty cool, man. Alright, yeah, keep it up, kid." To me, again, it was the same thing that you did to Lee Tergesen's Beecher: "Hey buddy, I'm going to take care of you." And then he just completely abuses the guy once the next scene unfolds.

JKS: You know what? I never actually thought of that direct connection until this very moment. You're absolutely right, yeah. Sort of laying the, you know, baiting the trap with honey there, yeah.

AV: I'm sure you've gotten so annoyed now. I can't imagine how annoyed you get when people ask you if you're rushing or dragging, so I'm not going to ask you that. What I will ask you is that the Oscar speech was awesome when you said, "Hey, go call your mom, call your dad. Don't text, don't do any of that stuff." Where did that come from? Was that planned or was that spur of the moment?

JKS: It was some of both. I mean, you know, I just went up there knowing that I wanted to talk about family and, you know, acknowledge my wife... My kids were there and, you know, that's always been just what's most important to me. So, that was what I wanted to focus on... In the two years before that, I had lost both my parents, and, you know, we were close and had a great relationship... I was missing them, and, you know, and as close as we always were, you know, there's that aspect of "You don't really know what you've got 'til it's gone." So, that was what was in my brain, and then those are the words that kind of tumbled out of my mouth in front of a billion people or however many were watching.

AV: It was a fantastic moment. I think you definitely stumbled upon something which is actually true, which is [that] too often we're just so technology-obsessed; there's something to be said for just calling and reaching out. Last one for you. To go back to your character in *Whiplash*, is "good job" the worst bit of advice you think that people do give? Do you agree with what your character espouses in the film?

JKS: You know what? There's a lot of that philosophy and that sort of speech that I give to him in the club. And I went off on this improvised rant about it that Damien didn't use. Because there is an aspect of that that I find absolutely true. And being a dad, raising kids, our kids are teenagers now, and I find myself doing it all the time, giving this sort of heaping praise on a kid for just a very random and not particularly monumental achievement... It's

out of love, of course. You're praising your kid, but I think there is that aspect of every time a kid does something, if you say good job, then how are they supposed to develop a work ethic and how are they supposed to really want to aspire to greatness? Yeah, but everybody needs to aspire to greatness, too. That's where I got into my own personal sort of philosophical battle, because it's like...I think aspiring to greatness can lead people to lead kind of screwed up lives sometimes. But again, that's the dichotomy and that's the ambiguity of the movie *Whiplash*. I think that's one of the things that made it such an impactful movie for so many people.

AV: That's great, man. I appreciate the time.

JKS: Alright, thanks Adnan.

CHAPTER 9
Monica Bellucci: Bellissima

April 17, 2023

Monica Bellucci is breathtaking. There is nothing novel in that sentence. She has been one of the world's most stunning women ever since she made her debut in the 1991 Italian comedy *La Riffa*, and she quickly became the most desirable object of affection in films as varied as *Malèna*, *Irréversible*, and *The Matrix* sequels. She is 100 percent Italian and has made her home country proud both domestically and abroad.

I had the pleasure of interviewing her while she was promoting the comedy *Mafia Mamma*, which I enjoyed more than most critics. I was delighted to see Toni Collette let her hair down in a comedy for a change and enjoyed the chemistry between her and Bellucci and the entire silly plot. I also interviewed the director of *Mafia Mamma*, Catherine Hardwicke, who said, "We were so lucky when Monica said yes, because she usually doesn't do comedies, but she just had fun with this role. She's very playful even though she's the most elegant human being on the planet with that mesmerizing voice. You just want to agree. She hypnotizes you. Whatever she says, you're like, 'I'll do it.' "

I was quite highly strung before interviewing Monica, harboring a school boy crush like so many men of my age. She ended up being thirty-six minutes late for the Zoom interview, which is the longest I've had to wait for a scheduled interview, but like so many things

in life, good things come to those who wait. My heart was beating a thousand times per minute the entire time, as Signora Bellucci remains mesmerizing.

★ ★ ★

Adnan Virk (AV): It's such a pleasure to welcome Monica Bellucci. I'm a huge fan of your work. You have been a terrific actress for decades. Monica, it's great to see you. There's been so many films about the Mafia, and your film still feels different and funny. What was your reaction when you read the script?

Monica Bellucci (MB): I was so happy when I read the script because I laughed out loud. Comedy is a genre I've done very little in my career, so it was a completely new experience for me. I'm very grateful that after my appearance in *Call My Agent!*, I had the chance to play in a comedy again.

AV: One of the funniest lines of the movie, Monica, is when you're talking to Toni's character and she's really infatuated with Lorenzo, and then you said to her, "Have you ever farted in front of him?" That was one of the funniest lines of the movie.

MB: "So, you don't know?" She said no. And I said, "Oh, you don't know him." But actually, you know, the thing is, they cut out this one, because my reaction means you don't know him. But I mean, you know, we went really far, actually. And this is what we have to say, even Catherine, because she gave us the freedom to build this, you know, synergy between us.

AV: My wife and I went on our honeymoon to Rome and then to Venice. And watching your film, I said, "We gotta go back." I think you live in Paris now, but you're thoroughly Italian, so it must

have been nice to be shooting in Italy, which is such a gorgeous place to shoot.

MB: To see Rome like that, Rome is so beautiful. Because during the interviews, I realized how many Americans didn't go to Europe. And so, through the film, they can see the beauty of Rome, because Rome is filmed in an amazing way by Catherine. Rome was a magic place for this movie. Even now, you know, I live between Rome and Paris, but when I go back to Rome, I'm always very happy. The light of Rome is unique. You know, I grew up with Mafia movies, like so many of my generation in Italy, such as *Once Upon a Time in America*, *GoodFellas*, *The Godfather*, of course, but I never imagined that one day I would play in a comedy like this.

AV: I want everyone to go see *Mafia Mamma*, but let's go back to *Malèna*. I mean, I fell in love with you watching *Malèna*. I said, god, you're gorgeous, the movie is gorgeous, the music by Ennio Morricone. I love that film and I think it really brought you to an international level. Everyone knew the name Monica Bellucci after *Malèna*. What memories do you have of that film, which I think is so beautiful?

MB: It actually was a strange story because I knew Giuseppe Tornatore for *Cinema Paradiso*, like all of us. When he won the Oscar, he was twenty-eight years old. And, oh my god, this is the most beautiful film ever. So, it was funny because I did a commercial with him for Dolce & Gabbana. And Tornatore told me while we were shooting the commercial, he was watching me. So, he told me, "One day, I would like to make a movie. If one day I'll do this movie, I'm going to call you." Four years later, I was shooting with Morgan Freeman and Gene Hackman in Puerto Rico. It was my first American movie. I was doing *Under Suspicion*. Actually, with this movie, I went to Cannes for the first time. And while I was shooting, Tornatore called me and said, "Do you remember the film

that I was talking about?" I said, "Yes, of course. I want to make this movie."

AV: *Irréversible*, I thought, was an incredible film. It was so brave that you made it. It was such a courageous film. I still don't know how you made that movie, but people still talk about it today.

MB: It was funny because the film came here again with a new version. *Irréversible: Straight Cut* just came out in America not long ago. And because the director did an addition in order, because the film in the beginning was in reverse, and he did a new editing in order, and so it was a new movie in some way. And yeah, this film was completely crazy, completely crazy experience. But even the way we shot was so new, because we could play for twenty minutes nonstop, like in the theater. But actually, I have to say that the most crazy thing I've done for me was an international tour, for three years, in theater. This was the craziest thing I've done ever, with the Maria Callas tour. It was an international tour, we went to so many different countries: France, America, Turkey and Istanbul, Greece, Portugal, Spain, all over the world. And we did the show in three languages. So, this was the craziest experience I've had as an actress.

AV: Amazing. When I saw *Malèna*, I told my Italian friends, if I ever meet you, I gotta tell you, *Tu sei la ragazza più bella del mondo* (You are the most beautiful woman in the world). And also a great actress and a very funny one as well.

MB: Thank you so much.

CHAPTER 10

Michael Shannon: Master of Malevolence

April 11, 2023

Michael Shannon is as reliably enthralling as any actor I can think of working today. I seek out any movie he's in, regardless of how large or small the role will be. I think he's at his best when he's off-kilter, or as a villain with a thousand-yard stare that could melt ice. But his range is undeniable, even if he easily could have been typecast as the bad guy every time.

I was thrilled to interview him and was pleasantly surprised at how warm and soft-spoken he was. On the screen, Shannon can be prone to breaking out in a paroxysm of rage. Thankfully, in person, he was much more docile. I told him what an enormous fan I was, and he was appreciative and friendly in return.

<p style="text-align: center;">★ ★ ★</p>

Adnan Virk (AV): One of my favorite actors, two-time Academy Award nominee, his name is Michael Shannon. He is back with *Waco: The Aftermath* on Showtime, April 14, a five-part limited series. I binge-watched it, Michael, it's phenomenal. Congratulations on making another terrific series with Showtime.

Michael Shannon: Master of Malevolence 85

Michael Shannon (MS): Well, thank you so much. It's crazy to have two more with *George & Tammy* kind of back-to-back like that.

AV: Well, in the first episode you're talking with John Leguizamo, and there's this great scene where you said, "There's an undercurrent of rage in America, and we helped to create that. Payback is coming." To me, that was so much what this series was about, the way you sow the seeds of discontent, and this was almost a precursor to what came after that. Is that how you saw that?

MS: Oh, definitely. And I mean, it just keeps, the dominoes just keep falling, you know? You start to wonder if you're ever going to see the end of it. But I hope the show kind of makes people consider, because I think you hear a lot of talk about it, but I think this comes at it in a much more visceral way, where you can really feel how this is all coming to be.

AV: Yeah, it's not only visceral, but I love the dialogue. I mean, some of these lines—I think it's episode three, you're talking to this one character, and you say, "So, how's a nice girl like you end up being a neo-Nazi?" And later your character says, "This is quite a lateral move from pole dancing to a member of the Aryan Nation." How much fun was it to dive into dialogue like that?

MS: Yeah, I do love the dialogue in the show. The Dowdle brothers, John and Drew, I just love working with these guys. They're so smart, and they're amazing writers, and they're just so easy to work with and fun to be around. I hope to be working with them for years to come. They're some of my favorite collaborators right now.

AV: For your character, you're playing Gary, the FBI agent, for those who did not see *Waco* originally. This is a guy who is just haunted. You know, you have this great sense of weight and

responsibility and guilt, and there's a scene in episode three, I think, you're talking to somebody who's in prison, and he's asking, "Do you hear their screams at night? Do you smell their burning flesh?" And it's really, it's a tough scene, and it's a tough character. How much of that weighed on you, playing a character who seems to be just so haunted by what happened?

MS: Well, I have the extraordinary benefit of actually knowing the real Gary Noesner and being friends with Gary Noesner and being able to basically talk to him any time I want about anything, which is an amazing, amazing resource for me. And when I talk to Gary, he's somebody, who, despite all of the horrible things he's seen and horrible situations he's been in, is still very much able to appreciate his life and still knows how to have a good time. And I guess he's acquired that ability just through years and years of practice. And now he's retired, and I don't know really how much it weighs on him nowadays, but he says he's kind of...I don't want to say he's gotten over it, but he can handle it.

AV: You and Giovanni Ribisi got a dandy of a scene, Michael, and it's just like two sharks circling each other. What worked with Giovanni? Because you guys are both terrific.

MS: Oh, thank you. I was so excited to get to work with him after all these years of watching him. I was wondering if our paths were ever going to cross, and when John and Drew told me that he was going to be on the show, I was really stoked. He is super committed to his work. He does not mess around. When you see him on set, you can tell he's always thinking or running his lines or leaving no stone unturned. And again, he got to spend some time with the fellow he was playing, which I think he appreciated. But yeah, I just had a blast with him. We didn't get to socialize much because that's how serious he is. He doesn't even go out after work or anything. I think he just goes home and studies.

AV: As I mentioned, you're one of my favorite actors. [The] Shape of Water, man, what a movie. Best Picture, so beautifully done. I just love everything about that film. Del Toro seems like such a big, generous, big-hearted guy, the whole cast. Whenever I get mad at my kids, I turn my Michael Shannon on. "Where is he?" You know, that line you said when you got mad at Sally [Hawkins]. How are you so good at being menacing?

MS: Oh, dear lord. It's not like in my real life, it's not something I practice. I'm actually kind of a scaredy-cat, really. I get easily scared. I don't know what it is. I guess it's just a matter of having access to your imagination and your feelings. I also think some of it's just my physical being. I don't know, maybe the way my head's shaped. I really don't know. I mean, I guess, my father, god bless him, he had a bit of a temper. So, maybe I took some notes from him.

AV: It could be. Revolutionary Road, man. You got Sam Mendes, DiCaprio, Kate Winslet, Kathy Bates, and you steal the movie. That character is so well done and he's so funny as well. Like, he's the one guy speaking the truth when nobody else wants to say it. How did you approach that character, someone who in that era is just mentally ill, but you're the one speaking the truth that nobody else wants to say?

MS: Well, yeah, my guide in that one was the book. I mean, the writing of that character in the book is so spectacular and vivid and detailed. And when I read the book, that's what I saw in my head, in my imagination. And so, it's such an extraordinary opportunity to actually get to show that to other people, like, what you see in your mind when you're reading something. Most of us don't get a chance to do that. It just stays in there. But yeah, that's just what I saw when I read the book. That's what I heard and felt that guy was.

AV: Are you staying in character as much as possible? Or could you say, "Hey DiCaprio, let's grab a beer after the show."

MS: I don't. Yeah. When I wrap, I need a little downtime, too. I wouldn't want to keep acting after I leave the set. That would be too much. So, I usually try to relax. You also have to get a lot of sleep. Usually, you're not able to. You don't have that much time to screw around. You just need to get to bed.

AV: *Boardwalk Empire*, you're so good in that show. I know you had a lot of work, obviously with Terence Winter, it was his brainchild. But I'm just curious, how much did you talk to Scorsese at all? I know he directed the pilot, but was Marty involved as far as talking with you with the character of that era?

MS: I think the most in-depth conversation I had with Mr. Scorsese was when I went in to meet for the job, because I met him and Terence and they talked at length about the premise of the show and Nelson Van Alden, and how they envisioned his story coming to be. That was the most in-depth conversation we had. Then, he directed the pilot. There was one night, we had a really long night, and it was like three in the morning and I was just sitting next to him, and he started talking to me about so many things. Sometimes, it would just explode out of all these thoughts and historical facts and all these things. And I'm just sitting there, like, trying to keep my eyes open because I'm so tired, but I'm like, Martin Scorsese is talking to me. I've got to listen. Wake up, wake up! But it was three in the morning, so it was a struggle. Then, after the pilot, he kind of was pretty much behind the scenes after that. Like, I think he would watch the episodes and give notes, but didn't come to set.

AV: Marty has always been a night owl, so that makes sense... This was just the tip of the iceberg, all your work with Jeff Nichols. I love

Take Shelter, of course. I think you're an unbelievable talent. I can't thank you enough for giving me a few minutes.

MS: Oh, no problem, my pleasure.

★ ★ ★

In December 2024, I was invited to a screening of *Day of the Fight*, which ended up being my favorite movie of the year. After I parked my car and was walking to the escalator, I saw a few guys asking an actor for an autograph and he curtly responded, "Not now guys, the movie's about to start."

The actor turned to his friend and in his profile, I immediately recognized Michael Shannon and heard him growl, "I'm really getting tired of that shit."

I'm normally not shy about approaching famous people, especially since I wanted to thank him for being so kind and gracious in coming on *Cinephile*. But I must confess that when we got to the top of the escalator and I saw the scowl on his face, I immediately changed my mind and allowed our previous interaction to be the only one that we would have, as Michael seemed very ornery.

Incidentally, when we walked into the theater, Richard Kind was coming at the exact same time, said hello to Michael briefly, and seemed as kind as his surname would suggest. Again, the movie was about to begin, but I regret not telling Richard how much I have enjoyed his work from *Spin City* to *Curb Your Enthusiasm* and of course, the tragic and self-sacrificing Bing Bong from *Inside Out*.

CHAPTER 11

Nicolas Cage: King of Cool

February 7, 2018

My first experience at the Sundance Film Festival was marred by the fact that I had to spend time in an emergency walk-in clinic with an abscess in my throat. (That sounds like a pitch for an Eli Roth film.) I had a sore throat for a few days prior to traveling, but doggedly self-medicated with Advil to lessen the pain and assumed it would pass (it didn't). Once swallowing became so incredibly painful that I wanted to cut out my own tonsils, I sought assistance at the walk-in clinic, with deep gratitude to the fine doctor in Utah, who—while appalled by what he saw down my throat—gave me amoxicillin and sent me on my way.

However, two of my favorite interviews occurred at Sundance. Nicolas Cage was promoting his film *Mandy* and Ethan Hawke was there to build buzz for a movie he directed about a folk singer called *Blaze*.

Cage was dressed almost like his character from Brian De Palma's *Snake Eyes*. He had a garish, gigantic winter coat on and was wearing sunglasses with a red tint—if I recall correctly—and had his PR staff with him.

There were probably about fifteen of us who were waiting to interview Nic, and I was sixth or seventh. As I was waiting patiently,

trying not to swallow my own saliva because it was so agonizing to do so, I was alarmed by what I was hearing.

The interviewer asked Cage something to the effect of how he mismanaged his money. This was not going to turn out well. Cage brushed off the question, but the interviewer persisted. This was hot on the heels of a story being published about Cage squandering much of his vast fortune on bizarre artifacts, with Cage refuting some of the story and saying a lot of money he lost was not on eccentric spending habits but rather porous real estate decisions.

Regardless, there was the moment that froze all of us in the room, and I can still hear Cage's inimitable voice deliver it:

"I know what you're doing."

It made the hair on the back of my neck stand up. The reporter tried to backtrack slightly while attempting to still hold his ground. Nic's indignation was palpable.

Cage repeated himself: "I know what you're doing."

Like a scene out of *Kiss of Death*, I assumed the next moment would be Cage's posse roughly picking the guy up and throwing him out of the room, headfirst on the glass door to open it.

Thankfully it wasn't as violent as that, as the PR guy told the reporter, "You've got enough." Taking a deep breath (but trying not to swallow since it was too painful), guess who was up next into what now felt like the lion's den? Yours truly.

★ ★ ★

Adnan Virk (AV): It is your second time at Sundance. What have you noticed about the festival and how it's changed since you were here last time?

Nicolas Cage (NC): I don't think it's changed much. I mean, it's still the same very sincere group of film enthusiasts who are taking their movies seriously, waiting out in the snow to get tickets, and are proudly cinephiles. I mean, it's a wonderful festival to be invited to because I came out of independent cinema, but this is the first time I've ever had a movie premiere here. I'm very thankful.

AV: Nic, next year will be the twentieth anniversary of the movie, which I love, *Bringing Out the Dead*. You gave such a soulful performance working with Scorsese, and I think people should recognize it more often. What was it like working with Marty on that movie?

NC: Marty is very vivacious, and he's got a tremendous amount of zeal about him, and he's a kind man. I mean, he really is, he loves, he breathes, his whole life is film. And he was so thoughtful, and he would give me movies to watch, and he'd let me use his screening room in New York. And I remember it was my birthday and he said he had a cut of [The] *Masque of the Red Death*, and he showed me this beautiful version of the movie. And it was very touching, you know, to work with someone who loves movies that much, and has been a protector of cinema for so long. It was one of the best experiences of my life.

AV: *Adaptation*. I just adore that movie. I've always been curious: which character is more fun to play, Charlie or the brother, Donald?

NC: You know, it's a great question, because when people talk about the movie, and they say, "I really love Donald," I get jealous. I am like, "Well, Donald...? I thought I was Charlie." I don't even

remember playing Donald. So it's like, I mean, I don't know why they...it's just weird. I had a great time playing both of them, but I really connected with the Charlie character, and Donald is almost like I don't remember doing it.

★ ★ ★

Before starting the interview and introducing myself, I had said I worked at ESPN. At the conclusion of the interview, Nic said to his PR guy, "How about the sports guy knowing more about film than the other guys?"

I was so humbled and thanked him. He continued, "Nobody's mentioned *Bringing Out the Dead* to me in a long time. I love that film."

There's no other actor as distinctive or idiosyncratic as Nicolas Cage. I found him engaging and thoughtful, especially since just a few minutes earlier he was understandably pissed. Here's to *Leaving Las Vegas, Red Rock West, Face/Off, Bringing Out the Dead, Adaptation, Kiss of Death,* and so many more.

CHAPTER 12

Ethan Hawke: Versatile Heartthrob

February 7, 2018

They aren't supposed to be made like Ethan Hawke. When you're handsome and have been in the public eye since you were a fresh-faced teenager, you should just coast on your looks in rom coms and build yourself a nice, lucrative career appearing in the bland and banal.

Except Ethan has always had higher aspirations, like giving a bravura performance starring in Paul Schrader's magnificent *First Reformed*, which was one of the best films of either's career. Or starring as Chet Baker in the criminally under-seen *Born to Be Blue*. Or writing novels and appearing on stage in Sam Shepard's *True West*, which I was lucky enough to see on Broadway.

Here's my interview with Hawke at Sundance, where he was as friendly and attentive as I imagined he'd be.

★ ★ ★

Adnan Virk (AV): Ethan, you've been one of my favorite actors for a long time, Academy Award-nominated for your acting and writing. What was it about *Blaze* that you wanted to make it your directorial debut?

Ethan Hawke (EH): Well, I've been directing since I was a kid. You know, I had my first film as a director here at Sundance in 1994. I directed a short film. I ran a theater company. So, it's kind of like I'm a professional actor and I direct for love.

AV: Well, it's amazing because you have that skill set. Even the subjects you choose are all over the place. You don't really get defined by genre, although I think music is always very important to you and your characters. What is it about music?

EH: You know, I guess it's my first love. It's the way we communicate with each other nonverbally. It's the way...I mean, one thing I always loved about Willie Nelson is that, people on the right love Willie Nelson, people on the left love him. He can actually communicate, and then you realize, well, we're not all as different as we thought. We all love the redheaded stranger. You know, we... there's so much in this world that's dividing us, and music is one of those great tools that brings us together.

AV: I loved your role in *Boyhood*. It was so great, and I said to my wife, "What a good dad he is. He's trying to spend time with his son, playing music." She says, "I like Ethan Hawke a lot, but I think he's a terrible dad. He's so negligent, he just cares about his own music." And I think that's part of the charm of that. Two people can see that movie and have a totally different read on your character.

EH: Absolutely. I remember Patricia Arquette used to use this expression and said, "Everybody in this life has blind spots. We all think we're doing well. We're all trying to do our best, but we have blind spots and aspects of ourselves that we can't see. We don't know what glasses our tails are knocking over sometimes." And I think that movie is very wise about that. You could say the same thing about the mother character. In some ways, she's a wonderful mother, in some ways she's a terrible mother.

AV: Two of the best movies of 2016: when I saw *Born to Be Blue*, I bought the soundtrack right away. I love that it was shot in Canada. And then *The Phenom;* working at ESPN, I thought that was a great sports movie.

EH: Isn't it funny that I was really proud of that movie, too? I thought that movie would find more life than it did. And I don't quite know why—it's funny, one person, I think I saw on a Google alert, put it as one of the best movies of 2016. But most people didn't even register it. And it's a wonderful film, I'm really proud of it.

AV: Working as a sportscaster, Ethan, I see guys like that all the time, crumbling under pressure, Johnny Manziel types, and your character, Giamatti trying to help. Your guy is just so abusive and so reckless. But again, you can see guys rationalizing and saying, "I'm doing this because I love you. I'm doing this to help you."

EH: I think that movie is extraordinarily well-written. And the young guy who plays the main guy, Johnny Simmons, does a beautiful performance. Giamatti, I mean, I really hope that people see that movie.

AV: You're one of the best actors going, Ethan. Thanks for the time, man.

EH: Okay, be well.

CHAPTER 13

Will Arnett: Canada's Funnyman

May 31, 2016

I don't watch a ton of television, but for me, *Arrested Development* is the gold standard of comedy. It ranks right behind *The Larry Sanders Show* for the funniest show ever and is on a short list with *The Sopranos* and *Homicide: Life on the Street* for my favorite shows ever. *AD* was so incredibly clever, original, hysterical, and incongruous on so many different levels. I'm always incredulous when someone tells me they haven't seen the show, and then I'm jealous of them, thinking that I wish I could get back the feeling of gut-busting hilarity that I enjoyed the first time I saw each episode.

So, I was particularly excited to meet Will Arnett, fellow Canadian and the man who played the character Gob (George Oscar "Gob" Bluth II) from *Arrested Development*, a master illusionist. Arnett was the very first guest on *Cinephile*. He has become considerably more famous in the near decade since, with his own massively popular podcast *SmartLess* with Jason Bateman and Sean Hayes and his phenomenal array of vocal work, including lending his gravelly tones as the Dark Knight in *The LEGO Batman Movie*. Will lived up to the hype.

★ ★ ★

Adnan Virk (AV): The first ever guest on *Cinephile*: the Adnan Virk movie podcast. You knew we were gonna get a Canadian, even

better, a fellow Torontonian, the pride of Leaside High, and also the most famous person that follows me on Twitter—Will Arnett is in the house. What's up, man?

Will Arnett (WA): Hey, man, I didn't realize that this is the inaugural, the maiden voyage.

AV: Right. We've done one other podcast prior to this, and now this is the first ever guest. You're setting the bar right now, like I'm host James Lipton and you are on *Inside the Actors Studio*.

WA: This is smart. To set it low is the best idea. I always tell people to set the bar low, I really do.

AV: No way *Teenage Mutant Ninja Turtles* is out. I have two young boys. We're fired up to go see it. We'll talk about that shortly. But *Arrested Development*, it's crazy to think it was over a decade ago, and people still talk about it so much. I'm driving the other day, I heard "Final Countdown." All I picture is Gob Bluth, and I think of my favorite moments. And there's that episode where you try to sink the yacht and "Final Countdown" comes on. You have a knife in your teeth, and this expression as you're walking backwards. It always makes me laugh. I think probably the best scene ever is when you are talking to the guy in the elevator: "Yeah, the guy with the $4,000 suit is gonna be the guy. Come on!" Do you have a favorite scene or memory or moment of that show?

WA: No, it's funny. Each one of those things, I do have distinct memories of doing those, of shooting those days. That's the way I sort of break everything up in a long timeline. I know, exactly. It's weird. And the scene where we shot, we made the yacht disappear, it was the spring break thing, doing that magic show. I'll always remember it because it's the first time I strained my left Achilles. I didn't pull it, I didn't tear it, but I strained it, and it

was a problem for many years, because I was wearing these, like, awful sort of leather, flip-floppy things, and I was doing what I refer to as "angry forward moonwalk," which was a move that I that I haven't patented yet. But I'd been doing it for a while as a bit with my friends, and I just decided to do it that day as we were shooting that, because there was no real direction. Mitch Hurwitz was just gonna do the thing, imagine, to make it disappear, sort of like a magic show, and just go, you know, "Action." And I'm like, *Oh, yeah, I gotta do an angry forward moonwalk,* so I did that with a knife in my teeth, right? And I ended up pulling it off and I'm like, *This is terrible.* So, that's my memory of that. I'll forever remember that.

AV: What about "come on"? That was such a great catchphrase.

WA: "Come on" was...you know, there's a great writer who has been Mitch Hurwitz's partner for many years, this guy Jim Vallely. He's not really his partner, but he writes a lot with Mitch and I have also written with him, and he's our friend, and he's one of the funniest people. He thinks of things that nobody else thinks of. There's a lot of Jim in *Arrested Development.* And Jim was the one who really kind of sold me the idea of "come on," he's just this absurd guy, and he was trying to explain to me, as we got the script, and we were going through and trying to come up with what that bit is, and Jim sold it to me. And so really, all those times, doing those bits was generally me trying to make Mitch and or Jimmy laugh or Bateman laugh. That's all it was. All those things on set were just us trying to make each other laugh in the moment, trying to surprise each other, you know.

AV: Well, you and Bateman are tight because I've listened to the audio commentaries on it, and you guys are constantly busting each other's chops. Your Twitter avatar at one point, the profile

said, "I'm Jason Bateman's sponsor," which is serious and funny at the same time.

WA: Which is kind of true and kind of sad, and it's kind of a lot of things, and it's still on there, I've never changed it after all these years. Yeah, no, we're super tight. There have been moments, like when we were shooting this show where I was living at his house, and we were legit, like, brothers. We've had major fights. We had fights on set. We had one major fight on set where he drove away. It was, like, very dramatic, and I called him on the phone, I was like, "You don't just drive away." Hilarious. We look back now, we were younger men then.

AV: I thought Mitch Hurwitz made a great point, though. He goes, you know, "Will is so good at playing these smug antagonists, and yet, you know, he himself is a very smart, thoughtful guy." And he said, "If you look at *Golden Girls*, because Betty White is actually whip-smart, but she plays the dumb one." And he goes, "It's an interesting thing." And I know you're an actor, first and foremost, that to approach the role you're so good at playing a guy who is the antithesis of Will Arnett.

WA: Well, thank you. That's kind to say. But I will say that people who know me might be like, well...you know. I can't remember who it was, but somebody was talking about how hard it is to play a dumb character, and that always stuck with me because of the idea that it's gotta be layered, you know, in a way. Look, it's fun for me to play a character who's dumb and cocky. I think that that is a fantastic combo. It's a winning combination. And I like those people in real life. I've got all the time in the world for people who are dumb and cocky. I mean, I will just stay. People are like, "Man, we got to go." I'm like, "No, hang on. I got to keep listening to this guy. He is a beauty."

AV: You're gonna love it here at ESPN. We've got plenty of arrogant and dumb anchors.

WA: (Laughs) Oh, really?

AV: Well, it's amazing because, I don't know about you, but I find I'm always late on things, meaning, when *Breaking Bad* became a big sensation, I had missed the first season, and I was early second season. [*The*] *Sopranos*, which you were on for a couple of episodes, I got into season two. *Arrested Development*, it was three or four episodes in, and two of my best friends called me saying, "You got to watch this thing." So, I take such pride now when people think back and go, "Well, it was critically acclaimed, but low-rated." I'm like, "No, I was there the entire journey." And I think people take pride in being loyal fans of the show that entire time and to see the success since then. Tambor was a big star, obviously, Larry Sanders, et cetera, but Bateman's gigantic. You're huge. The fact that Tony Hale' s won an Emmy for *Veep*, like, all these people, Jessica Walter, everyone's gone on to these great, acclaimed projects.

WA: Yeah, you know, Mitch Hurwitz is one of the greatest writers and great comedic minds. If you look at that show, especially the fourth season that we did for Netflix, if you actually watch all the episodes, and then you go back and you watch again, you realize what somebody once said—I think *The Washington Post* [said] that it's like the *Ulysses* of comedy. It is a really dense, complicated feat that he accomplished. But he was really good at putting a cast together, and the first time we all shot one scene together was at Lucille's penthouse in the pilot. And that's actually a suite at the Ritz in Marina Del Rey. And we recreated it on set. If you ever want to have the real *Arrested Development* Lucille's penthouse experience, you can rent out a suite at the Ritz. They've never advertised that... I remember, through us all being in this scene

together, there was just that moment when something clicked. And I was like, *Wait, this is really working. Everybody knows exactly who they are, where they are in the story.* And it just worked. And Mitch knew that. You know, it's his ability.

AV: Last one on *Arrested Development.* If there's a criticism of season four, it wasn't enough of you guys all together. Your episode was great. The song "Getaway" is so funny, but that was the criticism. I thought, *You got to get these guys together because they're such great players.* It's like sports, everyone's playing off each other. If there is a season five on Netflix, do you think it would be a situation where there would be more of you guys together, or your schedule is so difficult that that is an impossibility?

WA: There is a good chance that it's just me.

AV: The Gob spinoff!

WA: The Gob show. All bits aside, I probably shouldn't say this. It is something that Mitch and I have talked about a million times. We should just do a Gob spinoff for no reason, and not explain it, and then just do it. We talked, we laughed about that, like, last Wednesday. I'm not kidding. It feels like a dare that one of us will eventually go, "Let's just do it," and we'll do it. Yeah, you know, look, the show is at its best when everybody is together, for sure. There were a lot of schedule issues in that fourth season, and I think that if we do come back, one of the conditions will be that we shoot all our stuff together, and it's the way we prefer to do it, too, because, you know, that chemistry is so great. You know, Tony Hale is on *Veep* and to date, there is nobody I've ever worked with who makes me laugh, who makes me break more.

AV: More than David Cross?

WA: Well, David Cross is pretty good. Yeah, David Cross. But I pride myself on being someone who doesn't really break a lot in takes. Tony Hale gets me, and I look at him when he's just preparing to play Buster. Sometimes, he'll be like, getting ready to roll or whatever, and he'll just kind of turn around and he's kind of embodying him and I'll lose it, and Bateman will too, and we'll have tears in our eyes, and I have to leave. I'm like, "Tony, don't, don't look at me, man." So, you know, for that, just for that alone, would be amazing, but, you know, to get him, he's on *Veep* on HBO, and HBO doesn't want to let him be on our show. That's the truth. I probably shouldn't say that, either. And they're, they're super hardcore about that and, so if the fans have a beef, write HBO, and say, "Stop being such jerks."

AV: The chairman just stepped down there, I think, right? I just thought the other day I heard that—

WA: Because of this!

AV: So, you grew up in Midtown Toronto?

WA: I grew up in an area that will remain...Rosedale.

AV: Oh, you're right in the city. You're not Etobicoke.

WA: I grew up right downtown, and then moved to Yonge-St. Clair the rest of life.

AV: I was born in Toronto. I grew up in Kingston, which always throws people for a loop. They go, "Kingston? In Jamaica? I don't understand." But it's a long story, but you would know: Don Cherry, the whole bit.

WA: 401, I'm familiar. I always say the best thing out of Kingston is the 401.

AV: I agree, because it's on the way to Montreal. But it's interesting for you; your dad works for Molson's, right? Originally from Manitoba, you get into acting and I think people realize Toronto is really fertile ground for comedians, actors, et cetera. You went to Concordia, you drop out from there—shoutout to the Stingers. But the voiceover work, I'm in my mid-twenties, Will. I was a sportscaster at theScore, which is the number three sports network. You're behind TSN [The Sports Network] and Sportsnet. And one of my friends said, "You gotta try this voiceover business. I mean, it is a cash cow." He goes, "You're a broadcaster. You got a good voice. You can do it." I'm not kidding. I'd say, out of one hundred auditions, I got two: one was playing a sportscaster and the other one was for Quiznos. And you can help me with this, because you made it a lucrative, highly successful career. They don't want an announcer. Like, I had to go in there and go, "All right, go to Subway today." And they go, "No, no. Little less, little less." The only one I got was the voice of Quiznos, and it was like this: "Quiznos, a cut above, great taste, at low prices." And I'm like, "That's what you're looking for?"

WA: Very measured. I like that. That was a great take.

AV: Every time a little less, a little less. How did you become great at this?

WA: Well, you know, look, you say you go for one hundred and you get two, and I booked my first job, my first audition. No, that's not true. That's not true, but, you know, I remember being in the '90s in New York, and I made it, you know, I didn't have to wait tables. I paid my rent, and then some, being a voiceover guy. And I didn't know anything about voiceover. My first agent was at the former

William Morris Agency, and I got in there, and they said, "Great," you know, blah, blah, blah. "We want to work with you, but you should meet our voiceover department." And I go, "What's that?" And they're like, "Well, the voice is in a commercial. You ever think about that?" And I was like, "Oh, yeah, I never really thought about that." I'm a dumb guy, so I go in there, so this whole ability opens up to me, and I'm like, *This is crazy.* And I start doing it, and I start working. There's a very tight-knit group of guys in New York. And I'd see them all day everywhere, you know, at all the places auditioning for the same spots. And it was, at the most, thirty guys. And at the real core of it, it was like fifteen guys who were getting all the jobs. Especially this guy, a very famous voiceover guy, named Don LaFontaine, who has since passed away.

AV: The movie voice guy.

WA: Yeah, the original movie guy. Don did an interview with *The New York Times* in the mid-to-late '90s in which he talked about how much money there was in voiceover and how much money he made. And then he was driven around Los Angeles in a limousine, and he'd go in and you do two three takes, and then he'd go to the next job. I remember being at a voiceover place that I'm not sure is still there, called Just Voices in New York on 40th Street, and sitting there, and this voiceover guy, a really good guy who you've heard a million times, Paul Christie, was the voice of one of the Budweiser lizards. Remember those Budweiser spots amongst a million? He's a top-notch, classic, awesome voiceover dude. Really good. I remember him coming in and being in the waiting room. Paul goes, "That's the end." And sure enough, he was right. And everybody wanted to do voiceover, and everybody said, "It's so easy. I'll just go and everybody and their brother comes and do a voiceover." And it turns out there is a little bit of skill needed. Now, look, it's not rocket science.

AV: But you can do different accents, like I said, be a little more measured, a little more upbeat.

WA: Well, just to find that right spot. People are going to be listening to this, being like, "I can't wait." You know, we live in this world. Everything I say now, I'm always like, I can just hear the backlash. It's all backlash. I do everything to avoid the backlash, because everybody's got a voice now, have you noticed that?

AV: Oh, yeah, too many voices.

WA: Too many voices. And it's the thing that I dislike about social media, that everybody's voice is at the same volume.

AV: I can't imagine how much you get peppered by people who go, "Listen, I'm an aspiring actor. I think I've got a great voice. Help me out."

WA: Well, that. Or everybody is just like, "Hey, I watched your thing. It sucks. You suck." Okay, well, thanks man, thanks for taking the time out of your day.

AV: But that's the thing. On a serious note, *Flaked*: it got some harsh reviews from the critics but fans liked it. You put a lot of yourself into this. This is about sobriety, dealing with AA, and struggling actors. That's got to be...I'm not being dismissive of some of the other projects.

WA: No, no, no.

AV: *Let's Go to Prison*, by Bob Odenkirk, okay, that's fun, but this one, you're really putting your heart into *Flaked*. It must be very tough.

WA: It was tough. And a lot of the critics...there was something I took issue with, which I kind of mentioned. I did an interview that got covered pretty widely, where I talked about how I dismissed a couple of the reviews where they said, you know, "This is not an accurate portrayal of recovery," blah, blah. And I was like, "Hey, fuck you." There's this guy who's a reviewer, and he went out of his way, when it was announced that we're getting picked up for a second season, to say on his Twitter, "This proves that anything can get renewed on Netflix." I honestly almost tweeted, "Fuck off, man." Why are you taking your time? You didn't even need to. It's not even in your purview anymore. Just fuck off. Can we say that in the world anymore? Can we just tell people: fuckkkk offff. Go mind your business, you dick.

AV: Owen Gleiberman, the longtime critic at *Entertainment Weekly*, now writes for *Variety*. You mentioned you had a great reference; by the way, on the *Fantasy Focus* podcast, Will dropped a *Great Santini* reference. I love Robert Duvall. Duvall was so upset because Gleiberman criticized *Tender Mercies*. Duvall won the Oscar for that and he said it wasn't an accurate portrayal of Southern life. Duvall was so incensed, he sent this guy a handwritten letter to Owen Gleiberman, saying, "Listen, you don't know anything about the South. You know, you don't know anything about what this is like." And I think people don't realize actors are very sensitive to this stuff. You say, "Well, who cares what the critics think?" It is important, because they can shape people's opinion.

WA: Well, they've really become trolls. These guys...in order to pay his salary, he needs more clicks, and people aren't going to read something positive. They're going to read something shitty. It's just human nature. You're going to click on the shittier thing. So, he needs to get clicks, because more clicks equals more ad revenue. It's just commerce. It makes sense. If he tells you any different, I call

complete BS. Plus, I take a look at this guy. I pull his thing up, and I'm like, *If I did anything that this guy liked, I'd hang myself*. Honest to god. I want to be like, "Stick to what you know, which is where to find bulk cat food and Häagen-Dazs." Look at this loser. I don't care. And yet, he gets a voice.

But the truth is, you put yourself out there and it's not easy. I rarely read that stuff and rarely care. This was personal. And if you say you dislike it, that's one thing. That's fine. You're completely entitled to it. I dislike lots of things, but to say it's an inaccurate portrayal of recovery when it was accurate, real time—almost a diary of what I was going through in the moment. That's not fair, and you don't know what you're talking about, and you should publish a retraction saying "I don't know what I'm talking about," because that's not true. What was printed was not true.

AV: Will Arnett... Check him out on Twitter. He's the greatest... Thanks a lot, man.

WA: Yeah, thank you.

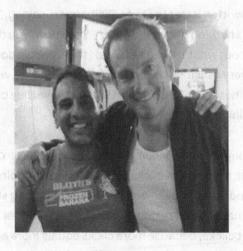

CHAPTER 14

Kevin Hart: Little Big Man

October 25, 2016

Kevin Hart isn't just a gigantic presence in the world of comedy, but a massive production company unto himself. How many comedians have been featured on *60 Minutes*, can pack a global audience for a stand-up tour, and whose mere presence in a movie ensures it'll be a hit? I've interviewed Kevin twice and this first time, I was impressed by the size of his entourage (at least seven deep) and his ability to do more than one thing at one time, as you'll read below. He is the first to poke fun at the fact that he is diminutive, but Hart's personality is truly outsized.

★ ★ ★

Adnan Virk (AV): Kevin Hart is in the house. First and foremost, how about the multitasking? You are right now sending a tweet and a text as you're having this conversation.

Kevin Hart (KH): Yes, I'm promoting my movie on the podcast and through Twitter simultaneously. Simultaneously? Simultaneously? When did I start having trouble with that word?

AV: *What Now?* is in theaters right now.

KH: Yes, it is.

AV: Every time I go to the movies now, Kev, I see trailers and it's either you or Ice Cube or the Rock and I'm sick of it.

KH: That's a good thing.

AV: We need to stop! I appreciate your work ethic but we need to take a break!

KH: No, there's no breaks. The ubiquitous Kevin Hart. There's no breaks. You take a break when you die. I want to make every movie on the planet if I can.

AV: I think you're doing it.

KH: My goal is to have a movie plan and have nine trailers of my movies that are coming out and in between that also come out and serve you your popcorn. That's my next goal.

AV: The multi-talented Kevin Hart.

KH: That's my goal.

AV: I give you credit because of the trailers—"the ubiquitous Kevin Hart," that's all the trailers say now. But I do give you credit because it's the work ethic. And I know you were not always this superstar. You were not always this comedic icon. So, I respect where you came from to get to this point. How rewarding is that now? You financed this film yourself. How gratifying is it to now have achieved this success?

KH: I mean, look, it's huge. At the end of the day, you don't do things to not be successful. You do things to make your mark and your imprint on history the best way you can. So, for me, financing and funding and owning is definitely a priority. It's

definitely important. And I think what was really, really important was making sure that I got the best piece of product out to my fan base. I've always gone above and beyond in recreating myself and in trying to come back better than what I was before. So in *What Now?*, I just wanted to come out. I wanted to be above and beyond what I was when I did *Let Me Explain*. That's why I took my time with it. And to sell out a football stadium, 53,000 seats, that's nothing to be frowned upon. That's a big deal.

AV: I love the episode of *Comedians in Cars getting Coffee*, you and Jerry Seinfeld, in which you said to Seinfeld, you know, "My daughter's asking, do we have a lot of money? Are we rich?" And you asked Seinfeld for advice. And Jerry says, "You know what I tell them? *I'm rich.*"

KH: I'm rich. Yeah, as he says. Yeah, I tell them, I'm rich. You're not, I am. That's one of the best things that Jerry's ever told me. I think it's tough love to the extreme right there.

AV: You've made that joke in one of your stand-up specials. I believe it was either going with athletes or rappers. Like, they will rent out all of Disneyland. And you said, "Well, I have a checking account. I feel like I take out a certain amount of money."

KH: You got to explain your financial situation. I think everybody sometimes assumes that you're where they are. So, sometimes it's best to explain it so they know that you're not participating in the extreme spendage that they're taking part in. You just gotta separate yourself, that's what I've learned.

AV: And you're so gifted in using personal information in your stand-up, which is what the great stand-ups do: Richard Pryor, Chris Rock, yourself, especially the jokes about your dad. On a serious note, your dad was a cocaine addict. You've talked about

the fact he was not there for you, and yet you've mined so much humor from it. Where is the kernel of truth and where is Kevin Hart saying, "Let me just use some humor to embellish it a little bit?"

KH: Well it's all, it's all true. You know, I think the one thing that...

AV: He showed up with no underwear, track pants, and a little girl. So what's that?

KH: Listen, the one thing you got to do, you have to pull from a real place. You can't go and have everything be fiction. It's best to have some reality. And a lot of my stand-up is based on my reality. And I think that's why my fan base has grown with me over the years, because I'm relatable. You see that the guy that you're dealing with is real. He's 100 percent into whatever it is that he's saying. And I stand on that. I stand on that. And I'm never going to change from that. I'm always going to go above and beyond and deliver something that people can walk away from and not only relate to but go, "Wow, I believe that. I feel like I know this guy." That's the thing about stand-up comedy. You want to be relatable. And I am.

AV: You definitely have proven that. *Kevin Hart: What Now?* is in theaters right now. My buddy Cab, who is a huge fan of yours, told me to ask you about when you first started doing stand-up; you used to perform in some male gentleman's clubs.

KH: Yeah, very true. Male strip club by accident. I had no idea that's what it was. I got there and I thought they wanted me to dance. I was like, "I don't do that. You know, I'm not here for that." They said, "No, you're on the break. We're going to bring you up on the break." So, I performed. Definitely didn't do good. That's one of my worst shows, because women had no interest in seeing the man with clothes on, I'm just going to guess. So, once I was able to figure that out and move on, we went in the right direction. But,

Kevin Hart: Little Big Man

you know, it was a learning experience. At the end of the day, you need those things to know what's good and what's bad. And that was definitely bad.

AV: But you are in great shape.

KH: Yes.

AV: So if *Magic Mike XXXL* comes out and they offered you a part, you wouldn't be averse to that, would you?

KH: Yeah...you know, back then, you weren't dealing with the same type of dude. I was all over the place. I was a little mushy back then.

AV: Like you said, you've had this self-belief in yourself, Kevin, and had this confidence and this drive and this determination. But I am always curious how people deal with critics. What do you say to critics who say, "Kevin Hart's a really funny guy, but the movies aren't as good as his stand-up, which is so good?"

KH: I mean, look, everybody has an opinion. You can't be upset with somebody for thinking of feeling a certain type of way. They're individuals. You can have your own brain. You're not programmed to think how people want you to think. You think for yourself. So, I don't get into that. Nothing bothers me. I'm never upset. You know, some people are fans. Some people aren't. The ones that aren't, they don't make me mad. I'm not like, "Oh, man... You wrong. You know, you should like me." It is what it is. I get it. You know, hopefully one day, I win you over and you say, "Oh man, I'm a fan." If not, then, you know, I guess I wasn't meant for you.

AV: The positive approach to have. You have developed your own brand now. It's almost like Kevin Hart, Inc. What is next? What is the goal here? Because you've done movies, stand-up, and music.

KH: I mean, you're looking at a guy who's touching all lanes. And like you said, from stand-up comedy to acting from producing to writing to directing to, you know, eventually becoming your own brand to the point to where you're partnering with the major brands. I think starting my network, the Laugh Out Loud network, is a big step. I'm still partnered up with Nike. I'm still signed as an athlete. I'm still a health ambassador with Rally Health. Animation films coming out. There's a lot going on in the Kevin Hart world, but it's never too much. I'm never too busy.

AV: How would you describe Kevin Hart in three words?

KH: Live, love, laugh. The guy who likes to live, the guy who likes to love, the guy who likes to laugh. That's it.

AV: And since you've given us the gift of so many laughs, I have a gift here for you, courtesy of *Cinephile*.

KH: I like it. I like the fact that you guys got a big budget around here. I got a T-shirt, and it's a size large, so it's something I can't wear due to the fact I'm small. But this is it. Guys, thank you. You thought about me correctly. And you know, it's the thought that counts. And obviously you guys didn't think this through at all. We only have largest and extra largest. That's a good thing, guys. I'm glad you're prepared for all types of people that come through at your podcast and make sure you treat them correctly. This is amazing. I'll never forget it. This is a T-shirt that I'm definitely going to look at and go, "Those guys were jerks. They gave me a large shirt knowing that I'm a petite small." So, this is good, this is really good for me.

AV: (Laughing) Kevin Hart. Thanks man.

KH: Thank you so much.

CHAPTER 15

Mahershala Ali: Dignity Personified

December 6, 2016

Mahershala Ali always carries himself with dignity and grace. Whenever I see him on screen, I have the comfort of knowing I'm in good hands. He has been lauded by his fellow actors, winning two Academy Awards for Best Supporting Actor for *Moonlight* and *Green Book*. He also starred in the third season of HBO's critically acclaimed *True Detective* and has the adroitness to bring credibility to popcorn pictures like *Jurassic World Rebirth* as well. Mahershala has transitioned from character actor to an award-winning leading man, but still carries himself with the same humility. I know this firsthand because with both of us being members of the Ahmadiyya Muslim Community, Mahershala is close friends with my cousin, Saleem Qadir, and visited my father-in-law in the hospital late in his life before he ultimately passed. Mahershala is a fundamentally good, kind soul and that virtuous self always radiates on screen, no matter what the role is. It's fun to revisit this interview from before he became a household name.

★ ★ ★

Adnan Virk (AV): If you haven't seen *Moonlight*, go see it. Mahershala Ali is cleaning up right now. Critics' Choice Award nominee, a winner of Best Supporting Actor, New York Film Critics [Circle] Award winner, and LA Film Critics [Association] Award winner. Thank you so much for coming on *Cinephile*, my man. And

please, I know you're going to be humble. Start working on that Oscar speech. Let's go!

Mahershala Ali (MA): Oh, brother. I'll just...look, I embrace it. It's been a wonderful ride. And honestly, when we went into shooting it over a year ago now, it's just not something we, any of us, expected. We made that movie with a bag of nickels, and it was on the lower end of films I've ever had an opportunity to do in terms of budget. But we were there for the right reasons, I think, and really put our heart and soul into it, and people are appreciating it. And I appreciate the recognition and all the positive things that have come along with it in the tailwind of the release of the film. So, it's been good.

AV: It's a beautifully made film. And there are those who have not seen it yet going, "Oh, wait, is that the gay Black movie in three parts? No, I'll pass." But that's not what it's about. It's about a child coming of age. It's about your character playing a drug dealer, and a mentor. It's a side of life you don't really see. So, I think it's important people realize, hey, this isn't a movie that is tailored to one community. In fact, it's about tolerance and acceptance for all people.

MA: Right. You know, it's funny, because after the election, and I don't know how any particular individuals in your office and in your audience feel about that, but after the election, there were a lot of people who didn't feel represented and were angry about how things went. And it was so interesting to me that the box office went up 40 percent on a Wednesday. And it was in large part a response to people who didn't feel represented or didn't feel safe in some way, shape, or form, finding that safe place—a place where they felt their tribe was. They felt recognized somehow, or something about *Moonlight* spoke to them, as that's where there's a good portion of people went in order to get away from it all.

And I think, in some ways, what's interesting is that the film itself focuses on "the other," the person outside of the tribe, the person who was not being embraced by his peer group, who was persecuted in some ways and misunderstood. But also, you get to experience seeing characters who usually are thought of in a one-dimensional way, such as just the crackhead mom, drug dealer, cousin or mentor, or guy on the corner. And he pierces through those stereotypes by really making these people human. And it's a wonderful experience, because people see the film and often, I found myself thanking them a few times for enjoying it. Like, I was just saying, "I'm glad you enjoyed it." But as I've made that mistake a couple of times, I realized that it's not really a film you enjoy, but it's something that you just kind of experience.

AV: I think one of the best attributes you have as an actor is that you're able to have tremendous presence, and you have all your characters who always have this quiet dignity. You don't have to be saying a whole lot. You're holding the screen, you're commanding the screen. I think that's why audiences are loving this movie and why critics are praising it so much.

MA: But you know what? I think the same thing about you on ESPN.

AV: Oh, thank you, thank you, man. I'll send the check to Saleem because I know he's listening. My cousin who you're boys with, I'm sure he set you up for that one.

MA: (Laughs) No, but thank you brother, really sincerely. Thank you.

AV: I want to mention two scenes in particular in *Moonlight*—the one on the beach and another one at the dinner table. You're conveying so much, but you're doing it in a real minimal manner.

What was it like acting against a boy who is so shy and so quiet in the film?

MA: Well, I think the key is the flip side of what you said acting is. I've grown up and I never quite understood it, especially coming from the world of sports. I used to play basketball in college. And what I always had a difficult time relating to was this mentality of beating the other team or beating the other guy, when I always thought it just made more sense to try to be your best self and work with your group to be your collective best, whatever the score says at the end of forty minutes. And so, I think how I've taken that approach with acting to just do my best work, really connect to my character's deepest truth, and try to allow that to move through me. And working with someone like Alex [Hibbert]—who is so new to it all, but so pure and clearly talented—it was just about mutually finding our rhythm together, locking in together, and sort of being in sync. And if you do that, if you're able to sort of listen with your being and not just with your ears, I think you tend to hear what is necessary. You get directed. After a while, it is a skill that develops where you get directed by the environment at some point.

AV: LA Film Critics just named *Moonlight* Best Picture. Barry Jenkins, Best Director. All the accolades for you, it's awesome, I'm so thrilled for you. You were also Emmy-nominated for *House of Cards*, and I think a lot of people love that show and your character in particular. How would you describe that experience?

MA: *House of Cards* was great. It was a bit of a surprise, the way everything came together. None of us knew what it was. I think what it had going from the jump was that David Fincher was directing, and I've worked with David before, so it was pretty obvious to me how brilliant he was and the potential of the show because he was involved. But also Kevin Spacey, Robin Wright, and lastly Beau Willimon, the creator. So, I think, as a group, if you're

going to take a dive into launching online content and stream something which was essentially unheard of at that time and put $100 million into the first two seasons of it, and it was greenlit from the jump, I was kind of all in. I was like, "Let's give it a shot." And in doing it, it was a pretty great experience.

And the way the show hit, the way that character sort of took off for me, I know it just changed a lot of things for me. I was somebody who did the best with every part I've been given and fortunate to have, but it was a show where the right people saw it. It led to more fulfilling opportunities. I just finished, I did my last season last year, and so I think it's sort of responsible for, in some ways, why everything is kind of happening the way it is right now. Because now that I'm off that show, it's opened up the calendar and given me the opportunity to do all these other wonderful projects.

AV: And one of those other projects is *Luke Cage*, the Netflix show, the Marvel series. It's interesting what Marvel is doing here because we are going well past the bright, splashy comics like *Dick Tracy*. Now it's dark and we're going into territory that I think true comic book aficionados appreciate because it's true to the source material. What was it like for you playing the villain?

MA: It was wonderful but it was extraordinarily difficult at the same time. They really wrote for me. And what I mean by that is, he wasn't a character who was there to pass through. He was there to be featured and really be the leading force and sort of push the narrative along on the antagonist's side. And so, that was really wonderful to experience, having to step into that responsibility and have conversations about not so much the arc, but just little details that sort of fill out the character. Having that sort of input was amazing. What was difficult though was, when you play a character like that who lives in such a high reality, but he can justify his actions in his own mind—your job as an actor is to not judge your

character, but if anything, advocate for him and buy into what he's doing and why he's doing it for the period you're planning.

But when you do that, there's a real residual energy from that. Like, when you are for eight hours a day throwing somebody off of a roof, and then you go off and you shoot somebody, but then later on you have an emotional scene because you found out that one of your old-time pals has passed and you're sort of responsible for it...that does something to you emotionally. If you do that day after day, you kind of string those days together. It could be a little bit difficult to sleep at night. The energy that you begin to take on lives within you for a period of time while you're carrying that along—it becomes a challenge. It's sort of creatively toxic, but that's what you sign up for as an actor, to bring these characters to life in a certain way. So, it just has residual, it has wear and tear on your body in the same way sports does. You can go for two hundred yards in a game, but there's going to be a real residual effect of that because you got beat up with those thirty carries. And that's what happens in acting a little bit.

AV: Yeah, you mentioned not being able to sleep well at night. So, that dovetails into what you mentioned earlier with the fact that president-elect Donald Trump has caused a lot of us to be a little bit concerned. You and I both belong to the same community, the Ahmadiyya Muslim Community. And what it's like right now, we may have to start registering, which is such an insane idea to even say out loud, but what has it been like for you personally, your family as an actor, as a Muslim working in Hollywood?

MA: Well, as an African American growing up in the country, there's always been these different degrees or shades of difficulty, right? It's something that I've just grown up with. It's not something that I'm not accustomed to, like what my parents came up with, with my grandfather being president of the NAACP in certain

local chapters in the Bay Area. So, I've just grown up very much aware of people being, processing, dealing with, and experiencing some form of discrimination. That's never not happened to me. It's just a different layer of it, speaking personally from me and my family. There's an added layer after I converted to Islam. And, say, the year and a half after that, less than a year and a half after 9/11 happened, and some of the reaction from that, which people don't realize.

You know, for a Muslim, an American Muslim, 9/11 was extraordinarily difficult because, one, you're an American and you see all these people who have been killed for nothing. And then on top of that, you are Muslim and know they did that, claiming it in the name of god or on behalf of Islam. And, you know, that, that does not represent Islam, but people don't know enough about it. So, they kind of have no choice but to buy into that story and don't know that that is clearly not what Islam teaches in any way, shape, or form. So, I think that the pain that I personally felt—and not to try to create some hierarchy of suffering—but it's very difficult for Muslims who have, I would say, a better grasp on the teachings. I would say most Muslims do and are really clear on the fact that those things are forbidden and looked down upon. There's no compulsion in the religion. You can't force anyone to convert.

You can't threaten people by the sword. You can't go off and commit suicide. You can't harm innocent people. All these things that we just know. When those acts are perpetrated in the name of Islam, it's painful and then it's also more painful because you're an American as well. So, it's been challenging and we have our concerns about what's gonna happen going forward in the next four years. But I do believe the positive thing to me is that the results of the election have woken a lot of people up and it's an opportunity for people of all faiths and creeds and colors to really

come together and work to create a country that reflects what it should be on paper.

We have all these wonderful documents that speak about these things, about equality, human rights, and all these wonderful things. And hopefully, all those people—who really, truly, sincerely believe in those things and want all of us to be able to live and roam freely and have tolerance and love for each other in their own individual spaces and communities—will come together in some way or another. Hopefully those people will rise up and come together in order to really create that world.

AV: That is beautifully expressed, man. And particularly in your community, I think the arts take on such importance in times like these, of uncertainty, of upheaval. And particularly, as you said, for African Americans, it's been well-documented. Take the hashtag #OscarsSoWhite over the last couple of years. People feel like *Selma* should have been recognized, and other films as well. And this year, you could have yourself, you're going to get nominated for Best Supporting Actor. Viola Davis for *Fences*, Denzel Washington for *Fences*. I mean, this could be a really strong statement.

MA: You really got that crystal ball going, huh?

AV: GoldDerby.com is my spot, I'm telling you, man. So, it could be a really strong stand.

MA: Yeah, no, it's wonderful to see the representation. And I think, to add to what I would love to see...look, I grew up in the Bay Area. The Bay Area is extraordinarily diverse. I went to one of the most diverse schools. I went to Hayward High and Mount Eden High School in Hayward. And I believe Mount Eden High School was the most diverse, especially diverse school in California when I was in

high school, if I'm not mistaken. And so, for me, I grew up around Samoan kids, Filipino kids, obviously Black kids, white kids, you know, Asian, Latino.

So, I would love to see, as we move forward, stories that really organically mix the races in general in a way that is not a Benetton act, but in a way that just feels organic to some of our upbringings where we grew up around different communities of people. And I would love to see Blacks and Latinos and Asians and whatnot be able to be the leads in some of these stories as well, when race is not the driving point of the story in some way, shape, or form. So, hopefully this is the beginning of a real, sustainable change. And I think, if you're going to think about diversity and put people in a position to enfranchise communities in some ways, I think this is the best time for that to happen because there's more content right now than there's ever been before, with all the networks and streaming content, the independent films and whatnot. This is a really good time to continue to move in that direction.

AV: One other thought, one more movie I thought you were great in, and that was the indie movie *The Place Beyond the Pines*.

MA: Oh, wow, thank you.

AV: You, Eva Mendes, Ryan Gosling star in it, but settle this, Mahershala. You could beat up Ryan Gosling in real life, right?

MA: (Laughs) Ryan, he's a pretty tough guy. I don't know who would win, but Ryan's no chump. He'd be ready to go for sure. But yeah, we'll see. Maybe we can talk to Dana White or somebody like that, and set something up for charity.

AV: I think that would be awesome. Seriously, on the acting note, and the success you're having with *Moonlight*, I hope to see a

leading man-type role. To me, that's the next frontier. For a guy like yourself, I think that's going to be the next challenge. Thank you so much for coming on *Cinephile*.

MA: Thank you for having me.

AV: We'll hang in San Jose one of these days.

MA: I look forward to it.

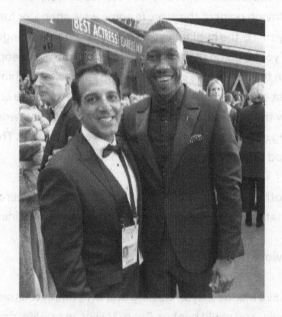

CHAPTER 16
Willem Dafoe: Virtuoso

December 12, 2017

I think you could make a compelling case that Willem Dafoe is the best actor alive to never win an Academy Award. From *Platoon* to *The Last Temptation of Christ* and all of his outstanding collaborations with Paul Schrader (especially *Affliction* and *Auto Focus*), Dafoe gives virtuoso performances and completely commits to the task at hand. His unpredictable repertoire of roles is matched by atypical facial features for motion pictures. Dafoe recalled riding the subway years ago when he heard a passenger say, "Yeah it's got to be him. Nobody looks like that motherfucker."

"That's when I knew," said Dafoe, "that I had a distinctive face."

This interview took place while he was promoting *The Florida Project*, a film by Sean Baker. Sean later made history by winning four Academy Awards for a single film, his wonderfully audacious and wildly unpredictable movie *Anora*.

★ ★ ★

Adnan Virk (AV): He has been a terrific actor for so many years, and now he is the front runner for the Oscar for Best Supporting Actor. He's fresh off a Golden Globe nomination. The film is called *The Florida Project*, and his name is Willem Dafoe. Willem, thanks so much for coming on *Cinephile* today.

Willem Dafoe (WD): Sure, my pleasure.

AV: *The Florida Project* is a really unique film, and it focuses on these kids who are obviously impoverished and just trying to make do with what they can, and you are the adult and this paternal figure. What was the appeal for you with this film and, dare I say, being the biggest adult in the room in character, looking after everybody?

WD: Well, I think initially I was interested in Sean Baker's work. I had seen his other films, and I thought he was an interesting filmmaker. And then, when I read the script, it was very strong. It was a world that I didn't really know. And I wanted to enter that world. And the character also was interesting, and it was a character that I probably didn't know exactly until I started doing it. But I knew that he was placed in the story in a very interesting way. He was sort of the connecting piece, and he was also a character that had to wear lots of different hats, so there were a lot of different ways to approach the character.

AV: Yeah, a friend of mine said that they love the fact your character is always fixing something and how it's a metaphor for the way he's trying to repair these broken lives. And what I loved about your performance is that the character is heroic, but heroic people are not overtly heroic. You know what I mean? You're this paternal character who's just looking out for everybody and you're just trying to make do as best as you can. And that is where you often find heroism, when working class Americans are just trying to do their job as best they can to help people in need.

WD: You said it, brother. I mean, you expressed it better than I can. I think that's very true. I mean, he's not an extraordinary person. He doesn't have extraordinary talents, at least that we know of, but he's a good man. And he's got a kind of good-heartedness. He

Willem Dafoe: Virtuoso

is trying to fix things, not out of a self-conscious altruism, but just a kind of practical manner. He wants to watch the ball game. He wants everybody to be happy. He wants peace.

AV: Yeah, I love that scene where we don't know for certain if a character is a pedophile, but he's this guy who's lurking around the kids, and your character very cleverly and adroitly says, "Oh, what are you doing? I need a drink. Why don't you drink that tea? You know it's a hot day." Tell me about that scene, because I love the way your character almost kind of soft-shoes that, right? You're nice and charming and then bam, you snap on the guy.

WD: Right. You know, we're working from a very strong script, but that was a case where we had some vamping to do, simply because of the practical reason that where I encounter this guy is quite far away from the logical place that a soda machine is, but it's very important for me to get him to the soda machine. And if you haven't seen the movie, it's a little hard to explain. So, we had to vamp, and I had to kind of manipulate him or find a way to get him to that soda machine, so it was a very concrete improvisation. And then at a certain point, when I'm convinced he's there for what I think he's there for, I lower the boom. So, it has a kind of drama to it that was fun to play.

AV: The kid performances are all excellent. You know, the one thing I was struck by is just how vulgar some of these kids are. I completely recognize it's tough, living in impoverished conditions. Have you ever kind of been taken aback by some of the material that Sean was putting in the film, the way this mother and daughter's relationship exists?

WD: Yes and no. I mean, I think it's certainly the Moonee character. She's six years old, but she's seen a lot of things, you know? So, she's growing up fast. And her mother is a bit of a girl child herself.

They're more like sisters than mother and daughter, so I didn't find it that unusual. I know that the parents struggled sometimes with some of the swearing and some of the attitudes for the kid, but it was certainly...look, kids search the internet. They're looking at all kinds of things and they're hearing all kinds of things. I mean, it's not like when you and I were growing up.

AV: No question. My wife and I had a debate, Willem, about...I don't want to give it away, but just the ending. Do you think that is metaphorical or is that literal, what happens?

WD: You know what? You can have the debate because I think Sean very shrewdly lets the audience participate. It really depends how you feel about the characters and what you want to happen. So, he doesn't sugarcoat it, but at the same time, he doesn't end it on downer note. He ends it on sort of a...you go into a different world, and it's really up to the individual audience member to interpret where he thinks Moonee and [her] mother will end up.

AV: Yeah, I love the fact that Sean is shining a light, like you said, on people we don't often focus on. We've all been to Disney World or know all about the Magic Kingdom, but here's also what's happening in Orlando. That really is a big part of the film. *Platoon* is one of my favorite movies. We can go in so many different directions, but what memories do you have of that iconic film with Oliver Stone back in 1986 and your character Elias?

WD: It's a while ago, but I remember it very well. It was a great experience. You know, when I met Oliver, he was unlike anyone that I'd ever met in the film business. And he had a story to tell, and it was a very personal story, and it took a bunch of us, some of us quite green; for some of the actors, it was the first film that they made. You cart us to the Philippines and you get some vet to train us in a serious way, and we apply ourselves to his story, and it was

a great experience, and all of us, really, for the whole cast, it was quite a bonding experience, and it was personal to everyone.

AV: Yeah, people have often said, in some ways comedy is harder than drama, and then if you go further, you say, to play the hero is oftentimes harder than the villain. And not to take away from Tom Berenger, who is fabulous as Barnes. That whole "I am reality" scene is wonderful. But I think your character is tough, because how do you play the good guy? How do you play this character who is looking out for Charlie Sheen and trying to be genuine? How do you play a guy who is ostensibly the good guy in the film, which is set in the jungle where there's so much pain and so much violence?

WD: Oh, you know, the truth is that it parallels something in *The Florida Project*. I had very concrete things to do. And when you have concrete things to accomplish in terms of action, in terms of doing things, it's easier to apply yourself to the scenes. And you don't think about whether you're the hero or the villain. So, I wasn't conscious of that. I was playing the scenes. I was trying to be a soldier. I was trying to take care of Charlie. It's good old-fashioned pretending. But I will say, you know, my character in that had a beautiful setup, how he ends dramatically, particularly, and how he gets set up. It's a very structured character that's structured beautifully. Tom Berenger, that's a performance of a lifetime. I mean, he goes deep. He taps into a scary anger and a scary disappointment that really just jumps off the screen. I haven't seen it in a while, but the last time I saw it, that was the performance that really wowed me.

AV: The way that your character smiles when he sees Barnes and then realizes, oh no, this isn't going to end well. And that death scene, Willem, it's one of the most memorable death scenes in any film ever. Tell me about shooting it. Did Oliver make it explicit he

wanted to have your arms up, like a Christ pose, which became the cover of the movie?

WD: No, he didn't tell me anything about that. It was just a practical thing. I'm reaching for the helicopter. I'm playing my actions. I'm running. From an actor's point of view, it was a very simple scene. I'm running for my life. And I'm trying to reach the helicopter. A very concrete action to do. And it's just like an athlete that's running a race. There's a very concrete action to do. You think, *Oh, that's not emotional?* Well, watch a guy do a sprint in a pressured situation. It's a very emotional thing to watch. Because your whole body, your whole mind, is dedicated to this action. There's no reflection. It's pure nature. So, that was a great setup. And then, of course, it was filmed beautifully. And they laid Samuel Barber's "Adagio for Strings" over it, which was a good choice of music for it, so that was a great opportunity and I was just there to receive it. I'm not being falsely modest. I'm just saying that it was really, you know, unique. As an actor, you have to be able to fill those opportunities. You have to meet them and run with them. No pun intended. But really, it was a great setup.

AV: Well, I think you're right in saying that you really were kind of carrying out Oliver's vision. And you know, when you have a great director—my favorite director is Martin Scorsese. When you worked with him on [The] *Last Temptation of Christ*, you clearly were the vessel of the project that was so incredibly personal to Marty, and he was facing obviously so much criticism from some people. Tell me about taking on a role like that.

WD: Well, that was a beautiful experience. People forget that it was a very low-budget movie, so we were driven by necessity, but thank god for Marty Scorsese. This was a personal film for him, and it was also a film that he had very well-realized in his mind. He's a master filmmaker, so that was a huge pleasure. Also, it's a movie

that required a lot of me, and I think that's when I work best—when I'm under the gun, when I have, you know, a demanding role. That's when I feel best.

AV: Yeah, in terms of preparation, I'm sure it's a matter of not just the Kazantzakis novel, but maybe seeing other biblical films or actually reading the Bible itself. And Marty, of course, is such a cinephile himself. He must have given you maybe other scenes or movies that he wanted you to channel. What was the research like to play Jesus?

WD: Well, the funny thing is, you want to sort of forget about Jesus because the whole thing is to play the human part of him. So, I wanted to cleanse myself of any expectations or any imagery, really. He did tell me to watch Pier Paolo Pasolini's [*The*] *Gospel* [*According to St.*] *Matthew*...I forget the proper title. I should know it because I played Pasolini. But he told me to watch that film. That's the only instruction he gave me. He gave me some articles about forgiveness. Of course, I read the Bible some, just so I could get the story straight in my head. And it was really about cleansing myself. I wanted to start from zero rather than accumulate images or thoughts about it. Because he was a passive character, a character that's acted on and then he reacts, it was really about placing myself in a way that the story could work on me. So, the research was really about coming into the scenes as clean as I could, as simple as I could, and then being receptive to them.

AV: The ending is so beautifully rendered when you see what Christ obviously resisted, what the whole point of the film is. How physically grueling were the crucifixion scenes, and like you said, the fact that you're under a tight budget and you're trying to just wrench all this emotional performance into the film. How tough was that?

WD: It was very physical, but that's where I live, that's where I feel happiest, when I'm doing physical things. It was a pleasure.

AV: I was reading *The Hollywood Reporter* and they have a great roundtable with actors generating a lot of positive buzz this holiday season, and they asked each of you your favorite performances. Sam Rockwell said, anything in *The Deer Hunter*. He also said his dad looked a bit like De Niro, as he has the mole. I love that movie. James Franco said the De Niro of *Mean Streets*, *Taxi Driver* and *Raging Bull*. Your choice was Boris Karloff from *Frankenstein*. Tell me why that performance is the one you love.

WD: Just because it was so theatrical and muscular, but at the same time, it was very touching and very human. So, it had this kind of strength, but also a fragility, and it's a beautiful thing to see when you can balance opposites at the same time. It's like holding two contradictory arguments in your head. That's really when you start to understand things. So, Boris Karloff, I'm sure in the day it was considered quite a…I don't know what it was considered in the day, but when I was a kid, it was like a kid's movie, it was a horror movie. But if you really look at it, it's a beautiful performance.

AV: The two things that I think about with Boris Karloff: one, I love that Martin Landau played Bela Lugosi in *Ed Wood*, and he's just always angry about Karloff saying, "How easy is that? How tough is that monster."

WD: (Chuckles) That's funny.

AV: And the second thing is, of course, your performance in *Shadow of the Vampire*. So, when I saw Karloff, I said, maybe you just had an appreciation for those types of movies, but that was a wonderful performance, too. I hope people recognize how good

you were in *Shadow of the Vampire*, and I hope this was a fruitful experience for you.

WD: Oh, it was a beautiful experience. It was really fun because I had such a strong mask. So, sometimes it's beautiful because when you sit in the makeup chair for three, four hours, you lose yourself and you're totally free—you become another character. You look in the mirror, you look different, you feel different. It really opens the door to pure pretending. And I had a good model, because basically I'm starting from a place of imitation, I'm really using the *Nosferatu* film as a base to start from. You can never truly copy, but sometimes that's a good place to start. It's like what musicians do all the time, you know. You learn the scales and then you depart from them.

AV: Two more movies and I promise we'll get you out of here. I love a couple of the movies you did with Paul Schrader, *Auto Focus* and *Affliction*. *Auto Focus*, to me, is such an underrated movie. Owen Gleiberman in *Entertainment Weekly* said that it was the first great film about sex addiction. And your performance, the relationship you have playing Carpy with Greg Kinnear, I just think it's a movie that people don't appreciate how powerful it was. The throes of addiction that character is in, your character, and especially the dilemma that each guy faces when they try to break apart. What was *Auto Focus* like, because I think it was amazing.

WD: Good! I'm glad you like that movie... It's a good movie. You know, I've worked with Paul Schrader, five, six times. And I think it's under-seen, but I don't think it's underappreciated. You know, some movies just don't get a strong release, and I think that was one of them. But I think it's a strong movie, and it's something I really enjoyed doing.

AV: And another movie that I love, speaking of Paul Schrader, is *Affliction*. Everything about that movie, just the way it's shot, Nick Nolte's performance, and your relationship. I think Paul said, "When you watch the movie, you think it's Wade Whitehouse's story, Nick's character. But when you watch it again, it's actually your story. It's Rolfe's, the brother of Wade." I love that haunting narration at the end, the last line you say: "Except that I continue." Lisa Schwarzbaum of *Entertainment Weekly* had a glowing review when she called *Affliction* a magnificent feel-bad movie.

WD: (Laughs) You know, it comes from a beautiful novel by Russell Banks. And Paul is very good at dealing with very hot, emotional, and spiritual issues in a very detached, aestheticized way, and this film was no exception. The role really is both [James] Coburn, Sissy Spacek, and also Nick Nolte is fantastic in it. They're great performances. I'm kind of in there for support, but I was happy to be there.

AV: There's humor amid serious subject matter. The scene where you say to Nick Nolte's character, Wade Whitehouse, "I was never afflicted by that man's capacity for violence," speaking of Coburn. And Nolte gives a big laugh and says, "That's what you think."

WD: It's good. No, it's beautiful. It's beautiful writing. The novel is great. If people respond to that movie, they should check out other novels by Russell Banks including one called *Continental Drift* that really was very prescient about the issue of immigration.

AV: Last thing. I read in *The Hollywood Reporter* that you said if you weren't an actor, you'd be a cook or a farmer. Where does that desire come from?

WD: You know, I guess, when you get asked those kinds of questions, you're not giving a lot of deep thought. But I always

admire and I like losing myself in practical things. I like washing dishes. I like to cook. I like to work there. When I had a vegetable garden, it was very satisfying. So, I don't really think about doing those things, and I'm sure I have a very romantic view of them. But a life where you're connected to nature and you're connected to making things in a practical way, this is very appealing to me. And in fact, as an actor, that's what I try to do.

AV: Thanks so much for the time, Willem, I really appreciate it.

WD: Alright, thank you. Good talking to you.

CHAPTER 17

Barry Jenkins: Auteur of *Moonlight*

February 13, 2017

Barry Jenkins and I will forever be joined at the hip. The Academy rightfully awarded him an Academy Award in a surreal scene. As I described earlier in the book, Warren Beatty and Faye Dunaway were given the wrong envelope (for Best Actress instead of Best Picture) and thus they incorrectly read the winner of Best Picture as *La La Land*, and I got to broadcast that moment backstage, working for the Academy, hosting a live stream with Ben Lyons, Sofia Carson, and Troy Gentile on Oscar.com and Facebook Live.

Barry took that monumental moment and has translated that into movies both big (*The Lion King*) and small (*If Beale Street Could Talk*). In a universe in which directors can be monomaniacal and intransigent, Barry is an outlier. He is self-assured yet grounded, and was gracious enough to join me twice on *Cinephile*: once before and once after his entire world changed.

★ ★ ★

Adnan Virk (AV): Joining us now is the director of *Moonlight*, Barry Jenkins. Congratulations on a wonderful achievement. Your film really is an example of indie moviemaking. It reminded me of a movie from the '90s, where you take a character-driven story and run with it. I'm sure you didn't have much of a budget and it just happened to hit, and all of a sudden audiences have responded,

you receive critical appraisal, and obviously now this bevy of Oscar nominations. At what point, either during the filmmaking process or once it started being screened by audiences, did you realize you had something special?

Barry Jenkins (BJ): You know, it wasn't during the process, because we made the movie in twenty-five days. It was a very sort of almost run-and-gun experience. We were just working constantly to keep everything together, so the process was just very much work. But when we were at the Toronto and Telluride Film Festivals, I started to realize very quickly that something was happening where people were watching the movie, and they were seeing our characters for sure, but they were also seeing themselves on screen somehow. And that's when I realized, okay, something is about to happen. I don't know what, but I guess I should be here for it.

AV: And certainly those film festivals are major ones. And you're right, once it started to hit in Toronto, you knew you had something special. How about the fact this is only your second film. I mean, I'm thirty-eight, you're thirty-seven. In the grand scheme of things, we're relatively young guys. And for you to be Oscar-nominated for Best Picture nomination so relatively early in the feature film game, what's that like?

BJ: It's surreal, man. I mean, I've had a very privileged experience with this film because I have friends who've made amazing work that nobody sees and people don't talk about, so I realize that there's just been this fortunate sequence of events that have led to this point. I just try to stay grounded and stay humble, man, because as amazed as I am that this has happened, as thankful as I am, I do realize how easily it could not have happened. So, I'm just thankful and happy for all the other folks who contributed to the movie that they're getting recognition as well.

AV: Well, man, we've had Mahershala Ali on *Cinephile* a couple months back. He's going to win the Best Supporting Actor Academy Award. He's been a wonderful actor for years now, and your film really is a great showcase for him because he has such dignity, he has such presence in the character of Juan. What was it like working with Mahershala?

BJ: Man, it was amazing working with him. By the way, I just knocked on wood, man. I just have to be happy every time somebody says something like that. I got to knock on some wood. It was dope working with him, man. He's like the godfather of the movie in a certain way because he was also doing *Luke Cage* at the same time. So, he'd be in New York for four or five days working, he'd take a flight down overnight, come and work for us for two days, and go back to New York. And so, he was the one actor who was there over the longest stretch of the script or the shoot.

He just kept coming back and forth, so I feel like his hands are kind of all over the piece. And he was just amazingly graceful and kind because, other than the one scene with Naomie Harris, all of his work is with nonactors or people who were acting for the first time. And it was wonderful to see him embrace that, you know, and go to these new places.

AV: Early on, *Moonlight* was being hyped as a gay Black film. And I said, you know, whereas certainly themes of sexuality and race are important, I thought it was a story of self-discovery and self-actualization. And granted, stories about gay Black men are historically underrepresented in Hollywood. But to me, what made the movie was the fact it was so universal. Did you feel like you had to impart that message to people or did they recognize that once they saw the film?

BJ: You know, I think people recognized that once they saw the film. Case in point, you know, last week, I did this international tour releasing the movie in all these different countries, and I was in Berlin, and this guy stood up to ask a question. He was like, "I know you say you made this movie about Miami and for Miami, but when I was watching that film, I didn't see Miami. I saw a small rural town. I grew up on the outskirts of Germany." He basically took the specificity of our world and applied it specifically to his world. I think that's what's happening. I think that's why the movie is being held as universal, you know. People find a way to see themselves and their own lives in these characters.

AV: A really curious decision you make, Barry. I was reading my *Entertainment Weekly* Oscar preview. It said the three different actors that play Chiron, you did not have them interact, which I found fascinating. I would have thought they're trying to mimic each other in body and gestures and mannerism and such. Why did you keep them separate?

BJ: I would love to frame myself as this brilliant guy making all these crazy decisions. But, you know, we just couldn't afford to have any rehearsal, you know? And I think at some point you lean into those things and use them to your benefit. You know, the movie is about how the world is reshaping this kid. Every time we meet him again in a new chapter, he's the same character, but he's made himself into a different person. And as you say, I didn't want them to mimic one another and try to carry these things from story to story. You know, the world weighs differently on Chiron's shoulders in chapter two than in chapter three. In chapter three, he's literally refitted to shoulders with many more muscles so he can carry that weight. And I thought the best way to communicate that to the audience was to allow these guys to each bring their own essence to the role and not try to bring this other thing from the previous story with them.

AV: And part of that is the restraint and the subtlety. Like, you know, the scene on the beach. You need to have a scene of young love, so to speak, and you do it in a very tasteful manner, yet we're aware of what's happened. At the end of the movie, you have an emotional connection with these two guys. And again, you're showing restraint. How much of that time were you saying, "I don't want to have graphic sexuality, I want to focus on the characters"? Or was it again a budgetary issue or some other reason that you filmed it the way you did?

BJ: No, that was intentional. I think it's just my approach to that kind of subject matter. My previous film *Medicine for Melancholy* is about a guy and a girl, you know, a very classic sort of love story or love pairing. And I think we still treat those homes of intimacy the same way. You know, I'm glad you mentioned that scene on the beach, because from a production standpoint, that is as large as we ever are in the film. There were no lights on the shore that night. These turtles come in to mate and they force all the buildings along the boardwalk to turn their lights [off] so the turtles will go back out into the ocean. We were not aware of that until about two weeks before, so the most lighting, the most crew, the most rigging we have is on that night of that beach scene. And yes, it's the most intimate moment in the film, and so those things were absolutely intentional. And we tried to give Ashton Sanders and Jharrel Jerome the space to be patient and take those quiet moments.

AV: You're nominated for Best Director, but also Best Adapted Screenplay. The script, like you said, is a series of quiet observances which lead to this kind of emotional wallop. How did you come up with the title, Barry? Because I think there's *Moonlight Mile*, and there's other movies with that title, yet it really fits the movie, and yet I can't articulate why? Why did you like it?

BJ: Yeah, you know, the source material written by Tarell Alvin McCraney, who is a MacArthur genius and now the head of the playwriting program at the Yale School of Drama, he's very good with words, man. And his piece was titled *In Moonlight Black Boys Look Blue*. And I just thought that was a bit much to have on screen.

But he had written all these sequences that to me took place "underneath that moonlight," to quote Frank Ocean. And it just felt like there was something about it, that it was a safe space with this character who was always trying to either hide something or trying to retreat from the world. In these sequences underneath the moonlight, he could allow himself to truly be. And so, I just had faith that we could put "moonlight" on the title and someone could watch the film and they could get that feeling: that sort of evocative emotion that I felt in reading this piece for the first time.

AV: Yeah, that's very cool. That definitely adds some resonance to it. On a personal note, Barry, you certainly overcame a lot of adversity in your own life. Your dad died when you were twelve. He had earlier separated from your mom and she believed that you were not her biological son. You were raised by another woman in an overcrowded apartment. So, these are clearly circumstances which could be challenging. Later made your way to Florida State University where you studied film, but how do you think those early experiences have shaped you as a filmmaker particularly?

BJ: I grew up as a kid in those environments. I was often watching. I was an observer. I was always watching how people operated, how they interacted, often because I was probably too afraid to participate. But, you know, I think I made myself an audience for my own life. And I think it's why, especially in *Moonlight*, there are certain things we do with the camera that are absolutely taking stock, that are actively aware of the audience as a participant watching these lives unfold. And so, I do think, in a very subtle way,

because I wasn't aware I wanted to be a filmmaker, the way I grew up absolutely has an impact on the way I approach the medium. And even more than that, one of the first lessons I was taught in film school was, I may not know how to hold a camera the same way some of these kids who grew up with the camcorders do, but I have a voice because I've lived through some things. And I always try to be aware of how my experience is influencing my work.

AV: There's definitely a lot of empathy in this film. I can only imagine, because you've lived through challenging circumstances, you're able to transmit that to those characters. Of course, *Cinephile*, this podcast, is all about movies, but you know my day job as a sportscaster for ESPN. What was your reaction when you saw your name and SportsCenter and Florida State in the same conversation?

BJ: Bro, it was crazy, man. You see, I played football during high school in Miami. I went to a very good high school, Miami Northwestern. There were three running backs from my high school football team: two made it to the NFL, one is talking to you. I've always had the dream of being on SportsCenter, man. And actually, I'll be honest, my agent was the one who sent it to me. My agent at CAA saw it, recorded it on his iPhone, and brought it to me. And man, it made my day.

AV: I can't wait to see you at the red carpet, and congrats on the film, Barry. Way to go, man.

BJ: Thanks, man. Much appreciated. By the way, I'm going to tell Kenny Lonergan you said what's up.

AV: Oh, *Manchester by the Sea*, phenomenal. Pass along his info. We'd love to get him on here, too. Both of you guys had great films this year.

BJ: Will do, bro, will do.

CHAPTER 18

Barry Jenkins: Part 2

December 10, 2018

Fast-forward to Barry promoting *If Beale Street Could Talk* and us reliving my call of his big moment at the Oscars.

★ ★ ★

AV: Seriously, Barry, this is forever my Al Michaels call. Do you believe in miracles?

BJ: (Laughing) Oh, man, you know, it's funny. I heard that a couple of days afterwards and I was like, "Man, Adnan just lost it." I mean, pretty wild, man. I don't know what it was like for you. Well, actually I do. I've seen what it was like for you backstage, but it was a madhouse, man. It was an absolute madhouse.

AV: I like the quote that you gave recently to *The Hollywood Reporter*, Barry. You said, "It's a fun thing to talk about. And years from now, hopefully nobody will care. We can just focus on our careers." But for now, there is always going to be that moment of what happened for you and Damien Chazelle. I know you've talked about it ad nauseum, but seriously, what was going through your mind as the entire world changed, your entire life changed in those moments?

BJ: I know. You know, I was so confused, man. I had no clue what was happening. You know, sitting in the auditorium, we didn't have as much information. You know, we couldn't see the close-up on the cards. So, it was just a very strange thing. I was like, *Okay, I'm going to walk up towards the stage because they're telling me to, but what the hell is happening?* And it wasn't until maybe like forty-five minutes afterwards, I didn't realize my heart was pounding. I literally had to sit down. And I was like, *I'm either going to go to the hospital or I'm going to take a nap, because this is intense.* But all's well that ends well, you know?

AV: When did you hear my call? When you messaged me, I think you went back to Florida State and they played my call. Is that right?

BJ: Something like that. Yeah, yeah. But I think somebody tweeted it at me, you know, because I think people caught on real quick that you and I were mutuals, as the kids say. So, somebody tweeted it to me and was like, "Have you seen this?" And I was like, *Oh, I have not seen this, but I've seen it now.*

AV: We are forever intertwined, man. I love it. You're going to be a great filmmaker for many, many more years to come. And I'll always be your biggest advocate, so I'm glad I got to share that moment with you.

BJ: Thank you, brother.

CHAPTER 19

Matthew McConaughey: From Texan Hunk to Oscar Winner

January 22, 2019

He is that proverbial man that is more than just a pretty face. Matthew McConaughey has matinee idol looks and would be the picture you'd see staring back at you if you googled "Texas hunk," but beyond that ruggedly handsome man is an awfully talented actor. Earlier in his career, McConaughey relied on the tried and true formula of taking his shirt off and exposing his eight-pack, and was labeled as bumptious for it. But deeper into his career, he's become a better actor, and a riskier one as well. His characters may move about languidly, but there's an intelligence deep at work. McConaughey deservedly won the Oscar for Best Actor for disappearing into the lead role in *Dallas Buyers Club* and I was only too happy to talk to him about working with legendary auteurs like Martin Scorsese and Christopher Nolan.

★ ★ ★

Adnan Virk (AV): Let's talk about *Serenity*; your new movie is coming out January 25, and I saw it and I enjoyed it. I wonder, Matthew, how much of the appeal was in playing a real Hemingway-esque character? You know, this is a guy who's a tax attorney, he's a man of action, he's been in the army, he's obsessive about fishing—it's all he cares about, it's all he wants to

do—and he doesn't appear to have any friends aside from Djimon Hounsou, who's his main mate there. Did you see Hemingway when you envisioned this character, when you thought about how you were going to play him?

Matthew McConaughey (MM): Yeah, this is Moby Dick, this is old '40s noir, this is Humphrey Bogart—these men that are iconic sort of islands unto themselves, alone, someone that really doesn't pander or placate to anyone else. I'm playing a man who's really escaped to this island in the middle of nowhere, and is obsessed with catching this fish because he wants to catch this fish for his son. Well, it's somewhat not a healthy obsession. He's been doing it for ten years and still only hooked this fish like four or five times. But this is this man's life obsession, to the point where he's partially insane. And then, without giving away any of the twists that happened, it's a man who's a detective in his own life, trying to figure out if he's real, if the world he's living in is real, and questions all of that, and, as I said, goes half mad through the journey of doing it.

AV: You got Diane Lane in the film. You've got Anne Hathaway, who's playing your ex-wife. And for all the ladies listening, Matthew does show his bare butt, at the twenty-six minute mark and the fifty-six minute mark. So listen, we got it all in here, man.

MM: Thank you. I did not have those time codes down.

AV: (Laughs) I want people to specifically know, no, don't go get popcorn at the twenty-six minute or fifty-six minute mark, Matthew's showing you the full monty.

MM: (Chuckles) Well, not the full monty... I get your point, I get your point.

AV: Steven Knight wrote and directed *Locke*, which is a really good movie, and also wrote *Eastern Promises*. Early on, there's an exchange with you and Diane Lane. She refers to you as a hooker, and you say, "A hooker without any money for hooks," which works on multiple levels because the guys are fishermen. How did you like working with Knight?

MM: Well, it's his brain behind this whole thing. If you've seen *Locke*, you've seen what he can do as a director as well. He's created this fictitious world that is sort of like a utopia in some sense, sort of a fantasy. As you said, I'm a fisherman, a hooker with no hooks. He has a sleight of hand in the way that he writes. One of the lines in the screen direction introducing my character was like, "Baker Dill lights a cigarette in his one-handed way." That's just like a song lyric. His dialogue is very lyrical. And if you say just that line, "lights a cigarette in his one-handed way," that doesn't tell you how he lights a cigarette, but you know exactly how that guy lights a cigarette. It says a lot about that guy. The dialogue was great. He's incredibly smart, sensitive, and listens to great ideas. So, it was free, it was creative, and it was fun to go to work every day.

AV: If you may indulge me, Matthew, on some other films of yours that I love; [The] *Wolf of Wall Street* is so brilliant, and your character is so magnetic. And I know you've told the story before about that ritual, which became kind of a theme of the music, which is you pounding on your chest. That's like a warm-up exercise you were doing as an actor, and then Marty saw you doing it, and Leo said, "We're going to put that in the film." Is that right?

MM: Yeah, to warm up, to relax. I find a rhythm for my character in every scene that I do, and that was the rhythm I was doing before that scene. And then we'd say "Action," and I'd stop doing it, and I'd start the scene. So, we do five or six takes, we have the scene, we're moving on, and it was Leonardo's idea. He goes, "Hey

McConaughey, what's that thing you're doing right before the scene when you're beating on your chest?" I told him, and he goes, "Oh man, do that in the scene." So, we looked over and said, "Hey, leave the cameras where they are, let's do one more take," and I did it, and that's the take that's in the film.

AV: That's fantastic. I asked Mark Wahlberg once, "Tell me something about Scorsese that I don't know. I adore his films, I know he's a cinephile, I know he's a film junkie," and he goes, "You know what? One thing you wouldn't know about Marty is he's hysterically funny and he's got a really dark sense of humor." What can you tell me about Scorsese that I wouldn't know?

MM: Well, I'll back that up. The man loves funny. I mean, he loves funny. Number two, he's obviously very musical, which I think is why he enjoyed and picked up on the thing that I was doing when I was pounding my chest, humming my beat. He and I didn't even talk much English in his direction to me. We were always talking in musical terms. Even when he would talk about how he was going to set up a shot, he's setting up a shot like he's playing a musical bass line: "And then the camera will be here and boom, boom, boom, and then right here, boom, and then it's right on your face, boom." And so, he's always talking in rhythms and in musical vernacular, which I quite enjoyed. So, yeah, his love of music, the rhythm of every scene, he sees it musically, I believe, and feels it musically; and then his love of funny.

AV: That's fantastic. And speaking of great directors, Christopher Nolan, who you worked with on *Interstellar*. I don't think that movie gets enough due, Matthew. I think too many people maybe found it enigmatic or didn't understand it. My whole view is you ride the wave, man. You go with the journey. You experience this different universe, and those that love the film appreciate that. Tell me about Nolan. He must be, I can imagine, being very cerebral?

MM: Well, there's another guy who is, yes, cerebral, sure. I mean, look at the world he created out of his imagination in *Interstellar* and even in his other films. He's come up with that. That's fiction. He's created that world. He's created the rules of the world in *Interstellar*. Unlike *The Dark Knight*, there is no previous material to come up with that world or that journey that we had in *Interstellar*. But here's another guy with a great sense of humor. You know, with all the wonderful and talented artists and the best I've been able to work with, I'm always looking to try to uncover that person's magic trick. And what I've learned is that there is no magic trick. There really isn't a magic trick.

People have a specific point of view and they have the confidence and the competence to follow through on those. And if it's in film, they have the confidence and competence to follow through on that vision through moving pictures and sound that come to life and make you feel like you're there, make you feel like it's not fiction. Nolan is the first one up the hill and the last one down the hill every day. You're not going to outwork the guy. And at the same time, when I say he loves funny, I would ask him certain questions like, "Wait a minute, explain this," and he'd be like, "Hmm, good question. I don't know." And we'd just laugh because he'd say, "But thank you for asking me the question. I'm going to think about that." And two weeks later, he'd come back to me and go, "You know what, I thought about that question you asked me." And he'd come up and give me a long answer, which was great.

AV: That's awesome. And the guy's actually paying that much attention to you. For a guy who's made so many great films, I could ask you about *Dallas Buyers Club* when you won the Oscar. But there's a movie of yours I think is underappreciated, and I thought you were fantastic in it: *Lone Star*. I love that movie and John Sayles's script. I think there's shades of *Chinatown* with how well

it's written, and you're great in that movie. What memories do you have of *Lone Star*?

MM: Well, yeah, Sayles did a wonderful job with that, and he's a great writer. One thing I remember is we were down, I think, around Piedras Negras in a little town just north of the Mexican border in south Texas, I believe. And the next day, we had that scene where it's Kristofferson and I, and he plays the sheriff and I'm Buddy Deeds, right. And Kris, acting was not his day job. Music was his day job. And we were staying in this little one-star motel in the middle of nowhere that had one lamp that was lit by batteries and all ground floor levels.

I was nervous, as I usually am before going to work. And I remember going over to him, and I said, "Hey, you want to read through the scene with me?" He was like, "Yeah." And so, we read through it, and then I remember we switched lines, we switched parts, and I read his part and he read my part, which leads to more Kristofferson stories, which are great, by the way. And I'm going to fit one in here. Have you ever heard of the book called *The Greatest Salesman in the World*?

AV: (Lying) I have, yeah.

MM: It's a book that really helped change my life, and I was reading it at that time, and I was in a little canteen that seats about five people, at about five in the afternoon, and I'm having a beer, and I'm reading that book, and in walks Kristofferson. And this is actually the day we met, and he goes, "Hey there Matthew, what are you reading?" And I said, "Hey, I'm reading this book, it's kind of a self-help, self-improvement book called *The Greatest Salesman in the World*. This chapter I'm on right now, it's about persistence and letting your reach exceed your grasp." And he goes, "Yeah, sounds good, tell me more." I said, "Well, like, look at this line here.

This one line says, 'I would rather throw my spear at the moon and hit an eagle than to throw my spear at an eagle and hit a rock.'"

And Kristofferson looks at me, and he looks down at the bar in front of him. It's a wooden bar. He starts digging his finger down to the bar, and he's getting pretty perturbed and ticked off. And after about ten seconds, he looks at me and he goes, "Why in the hell would you want to kill an eagle?" I said, "I don't want to kill an eagle, Kris. It's nothing to do with killing an eagle. It's a phrase of speech if your reach exceeds your grasp." Anyway, that was one of the funniest first moments I ever had with Kristofferson. And I remind him of that story all the time.

AV: The metaphor was clearly lost on him, but he is a true original, as are you. Matthew McConaughey, he's had an incredible career. His new film is called *Serenity*, the first Hollywood film ever shot in Mauritius. I know you're a genuine sports fan and big fan of Texas, so hook 'em and all the best with the movie.

MM: Deal. Appreciate it. Hook them horns. Let's have a good weekend of NFL football this weekend.

CHAPTER 20

Miles Teller: *Whiplash*

November 22, 2016

Mark my words: from the time I first saw Miles Teller in *Whiplash*, I knew he would have a successful and prolific career. Damien Chazelle's movie created some of the most buzz ever for a film that debuted at Sundance; it won an Academy Award for Best Supporting Actor for J. K. Simmons's tyrannical and officious music teacher, and put Teller on the fast track toward stardom. *Top Gun: Maverick* made him a household name, but it's fun to look back at this interview when he was still navigating his way to stardom. He could've been yet another example of callow youth, but instead has carried himself with confidence and assuredness. A genuine sports fan, Miles was positively thrilled to visit and navigate the vast compound at ESPN, and I enjoyed his candor and sense of humor.

★ ★ ★

Adnan Virk (AV): It's a real thrill to have Miles Teller here with us in the studio. Miles and I go way back. We met at last year's Celebrity Softball game.

Miles Teller (MT): Yeah.

AV: I don't have the box score saved, but I think you went two for three, a couple of infield singles.

MT: Yeah, which is embarrassing. I mean, dude, I was playing varsity baseball as a sophomore growing up. It's a different game. But yeah, an infield single in the Celebrity Softball game, you're never proud. I was just bummed I actually had to beat it out. I never wanted to have to beat it out in that game. I thought I was going to be hitting dingers, and it just didn't happen.

AV: I think what it was is you were apprehensive by the size of the crowd. Because you said to me, "Are they going to be full here in Cincinnati?" I was like, "We're expecting 30,000 for this."

MT: You know, that was one of the coolest experiences... I remember saying I had been to the Oscars at that point in my career and this was cooler for sure. I had always dreamed about that. I had always dreamed about being—I guess back in the day, they had [MTV] *Rock N' Jock*—but just being in an actual stadium and playing on the field that these guys play in. How many people get that experience as just fans? It's incredible.

AV: J. K. Simmons played this year. So, as soon as I saw him, I said, "Miles was here last year." He was like, "Yeah, where is that asshole?"

MT: (Laughs) Okay, so now I know the kind of vocabulary we're working with on this show. Fuckin' Simmons. He's like the stepfather I wish I'd never met, but somehow we're just linked for life.

AV: Yeah, I mean, he owes you and I don't mean the sarcasm. He owes you in small part with the Oscar because of how good you guys worked together in *Whiplash*.

MT: Any time you win Supporting Actor, usually the lead actor has something to do with it.

AV: Right, so his victory is also a victory for you. You can never let him forget that: "I was the lead in *Whiplash*. It was a Best Picture nominee."

MT: Yeah, I think he's looking for one more great ride before he goes off into the sunset. And I keep telling him, "Well, I'm busy, you know, figure it out."

AV: He really did enjoy taunting you and belittling you. But what actor wouldn't? How much fun would that be? Damien Chazelle was like, "Alright, you wanna torture Miles again today? Yep, we're gonna do that again."

MT: Yeah, pretty much. I don't know. I'm sure there have been a couple of costars of mine that would have enjoyed that opportunity. But in reality—you'll never hear this from J. K.—the set was actually a lot of fun. J. K. is a baseball guy, I'm a baseball guy. He's a Tigers fan. You know, baseball is a different sport. I feel like if your dad didn't teach it to you, then you probably missed it. But baseball fans, they just kind of, I don't know, there's a certain dialogue that they use that's different from other sports. But we're laughing on set. It's just absurd because I was like twenty-five at the time, and he's slapping me in the face. And this guy, I'm having these conversations with him about the Tigers and Phillies on action, he's slapping me, and I have to drop a single tear because it calls for it in the script, and he was saying, "Are you one of those single tear guys?" I was like, "Oh my god, I literally *have* to drop a single tear right now."

AV: How soon after graduation did you get that role with Nicole Kidman in *Rabbit Hole*?

MT: I got a manager pretty much right before my senior year, which NYU doesn't really advocate. They don't want you to try to

Miles Teller: *Whiplash* 155

start working professionally. They think while you're in school, you should focus on school, and then have the business come to you afterwards. But, I don't know, I got a manager, started auditioning, and I booked *Rabbit Hole*. I was doing an NYU student film maybe like two weeks before I graduated and then I got the call saying I just booked this part.

And you go from only doing things with your peers—I was only doing scenes with guys and girls my own age—to then boom. Three weeks later, I was on set with John Cameron Mitchell, Nicole Kidman, and Aaron Eckhart and no rehearsal, which is something I love now. At the time, I was like, *What do you mean that we don't get to practice this first?* And yeah, man, you're just in a scene with Nicole. And even now, I was just at the Governors Awards and everybody that you can think of is at this thing. Me and Nicole have known each other a couple years now, but yeah, man, you still work with people that you kind of grew up with, so it's hard to not see them as something bigger than themselves. Now, I'm better at it. But for those first couple takes, I remember feeling an out-of-body experience.

AV: You're promoting this new movie, *Bleed for This*. Even with your life, given the parallels here as far as the car accident. In *Whiplash*, there's a critical scene with a car accident, obviously with Vinny, and it completely changed his life, and you had a crazy car accident growing up. Tell us about that.

MT: Yeah, I did. I was in a pretty severe car accident when I was twenty years old. My buddies and I were coming back from a music festival in Connecticut. It was in Bridgeport. It's called Gathering of the Vibes—where my Deadheads at? Am I right?

AV: Bad memories of Connecticut.

MT: (Cackles) We were hell on the drums!

AV: If he had said, "Name one city in Connecticut," I would have been like, "Oh, I'm going to go Bridgeport."

MT: Yeah. It's a hot spot for kind of Deadheads and gym bands. So, we're driving back from that and my buddy lost control of my car, going about the speed limit on I-95, it was like seventy-five. So, he lost control going eighty miles per hour on a major highway. So, we went across three lanes of traffic, back across, went to the grass median, and flipped eight times. I flew out the window and the car landed straight up. When my buddy in the backseat came to, he looked in the front seat and saw I was not there. My buddy goes, "Where's Miles?" My best friend was like, "Oh my god," and got out of the car and looked around for me and saw me and I was just laying like forty feet from the car, unconscious, covered in blood. You know, he looked at me and thought I was dead.

And yeah, I mean, I remember him walking up to me and I looked at him and I said, "Hey man, what happened?" He goes, "Oh, we just got in a car accident. Oh man, my mom's gonna be so pissed." I looked straight to my car and I tried to sit up and he just looked at me and said, "Miles don't sit up. You're hurt. You're hurt really bad." And the look on his face let me know, so then I remembered where I was at. And I was thinking, *Oh my god, I've been ejected*. Thinking about all the things that come along with that. I couldn't feel my legs at the time. I literally thought I was paralyzed. And it was overwhelming, so I blacked out and woke up in a hospital.

AV: That's unreal.

MT: Take that, J. K. Simmons, you bitch! What have you done?

AV: Before we finish up here, I do wanna ask about *War Dogs*. I thought it was fantastic, and what I liked about it was it reminded me of what a Scorsese movie would be. That sense of adrenaline, the music, and you and Jonah Hill both had supercharged performances. It was almost as if you adapted *GoodFellas* to a younger generation and there were arms dealers instead of gangsters.

MT: This character that Jonah had, it's so rare at that age. I just feel like I'm biding my time in my twenties, but you really get your good parts in your thirties and forties. For Jonah to have a character in his twenties who just does not give a shit and is pulling out guns in the middle of the day and doing all these things that these guys did... They were the biggest international arms dealers in the world as a couple of twenty-three-year-old stoners. You know, the power that they had at their age was really unbelievable. Yeah, Todd Phillips is an incredible filmmaker.

AV: Yeah, what he did, obviously, with *The Hangover* and what he did with this film, which is comedy and also echoes the drama as well. Miles Teller, when you think about best actors under thirty, I think you're one of them. I mean, you're twenty-nine years old.

MT: Well, I'm turning thirty in February, so...

AV: Alright, best actor in Hollywood under thirty: Miles Teller for at least a few months longer.

MT: Get it while it's hot, because in two months, he's one of thirty best actors under forty.

AV: Miles Teller. Thanks man.

MT: Thank you, appreciate it.

CHAPTER 21

Josh Duhamel: Human Ken Doll

June 23, 2017

My wife would happily leave me for Josh Duhamel and I can't say I'd blame her. Our friend, Ben Lyons, would joke that JD is like the human Ken Doll. And yet, unlike that bit of plastic, the real-life embodiment has a lot of heart.

Duhamel may have started as a model and was appreciated for being swoon-worthy eye candy, but he's had a unique and distinct Hollywood career, all the while being a guy who is refreshingly down-to-earth and savors being home in his isolated Minnesota hideaway. Duhamel was born and raised in North Dakota and waves the flag as much as anyone for his home state.

Despite considerable success in what can be a cutthroat industry, Josh remains a devoted husband and father, and a man not defined by his work but certainly proud of it. He's mixed boffo box office with making movies about his own unique group of friends like *Buddy Games*. He was a buddy to all of us when he made his way to Bristol, Connecticut.

★ ★ ★

Adnan Virk (AV): It's great to have Josh Duhamel here with us in the studio. It's your second time here at ESPN, but you can verify this is like a college campus for those who haven't been before.

Josh Duhamel: Human Ken Doll

Josh Duhamel (JD): This place is unbelievable. I mean, you have everything here. You have basketball courts, you have cafeterias, you've got, you know, probably the nicest campus in the United States. The only thing is, you don't have any classes. You've got to be a professional, which is hard.

AV: Right, but this allows us to act in a sophomoric manner.

JD: Yeah. We don't even know the teacher!

AV: It's like a campus. I want to get to *Spaceman* in just a second, and the fact that you're a legit sports fan. Sometimes we have people come here and they go, "Yeah, no, sure, Twins, Kirby Puckett back in the day," but I know you're a legit fan. But let's talk about *Transformers*, the latest one; you're back in that universe again. Bigger, better spectacle, Michael Bay. Hype it up for me.

JD: It is a sight to behold. It really is. I hadn't seen it until about a week after doing a lot of press in China, and then I didn't see it until we got to London. And I was a little worried, because I remember while we were shooting it asking Mark Wahlberg, like, "Dude, are we, where are we right now? What are we shooting? Are we 15,000 feet above sea level? Are we 2,000 feet underwater?" He's like, "I don't know, man." We were eighty-four days in. You should know this. In other words, he had no idea either. But the movie really works. It really does. It's amazing what Michael Bay has in his head because he keeps it all there and doesn't really tell anybody. And the movie is really a lot of fun. It gets into the history of *Transformers*. It gets into how long they've been around and how much they've affected human history. It's just a ride. It really is.

AV: I wonder how the acting is with CGI; like, give me an example. Like, you're looking at a tree and it's supposed to be this gigantic

transformer and that's going to be Stonehenge. How do you do that?

JD: Yeah, well actually we built our own Stonehenge, six miles from Stonehenge, which only Michael Bay would do. But yeah, I mean, this is my fourth time doing it, so it's not as big of a challenge. And there's so many explosions and gunfire and just stuff going on around you that it really feels like you're in the middle of a battle scene. But yeah, you have to pretend that that tennis ball or that giant pole with the mask is Megatron, whoever he is. But there's actually a little commercial right now that they made where I'm supposed to be playing opposite of Hound, and there's a guy holding a tennis ball. And he's like, "How am I supposed to act with a tennis ball?" And so I came running in, I was like, "No, here, Hound, I'm here. I'm here." And he turns around and he goes, "I'd rather act with a tennis ball." So, the *Transformers* would rather act with a ball than with me. I'm not sure how to take that.

AV: Anthony Hopkins, Alec Baldwin has a great impression of him, and he says so, he goes, "You know, he's a Shakespearean actor, and he's a Welsh legend, and if you ask him, I hate the theater, I just want to do these movies—like Michael Bay movies, make a lot of money, sit in the sunshine." Did you have many scenes with Anthony?

JD: I had no scenes with Anthony in this movie. We were sort of on different parallels in this movie, but I did meet him at Stonehenge. I met him before. He was on it. Yeah, I did a movie with him that nobody's seen.

AV: No, I've seen it, I'm gonna ask you about that in a sec.

JD: Great. You think he's this refined, because he is that. He's Sir Anthony Hopkins and he's one of the greatest ever to live. But he's

Josh Duhamel: Human Ken Doll 161

also just a fun, really loving guy, really generous and selfless, and just wants to have fun. He had more fun making this movie than anything, I think. He really, really loved being out there working with Michael. Two people that you would never think would get along like they did.

AV: Somehow, they make it work.

JD: When he gets a chance to say "bitchin' " or "dude," or whatever it is, he loves it. Any chance he can.

AV: It's probably like when Sean Connery in *Finding Forrester* was like, "You're the man now, dog!" These guys are just happy to do something out of their comfort zone. You mentioned *Misconduct*. I saw it. Not only for you, but I love Pacino. And you've got that great climactic scene. For those who haven't seen it, check out *Misconduct*. Josh plays this guy who's caught up in a web of intrigue and suspense, an innocent man gone wrong, and then Pacino...I don't want to reveal everything, but you have a great scene with Pacino at the end. What was it like acting with Al?

JD: Well, that was the very first scene of the movie, which is never easy. I mean, first of all, I had just finished *Spaceman*. Literally finished the day before, and flew overnight to New Orleans to start shooting *Misconduct* with Al Pacino and Anthony Hopkins, two people that I was absolutely terrified of. And so, we fly to New Orleans, and we have to rehearse. I'm going to rehearse with Pacino because we start shooting in a day. And typically, in a rehearsal, you'll be in this little room where there's just the two of you. No, they had this whole theater, this famous old theater in New Orleans, lit as if there was a show about to go on, and a table in the middle with a spotlight. I walk in there like, *Really? As if this isn't intimidating enough? I've got to now rehearse in front of all of you with Pacino for the first time.* But he is another one who is just

the nicest dude you could imagine. He's Scarface. He is, you know, the Godfather. He is just the sweetest guy you could imagine.

AV: Does he offer any advice in between takes or does he leave you alone? Like, "I'll do my thing and you do yours." You have a director, obviously.

JD: No, he's really collaborative. Both of them were really collaborative. I would ask questions because I like to learn from guys like that. And, you know, they're just really generous dudes and really thoughtful, and really, really care about the work. You know, Pacino is just, he is neurotic when it comes to the work. He wants everything to be perfect. And you can see where his greatness comes from, because he and Hopkins have completely different styles. Hopkins sticks to the script. Pacino goes off-script. You don't know, when you're like, *Okay, when do I say my line? I don't want him to come in here.* But he just goes off, and it's beautiful, and you just have to sort of go with it. And that's where he comes up with all these iconic moments in movie history, is mostly by just having the balls to just go for it.

AV: Yeah, Azaria told us, when Hank Azaria was here, that scene in *Heat* where Pacino screams at him, he said, "Michael Mann, if he'll do one take, he'll do fifty." So, he said, like by the sixtieth take, and Hank is annoyed at this point, he told Pacino, "Just go for it." So, that's why the take that you see where he goes, "She's got a great ass," Azaria was legitimately terrified. Like, *Jesus, what's going on here?* But you're right, guys like that take chances.

JD: Yeah, he takes huge risks, and that's a great learning lesson for me. You know, it is, you got to be fearless. You can't be afraid to just, you know, be awful. Because if you're afraid to be awful, you can never be great. And that's what he does. That's really what I learned from him.

AV: I love *Spaceman*. I called it a baseball [*The*] *Big Lebowski*, because to me it's the stoner comedy of a guy on a journey. Of course, I know the whole story of Bill Lee, being from Canada, knowing the Expos growing up. And he was an eccentric guy, colorful guy, and I think a story that's been ripe for Hollywood for a while, and I credit you guys for making it. We had Ron Shelton on this podcast last year, and he told us you guys made it for no money. You did it for zero salary. What was it about the story that you wanted to make this?

JD: I think I actually lost money on that movie. I think I ended up spending more. My dressing room was the backseat of my pickup. But it was one of those that I did for the love of the game. I really did. I loved the script. I love Bill Lee. He's just such a great character. And it was a challenge for all of us to try to get a movie made on such a small budget in so few days, and it was just all hands on deck. And I'm actually very proud of that movie, not only for what we did with what we had, but the story I thought really worked. And thank you for the kind words about it, because it's hard to get little movies like that off the ground.

AV: Yeah, that was my first blurb, actually. I think I was on the poster for *Spaceman*.

JD: You were our biggest fan, and we appreciate you.

AV: Of course, man. Hopefully, people will check out *Spaceman*. The other thing is, with your work, I think you've kind of dovetailed between, like I said, doing these big-budget movies like *Transformers* and then doing these smaller projects. How do you finesse that? Is that the whole rule of "One for them, one for me"?

JD: Yeah, you definitely want to try to do commercial stuff and stuff for your own sort of creativity. And you have to be careful, because

one thing that I'm learning now—I'm starting to direct my first movie this summer starting in August—

AV: Nice.

JD: You learn quickly how they sort of gauge the value of certain actors. And you'll be like, "Well, he did this movie and that movie didn't do anything." It's like, well, you don't always do movies for the big box office. You do them because you want to do them, because you're an actor and you want to do something that gives you a chance to spread your wings. And I found out the hard way that, you know, sometimes that isn't working in your favor, even though I feel like I'm a better actor for it. It's all about the bottom line, right? And if the movies perform really well, it gives you value and it gives you, you know, it makes you more castable. I have no regrets about doing little movies like that. I really love it. I feel like it's given me a chance to do things that I got into this business to do in the first place—to try as many different things, tell as many different stories as I can. *Spaceman* is an example of that. It was just an opportunity to play a really outrageous character.

AV: Let's get to the vulnerable aspect of Josh Duhamel, when Ben Lyons sent me *Junketeers*, he said you're going to particularly love.

JD: I'm absolutely shameless, Adnan, shameless.

AV: Was it your idea to drop your pants and pleasure yourself in the final scene?

JD: It was written into this. It was written in. But I think I probably took it to a level nobody expected, just because I do stuff like that and then regret it later. And I was like, "We're not actually going to use that, right? That was just kidding around for you guys." And sure enough, they put it in.

AV: All guys do this!

JD: I'm not the only one! I'm not the only one!

AV: I hope at least one person has seen this, *Junketeers*.

JD: Of course, Ben Lyons would get me to do that. He just seems so innocent. He is a shark.

AV: Fresh-faced Ben Lyons.

JD: The baby-faced assassin is what he is.

AV: That's how he gets people... Last one for you. My wife Eamon is a huge fan. Not only a celebrity crush, but she also loved *Las Vegas*, your show with James Caan. You got a story for her about Jimmy Caan or that show in particular?

JD: Oh god, Jimmy Caan. He's...there's so many. He's such a great character. Still a friend of mine. You know he's...I'm just trying to think about what I can share on the radio.

AV: It's fine. Listen, we've already talked about *Junketeers*.

JD: Yeah, you know, he's like...he's like...god, I just remember I was telling him about...I was telling him that I was about to go on my first date with Fergie. He's like, "Oh man, she's hot. She's real hot. Here, let me give you a little piece of advice. Go work one out before the date. You can make it out what you want." I was like, "What? What was that? You want me to do what? That's your, like, advice? No thanks. No thanks." Sorry. Sorry back there. The producers are all cringing.

AV: No, they love it. We're keeping it for sure. Josh Duhamel, check out *Spaceman*. Check out *Misconduct*. Go watch *Transformers*. He's awesome.

JD: Thanks, buddy.

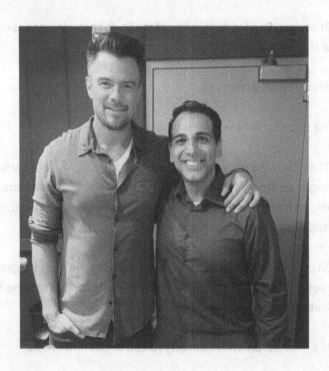

CHAPTER 22

John Ortiz: The Actor's Actor

December 20, 2023

I can't think of a higher compliment than to say that every time John Ortiz pops up on screen, I smile. He is naturally charismatic and no matter what the role this actor is in, he is reliably excellent. He's had a prolific career for decades and I think his work in *American Fiction* truly elevated that film, which was one of the best of 2023.

★ ★ ★

Adnan Virk (AV): Well, who says social media doesn't have at least one good thing going for it? I post how *American Fiction* is one of my favorite movies of the year, and then I get a lovely message from actor John Ortiz, who says, "Thanks so much, brother, I watch you all the time on MLB Network," and I thought, *This can't be the John Ortiz, who I love from* Carlito's Way *and his association with Philip Seymour Hoffman.* Thank you, first and foremost, this is your first podcast, John, this is great.

John Ortiz (JO): This is my first ever podcast, and I trust you wholeheartedly. Please handle with care. Yeah, I'm really psyched to be here. Thanks for having me.

AV: Alright, *American Fiction*. Brilliant. I have it my number four for my top ten movies of the year. I have it as the funniest comedy of

the year. It's the best satire I've seen in a long time. I think Jeffrey Wright is so great because he's one of those actors, every time you see him, this guy's great. And so, I see a lot of dramas, but to see him doing comedy, especially your scenes together. For those who don't know or haven't seen it, John plays the agent. And basically, the story is that Monk has written a novel, which nobody wants to read because it doesn't have the true Black stereotype. So, he writes one with Ebonics and the N-word, and single mom and drugs. And you, classic agent, call: "Hey, I got great news! We got 750 grand! It's not for the novel you care about. It's the one that is, you know, the trash novel, but whatever, it's all good." What inspiration did you take for that role? Are there agents you've known like that? Is there someone that you kind of drew on for inspiration?

JO: Yeah, a few. You know, I've met a few. So, you know, I grab a little here and a little there, and it kind of all adds up. But honestly, with this one, I didn't have a lot of time to do my research, which I love doing. I love, like, digging in and going through the weeds with the character, especially if they have, like, a job that I know nothing about. I actually played a horse racing trainer once, and I'd never been to the track. And once I found out how foreign the world was to me, I found the trainer that the character was based on, convinced him to let me work there. And I worked for a good couple of months, from four in the morning until ten every day, just to learn it. So, I love that stuff. But with this guy, luckily, I had some experience with agents, but I didn't have a lot of research, and we didn't have a lot of rehearsal time.

In fact, I knew Jeffrey from years ago back in New York doing theater, so I've known Jeffrey for over twenty years, so that was a blessing. But in terms of the script and going over the dialogue and that stuff, we didn't have time. And so, I leaned heavily on the personal connection between the agent and his client, and that's

something that, I've been with my agent for fifteen years, I've been with my manager for twenty-five years, and that's the intangible stuff. Because the bottom line business part of it, you kind of get— you just want to sell, you got to pay bills. That's not too hard to comprehend. But the other stuff is a little more nuanced. And it's really kind of what matters with why this agent is with this writer who doesn't sell any books.

AV: Let's talk about Philip Seymour Hoffman. He directed *Jack Goes Boating* and you won the Independent Spirit Award, which is phenomenal. That experience must have been so extraordinary. It was based on a play and is the only movie that Phil directed. I think, for many people that have seen it, they know that that's John Ortiz at his best.

JO: Oh, thank you. Yeah, that's when people ask me what's my favorite movie that I've worked on, that's usually at the top of the list. And it's because of not only Phil, but the whole trajectory of that film. Phil said to me, "I really love acting with you." And those characters were best friends, you know? And in fact, my character's married. I'm trying to hook him up with this mutual friend. And so, there's two love stories there, but then there's the third love story of just male friendship, and so it was really deep for us to pursue that. He didn't want to act in it, and it took a little convincing, but we ultimately convinced him to act and direct. But then he said, "Okay, I'll do it, but we need to add at least another week off of the schedule because I've never directed before and I'm going to be needing that extra time."

AV: He would direct a lot of plays, but I can imagine directing a film is much, much different. But that's partly why I admire guys like him, you, Ethan Hawke, Sam Rockwell. You guys are great actors, but you love doing the stage just for the art of it. I remember what Rockwell said about Phil after he passed, about how he could be

a little moody, and get a little grumpy sometimes. But Phil was such a committed actor. He really was an artist because he was so passionate.

JO: Yeah, yeah, yeah. I never met anyone who was so unrelenting and uncompromising when it came to the pursuit of truth, you know, and that's something that is easier said than done. But when it comes to being 100 percent committed to being honest when you're acting, especially in this business, when push comes to shove, it's really difficult and you kind of take whatever you can get. And it's just like, you know, the clock is ticking and it's like, "Alright, that's good enough." You know, with Phil, nothing was good enough but excellence. And he was, like I said, truly uncompromising when it came to it. And that's where Sam probably got the moody part from, because, you know, it ain't easy.

AV: I can keep you all day, but I'll get you a couple more. *Carlito's Way*. Great gangster movie. Pacino coming off the Oscar playing Carlito Brigante, Sean Penn unrecognizable as Davey Kleinfeld. He's so funny. What are your memories of working with a legend in Brian De Palma and a legend in Al Pacino?

JO: Oh, man, that was my feature film debut.

AV: Wow, didn't know that.

JO: It started there and then it all went downhill from there. (Laughs)

AV: Here you are, thirty years later, talking to me.

JO: I mean, I was like a kid in the candy store, as they say, I was so stoked. Pacino, De Palma, Sean Penn. And I was just, I felt so excited, so lucky to get that part. And I got a million stories about

it. I'll try to keep this one short, but it's not too short of a story. But it's my death scene. There's the pool hall, my final shot, right? You see the character and the final shot is a very complicated crane shot that starts with Pacino, Carlito Brigante, in the bathroom. And he's got the famous scene, "You think you big-time?" It starts tight on him with that. And then he kicks the door open. And you see in the background a body lying in a pool of blood. And that's me. And the camera pushes in on that. And he, as the camera almost discovers the body, pays his respect to his dying cousin.

Well, I was drinking coffee all day, and we shot at like eight o'clock at night. And the reason why I was drinking coffee all day is because I had prosthetics and I needed to, after working 'til eleven o'clock at night or midnight, be on set in less than six hours. So, I had like three, four hours of sleep so that they can put all this makeup on me. And that was happening for a good three days. So, this was the last, the third and final day of this schedule. I was twenty-three, I thought I could do it all, so I wasn't really taking care of my body the way I probably should have. I was relying a lot on caffeine to keep me up. And he also needed to be very energetic and he's the young, innocent guy, and the kid.

So, when it comes to that shot, as the camera is pulling in tight on me, and it's a super close-up of me, Brian De Palma would yell cut right before Pacino's final line, which is, "You said there were friends; there are no friends in this business, primo." And I would wonder why he was yelling cut so often before that line and found out that after the fourth time he said cut—and it's a complicated setup that would take a good fifteen, twenty minutes to do—was because my eyes were blinking as they were shut from the jittery nerves that I had from the coffee. Dude, so I couldn't keep them shut. And Pacino realized this after Brian De Palma told him, "You know what, we're going to alter the shot. I won't go down on him. I'll just stay tight on you. And you could just say the line." Because not

only was it getting late, but Pacino had to catch a flight to LA for the Oscars.

AV: Oh my god.

JO: It was the weekend before the Oscars. I'm lying on the pool and I'm not moving, I can't move. I'm in all this fake blood, right? So, I'm just lying there and I'm kind of really nervous. I'm like, *Man, this is my moment. I'm gonna be fired. They hate me. I suck, I can't keep my eyes shut. I'm just supposed to be playing dead and I can't even do that.* All those things. And that's not helping. But I'm very curious as to what other people are thinking and this is my first movie. And so, I heard that, and I'm just like, *Oh man*, it just killed me.

And Pacino says, "You know what? Just clear the set and give me five minutes." And De Palma's like, "What?" And he's like, "Yeah, just, I want everyone out of the room." And so, the whole crew leaves, and I'm just like, *I guess I should get up from the pool of blood I'm in*, and so I'm starting to move to get up. And he's like, "No, no, Johnny, stay, stay." And I'm like, "Okay, yeah, sure." And he's like, "Yeah, I just kind of had enough with these guys. I think I just need an espresso. I'm gonna order an espresso. Do you want an espresso?" I'm like, *It's the last thing I want, bro.* But it's Al Pacino offering me an espresso and it's just me. He's not offering an espresso to anyone else but me. I can't say no, so I'm like, "Yeah, sure, I'd love an espresso." So, he sends out everyone and that whole experience was like the most amazing thing. When he asked his assistant to bring him espresso, I thought, *It doesn't get cooler than that.*

So, five minutes later, an espresso comes! But I'm now thinking, *I hope he's not holding this all up for me, because he's got a flight to catch.* I'm worried about his itinerary to get to the Oscars,

John Ortiz: The Actor's Actor

but I'm trying to be cool because I'm having an espresso with Al Pacino, so I'm there, I'm just trying to fake it. I'm trying to suppress all of these crazy wild thoughts I have and trying to be cool with him. And I don't know what was said between us, but we had this espresso and he cleared it all up and he asked his assistant to bring the crew in and they all come in and we do the shot again. And the whole timing works out, the camera pushes in, and my internal clock knows when I'm going to hear Brian De Palma very angrily yell "Cut." And it's getting to that moment, it's getting to that moment, and it's real quiet and it doesn't happen. And it continues and we push past that moment, and I hear Al Pacino breathe and then he utters those lines and then he does something with my face, but there's some contact there and I'm like, *Holy shit, this is happening, but don't get too excited and blink your eyes right now.* And they yell "Cut" and De Palma says, "We got it," and everyone applauds. The last thing I'll say is, I'm still lying there and everyone is wishing him luck for the Oscars. I see him in the distance as he's leaving the room and I'm still lying down when he turns around as he's walking out the door.

AV: This sounds like a scene from *Field of Dreams*. Like, literally Ray Liotta is walking off and he goes, "Hey rookie, you were good." He says it to Moonlight Graham as Burt Lancaster.

JO: (Chuckles) Yeah. Well, he's almost out the door. He turns around and he tells everyone, "If I win 'em both, I ain't coming back!" And he just leaves and I was like, *That guy is the coolest human being in the history of the planet.*

AV: Because of course he was nominated for Best Actor but also supporting actor for *Glengarry Glen Ross*.

JO: Actually, was it *Dick Tracy*?

AV: No, *Dick Tracy* was the year before. The double nominee was *Glengarry*.

JO: Yeah, I'm impressed, man. You know your movies. Well, I saw that post on social media and I've known you from the sports world and I'm a huge sports geek. And then I thought—because I have actor friends and movie friends that don't quite know about *American Fiction* yet, it's a relatively small film. And so, when I saw that you saw it, I was like, *Oh wow, this guy is a real deal movie guy*. You know, I was super impressed. So, it shouldn't surprise me your knowledge of Mr. Pacino.

AV: The baseball stuff I've established for twenty plus years, the movie credentials, John, if you can know that...it's funny, I remember *Entertainment Weekly* had a cover after, it said "Pacino's Way" when *Carlito's Way* came out that fall. And they said when he won the Oscar, he got a standing ovation on the set when he came back. So, all those memories are fresh.

JO: Yeah, yeah, yeah. I actually was there. I wasn't scheduled to work, but I went to the set that day. It was a night shoot.

AV: It was raining and stuff.

JO: Yeah, yeah, it was raining. They had rain machines, and there was this bar I used to hang out at and it was a couple blocks from the set, and I walked over there, and so I was there. And what was cool is that I didn't infiltrate the center of it all. But he saw me across from the street and it was so cool. He actually waved at me and said, "Hey, Johnny," and I was like, "Hey, congratulations."

AV: But I'm 100 percent with you, you couldn't have turned that down. You either risk the ire of Brian De Palma or say no to Al

Pacino. I'll just have to risk it. De Palma fires me, that's fine. I'm not gonna say no to Al Pacino.

JO: Yeah, of course.

AV: *American Fiction* is in theaters right now. John Ortiz. This was awesome, man. I can't thank you enough. This was great.

JO: Yeah, I had a great time. Thank you. And I look forward to seeing you on the diamond one day or back here and talking about some more movies with you.

CHAPTER 23

Scorsese Stories: Il Maestro

He was born an asthmatic kid November 17, 1942 in Queens, grew up in New York's Little Italy, and became one of the finest directors in the history of motion pictures. Martin Scorsese grew up devouring films as a child, as his parents were fearful of letting him out on the mean streets because of his illness. In his apartment, and in movie theaters, the world's most famous cinephile was born. Most directors love movies, but no one is the definitive artist on motion pictures quite like Marty, who can rattle off references to the films that have inspired him without hesitation. It's one thing to entertain and educate audiences all these years, but Scorsese has also devoted his life to film preservation and teaching others about his cinematic heroes, keeping their legacy alive for generations to come. Powell and Pressburger (film production company), John Ford (film director), Federico Fellini (film director and screenwriter), John Cassavetes (filmmaker and actor), Akira Kurosawa (filmmaker)—Marty is indebted to them all, and with humility, always makes sure to praise them well ahead of his own work.

Scorsese was once quoted as saying, "I splatter bits of myself all over the screen." We're still ducking. There's never been a director more fascinated about the mechanics of sin or humanity's search for redemption. Whether it's a gangster picture or one of his religious epics, Scorsese never shies away from viewing humanity at its darkest and most violent, and yet, he isn't a nihilist. His movies probe through the seedy underbelly to find the humanity buried underneath.

I've seen every one of his twenty-six feature films and even the less-than-stellar ones have redeemable qualities, much like the characters in any of his films.

Who's That Knocking at My Door (1967)

The feature film that kicked it all off. Props to film critic Roger Ebert who gave it three stars and recognized the talent within. It's an excellent companion piece to Mean Streets and we see the early archetypes of Marty's movies: street violence and a Catholic male battling his guilt complex.

Boxcar Bertha (1972)

Arguably Scorsese's worst film, since it's rough around the edges and doesn't feel impassioned like so many of his other works, but an important movie nonetheless. Under the legendary B movie champion Roger Corman, Marty learned how to work fast and work cheap. An exploitation picture, it stars Barbara Hershey and Barry Primus, and true to Marty's Catholic roots, features a memorable crucifixion.

Mean Streets (1973)

For many people, this is Martin Scorsese's first film. It begins with a bang thanks to The Ronettes's "Be My Baby" and has had a lasting imprint on anyone who has seen it. Mean Streets was voted as the greatest independent film of all time, and for good reason. This is the classic often imitated but never duplicated, as it spawned so many wannabe facsimiles. Harvey Keitel is Marty's proxy, trying to make the morally correct choice but being dragged down by his buddy Johnny Boy, unforgettably captured by Robert De Niro in a star-making performance. It's a rarity to see De Niro play such a thoroughly daft guy, but he's undeniably charming before he

snaps like a method-trained pit bull. The scene of Keitel and De Niro talking in the back of the bar is one of many wondrous scenes of improvisation, and indeed, the entire film has a documentary vibe (no surprise, as Scorsese has often dabbled in docs, especially on musical subjects from The Band to Bob Dylan and The Rolling Stones). This slice of Italian American life is hysterical (the entire pool hall scene when a character gets called a mook set to The Marvelettes's "Please Mr. Postman"), and harrowing in the movie's finale with Scorsese giving himself the key cameo as the gunman who attempts to take out Charlie and Johnny Boy.

Alice Doesn't Live Here Anymore (1974)

Scorsese, like a stock portfolio, was looking to diversify after showcasing the bruising machismo of Mean Streets. So, he found a woman's picture, and famously told Ellen Burstyn before working together, "I don't know anything about women." Clearly, Marty's gift for bringing out the best in actors is what mattered most as he guided Burstyn to an Academy Award for Best Actress, playing a working single mom trying to navigate her precocious son and a romance with that bearded hunk Kris Kristofferson.

Taxi Driver (1976)

The poster is one of my all-time favorites: a downcast Robert De Niro wearing his military jacket and jeans and behind him is a New York City street scene. The tagline says it all: "On every street in every city in this country, there's a nobody who dreams of being a somebody."

Taxi Driver is the definitive film about loneliness and urban alienation. The movie was born from the fevered imagination of depressed screenwriter Paul Schrader, who wrote the entire script in ten days. It sprung out of him like an animal unleashed, and the

script immediately connected with De Niro, coming off an Oscar win for Best Supporting Actor for *The Godfather Part II*. Brian De Palma was offered the film by Schrader but recommended his good friend Marty, who also felt a kinship with the script, and the result still has lasting power today. Quentin Tarantino said in his insightful book *Cinema Speculation* that *Taxi Driver* is a top three movie for him and it has inspired countless others.

For such a bleak and unrelenting film featuring a memorable score from Hitchcock's longtime composer Bernard Herrmann, there is still an impishness in the scenes between De Niro and the object of his affection, Cybill Shepherd—not to mention the always amusing presence of Albert Brooks, playing Cybill's colleague. Brooks said years later, "Schrader thanked me for the way I played the character and said, 'You're the only one I couldn't figure out.' And I'm thinking, you couldn't write about the hardworking guy working for a political campaign but you had no issue writing a homicidal cab driver or a pimp named Sport?" I relayed that anecdote to Paul Schrader when I interviewed him for *Cinephile* while promoting his film *First Reformed*, and Schrader laughed and said, "That's absolutely true."

The scene of De Niro staring at his reflection in the mirror, repeating, "Ya talkin' to me?" was ad-libbed from a comedian he had seen, but as film critic Roger Ebert astutely pointed out, the key line is what Travis Bickle says after that: "Well, I'm the only one here."

Scorsese's movie-infused brain results in some clever homages, including a shot of Travis staring at the Alka-Seltzer bubbling in his glass, which is a nod to an image from a Jean-Luc Godard film, one of his many cinematic heroes.

Scorsese's favorite shot of the film is when Travis makes a call to Betsy after the horrific first date. It's a static shot and eventually the camera pans away and stays there, focused on an empty hallway. Marty explained the decision making by saying that we can't bear to see Travis getting his heart broken, it's too painful, so the camera has to look somewhere else. It was the final scene that they shot.

The blood-soaked finale also received a glut of notoriety when Travis inexorably acts as a vigilante, taking matters into his own hands to save fifteen-year-old Jodie Foster playing a thirteen-year-old prostitute under the thumb of her pimp, played by Harvey Keitel. The final moments are steeped in irony as Travis is still driving his cab but is now viewed as a hero rather than a villain for saving Iris and returning her to her parents. He picks up Betsy in his cab and they share a moment. Is it all a dream? Is it reality? Does it even matter?

Every time I watch *Taxi Driver*, I'm amused by something new. For example, the last time I watched the movie, I laughed when Travis, while talking to a member of the Secret Service, gives a fake name of Henry Krinkle and says he lives in Fair Lawn, New Jersey, which is very close to where I currently reside.

I saw *Taxi Driver* at the forty-fifth anniversary showing at the Beacon Theatre in New York City, meeting Paul Schrader outside the venue and then enjoying the stories told by Scorsese, De Niro, Keitel, and Cybill Shepherd. The film has lost none of its power to shock and awe, especially in a theatrical setting if you have the opportunity. Speaking of shock, the principals involved are still shocked by the resonance of the picture, convinced the movie wouldn't make any money and they were simply making this project for themselves. Scorsese couldn't believe when he got the

call from a pay phone that the line was around the block after the first week to see this quintessential New York film.

Was it a box office smash like *Jaws*? Of course not. But the movie made money and the principals were all incredulous about turning a profit. In addition to the cash, *Taxi Driver* received excellent reviews and four Academy Award nominations for Best Picture, De Niro and Foster for Best Actor and Best Supporting Actress respectively, and Herrmann, nominated posthumously.

One final note: in this age of Hollywood remaking everything, I'm fully confident no one will ever touch this brilliance. Imagine the pitch meeting: "So, this lonely cab driver takes this girl out to a porn theater..."

New York, New York (1977)

Seeking to showcase his versatility again, Scorsese stepped out of the gritty New York milieu for this throwback to the MGM musicals he adored as a kid. Robert De Niro and Liza Minnelli star as a saxophonist and singer who fall in love but then endure considerable strife before breaking things off. The tumultuous relationship was matched by the tumult off set as the movie ballooned over budget and over schedule before landing with a resounding thud in movie theaters. It's one thing for the movie to not make money, but it's the first time a Scorsese movie actually received scathing reviews. And yet, there's a faction of people like myself who enjoyed the movie, even acknowledging its flaws. Yes, it's overlong and unfocused, as Scorsese relied too heavily on the improvisations which he was so famous for on *Mean Streets*, but the musical numbers carried by Minnelli are fabulous, as are the lavish production design and costumes.

Scorsese was trying to meld the artificial, fantastical backdrop with his own gritty sensibilities and the method acting of De Niro. The result doesn't always work, but there are still some marvelous scenes, including a vicious fight between the two leads in a car and a heartbreaking scene in the hospital when De Niro's character Jimmy admits he just can't be a father and walks out. Film critic Carrie Rickey, on the film's commentary, also advocates for the movie being ahead of its time in showcasing working relationships between artists and women increasingly being self-reliant as performers and mothers. I loved the open-ended finale as the two hint at a potential reconciliation, but that type of happy ending only happens in a Vincente Minnelli musical, not in one starring his daughter (who later married her esteemed director). No one can quibble whatsoever with Frank Sinatra taking the title track and turning into an all-time banger for one of the finest cities in the world.

Raging Bull (1980)

So gimme a stage, where this bull here can rage.

And though I can fight, I'd much rather recite.

That's entertainment. That's entertainment.

So begins Marty's masterpiece, voted by critics as the best film of the '80s and routinely found on lists of the top ten movies of all time. Robert De Niro gives the performance of his career as the dyspeptic boxer Jake LaMotta, former heavyweight champion turned fat failure.

De Niro brought the project to Scorsese while he was hospitalized after too much cocaine had wracked Marty's body and soul. Marty had resisted Bob's previous overtures to make the picture,

Scorsese Stories: Il Maestro

using legitimate reasoning like he wasn't a sports fan and thus couldn't relate to a boxer and his challenges. But now, at wit's end, Scorsese found his way into LaMotta's story, and it was the self-destructiveness with which he could identify.

Once he was healthy and drug-free, the director threw himself into the project, analyzing LaMotta's fights and finding new ways to shoot those wonderfully captured scenes. In so doing, he created a new type of film grammar, as those twelves minutes of boxing scenes have been dissected by movie geeks and filmmakers, even in unlikely scenarios. The final battle between Robinson and LaMotta, with blood splashing onto spectators' faces and De Niro's bloody face as he taunts Robinson ("You never got me down, Ray") is particularly compelling. Scott Hicks, the director of the 1996 indie breakthrough *Shine*, describes a scene where Geoffrey Rush, the protagonist, suffers a breakdown as being directly influenced by *Raging Bull*.

Scorsese's key point of emphasis was unlike other boxing pictures; he demanded that the camera stay in the ring, giving the scenes a real feeling of German expressionism. Imagine *Nosferatu* director F. W. Murnau directing LaMotta and Sugar Ray Robinson with the brilliant use of slow-motion followed by the speeding up of the camera, smoke flowing, and, most ingenious, the use of animal sounds, including elephants, when LaMotta endures the beating of his life. Michael Chapman was the cinematographer on the picture and openly praised Scorsese's storyboards for their detail and clearly communicated visual expression.

So much of a boxing biopic, you think, would be about the beatings that LaMotta dished out and was the recipient of. But it's also about the blows this masochistic boxer inflicted on his first wife, and most distressingly, his teenage wife, played by the smoky-voiced newcomer Cathy Moriarty as Vikki. Vikki takes Jake's abuse

because she loves him until finally, in one horrifying sequence, he breaks down their bathroom door, wallops his loyal brother Joey, played by Joe Pesci, and then comes back and with one punch, knocks out his wife.

The original script was penned by Scorsese's college friend Mardik Martin, with whom he wrote his semi-autobiographical film *Mean Streets*. But Martin's script followed too conventional a path, so in came Paul Schrader. Schrader made the discovery that LaMotta had a brother and made the relationship between Jake and Joey the heart of the story (one incredible scene in which Jake asks Joey if he slept with Vikki and is unrelenting in his line of questioning was cited hilariously in Christopher Guest's brilliant comedy *Waiting for Guffman*).

Scorsese and De Niro went to the island of St. Maarten and worked on the script some more, adding a lot of Italian American authenticity to it. One of the funniest lines of the movie is an ad-lib from De Niro developed through this work: he tells his first wife, making his steak, "Don't overcook it. You overcook it, it defeats its own purpose."

De Niro vouched for Pesci and the movie put him on the map, and for good reason. Joey also takes the abuse from Jake but is willing to punch back, whether criticizing his older brother for his weight gain or imploring him to take a dive from his mob boss friends, including Nicholas Colasanto (Coach from the sitcom *Cheers*), because that's the only way he's going to get his title shot.

But really, this is De Niro's show. Bob won the Academy Award for Best Actor and his performance is routinely cited as one of the finest ever, and that's not hyperbolic. He trained with LaMotta, with the former boxer impressed with his pupil's legitimate boxing skills. Later to play the heavy version of the character, the

crew shut filming down while De Niro put on a staggering sixty pounds, loading up on pasta and carbs and eating his way through Italy and France. De Niro went from 145 to 205 pounds, and he felt the difference both physically in his labored breathing and psychologically as everything *felt* so much heavier. It's this level of commitment which has inspired so many other actors to gain or lose weight, like Christian Bale did in *The Machinist*. The practice has become de rigueur, but De Niro really was the progenitor in this regard.

LaMotta conflates sex and violence, even snidely saying about his good-looking opponent Tony Janiro, "I don't know whether to fuck him or fight him," later adding, "I'm going to open up his hole like this." LaMotta is the type of person who threatens a neighbor, "You're gonna find your dog dead in a hallway."

Yet somehow, Scorsese and De Niro find the humanity inside such a cretin and allow him the shot at redemption in the haunting final scene. Vikki has left and now he's a glorified lounge act, quoting Shakespeare and telling bad jokes in dive bars, but he's found a level of contentment. And the scene of a man staring at his own reflection in the mirror works on multiple levels: it's an actor Robert De Niro playing a boxer Jake LaMotta reciting a speech by Marlon Brando, who played a boxer Terry Malloy in Elia Kazan's highly influential *On the Waterfront* (a Scorsese and De Niro favorite). The movie finishes where it started, but now we've experienced this story of a man in full.

Scorsese used all those girl groups in *Mean Streets*, but this time, the soundtrack is dominated by the gorgeous music of *Cavalleria Rusticana*: "Intermezzo" by composer Pietro Mascagni. The opening titles, set to Mascagni's soaring music, matched with De Niro shadow boxing in slow-motion, is poetry in motion. Many years later, in the greatest show of all time, *The Sopranos*, Tony and his

consigliere pretend to throw punches in slow-motion when the song comes on in the restaurant where they're eating. Scorsese's good friend, Francis Ford Coppola, later used the same music in *The Godfather Part III*, but it still hits harder in this boxing biopic rather than during the death of Michael Corleone.

Redemption comes to us all, even those of us who don't seem worthy. It's the Catholic in Scorsese that sees this viewpoint come to fruition. *Raging Bull* was nominated for eight Academy Awards, winning two for De Niro's tour de force transformation and Thelma Schoonmaker's editing, although she was quick to say Scorsese deserved the Oscar as much as she did, as he was in the editing room with her the entire way. This movie also marked the beginning of their invaluable relationship which has continued to this day. Of any Scorsese film, it's the closest I can say to a movie being a genuine work of art. All these years later, I've seen *Raging Bull* a dozen times, and still, this picture knocks me out.

The King of Comedy (1983)

This was another De Niro star vehicle that Bob brought to Scorsese's attention. You can see the appeal for both actor and star after the critical acclaim that was lavished upon them for their previous collaboration three years earlier. Now, they could appreciate what it meant to be true celebrities and have stalkers fixated on their every move. But Scorsese's first Oscar nomination for directing, which came for *Raging Bull*, was not to be repeated for this dark comedy, which *Entertainment Tonight* called one of the biggest bombs of the year (Marty heard that on television while he was heading out to a New Year's Eve party with his good friend, screenwriter and former film critic Jay Cocks). But the movie has grown in stature over the years, especially among those in the comedic world, and Scorsese himself thinks it's one of his leading man's top performances.

Written by Paul Zimmerman, De Niro stars as Rupert Pupkin, a wannabe stand-up comic who plies his trade in his mother's basement (played hysterically, voice only, by Scorsese's own mother Catherine). The "P" in Pupkin stands for persistence, as he's obsessed with appearing on the late night talk show *The Jerry Langford Show*, hosted by comic great Jerry Lewis. It's a rare dramatic role for the nutty professor, but Lewis is excellent at showing the world the weary frustrations and stress of someone in such a high-profile role.

Pupkin goes to the Langford offices and attempts to give his material to Langford's staff. They kindly accept the tape but don't realize that Pupkin wants to wait until Jerry listens and agrees to have him on the show. Pupkin is delusional, as the movie intersperses fantasies he has, laughing and trading witty repartee with Jerry. Eventually, Pupkin travels with his friend Rita to Jerry's house, convinced that they're friends and Jerry will be happy to see him. Langford arrives home after golfing and with seething, slow-burning rage, tells Rupert he could have him arrested for trespassing. It's at this point that Pupkin turns from idolizing his hero to a decidedly different feeling toward him.

Pupkin hatches his master plan with the similarly obsessed Masha, played by Sandra Bernhard, to kidnap Langford so he can host his show for one night. With his moppish hair, moustache, and risible Vegas-style jacket, Pupkin hardly looks like a conventional, successful talk show host, but lo and behold, his act kills.

He goes to prison but becomes a star, writes a bestselling book, and achieves the celebrity he has so cravenly been seeking. Is the final denouement reality or another one of Pupkin's delusions? The audience is left to be the judge, but what's most resonant is how Pupkin triumphantly closes his set with his life motto: "Better to be king for a night than a schmuck for a lifetime."

Scorsese to this point was known for his restless, roaming camera, but this time he shot the film like a television show, with a lot of static shots which won't look away from the increasing cringe factor. Who knows why audiences didn't find the movie more appealing in 1983, but *The King of Comedy* is a darkly hilarious look at fame and celebrity culture.

After Hours (1985)

Scorsese's long-gestating passion project, an adaptation of Nikos Kazantzakis's *The Last Temptation of Christ*, fell apart at the eleventh hour and the director was crushed. He was in need of a new project, something he could shoot quick and dirty to reestablish himself. The result was this adaptation of a Joseph Minion script, produced by and starring Griffin Dunne. The result was another dark comedy, this time set during one long miserable night in SoHo. The movie did exactly what Marty needed it to and the result is an energetic and amusing stop in Scorsese Land—New York City at night. The camera is at its trademark restless and roaming self, from the very first careening shot to some inventive camerawork when a key is sent down to Dunne's protagonist. All that, plus a cameo from Cheech & Chong. It's not a personal favorite of mine and I'm surprised it won the Palme d'Or at Cannes, but perhaps it was a weak year or maybe the auteur was justly receiving his due for continued excellence.

The Color of Money (1986)

Paul Newman was robbed of an Oscar for his finely-calibrated performance as an alcoholic lawyer in the David Mamet-scripted and Sidney Lumet-directed courtroom drama *The Verdict*, one of the finest Boston movies ever made. Newman lost the Oscar to Ben Kingsley for *Gandhi* but finally was the recipient of a long

overdue Oscar for Best Actor for this Scorsese-directed sequel to *The Hustler*.

It's one of Scorsese's least inspired and most conventional films. Normally, his movies feel ripped from his soul, whereas this felt like a clearly commercial project starring two Hollywood stars in Newman and Tom Cruise, playing a hotheaded young upstart. There are some entertaining scenes energetically directed by Scorsese set in the smoky pool halls, but ultimately it's not a movie at all representative of the Scorsese oeuvre. It is meretricious and not worthy of its maker.

The Last Temptation of Christ (1988)

This was a film that Scorsese had been building for years. Earlier, the project was scrapped, but after his newfound commercial currency following *The Color of Money*, he had enough clout to get this picture made, albeit still on a shoestring budget. The altar boy who once dreamed of being a priest and then found his calling as the patron saint of cinema made a unique and original film about Jesus Christ, starring Willem Dafoe. The movie is scattershot at times and Harvey Keitel seems miscast as Judas, but there's no denying the passion of Scorsese's film, and the movie feels excavated from his deeply Catholic soul. The Peter Gabriel score also sends the movie soaring, and there are sequences, like Jesus being visited by the Holy Ghost, that stay with you. The movie was marred by controversy and Scorsese received death threats for the final passage of the film, in which Jesus, while on the cross, imagines what his life would be like as a regular man, sleeping with Mary Magdalene and having a child, before he accepts his fate and says the movie's final words: "It is accomplished." Regardless of one's religious beliefs, there's no doubt even getting this movie made was a genuine accomplishment by Scorsese, and the

Academy rewarded his grit, determination, and chutzpah with an Academy Award nomination, just his second, for Best Director.

GoodFellas (1990)

Raging Bull began the '80s with a bang, and so too did *GoodFellas* to open the '90s. Perhaps Scorsese's most popular film, it's a masterpiece from start to finish. The movie was cowritten by Marty with author Nicholas Pileggi, an adaptation of his novel *Wiseguy*, a memoir from mobster Henry Hill on his three decades of life in the Mafia. Henry was part Irish, part Italian and thus could never be a made guy, but Pileggi writes accurately about having dealt with so many self-absorbed mobsters over the years that Hill was sui generis in that he was "all eyes." Henry was incredibly observant about the people and places he inhabited and that's why the book had such a ring of authenticity to it.

For Scorsese, the opening passages feel almost autobiographical. Growing up in New York's Little Italy, afflicted with asthma so he couldn't leave the house, the image of a young Henry Hill observing the mobsters on the street down below serves as a proxy for young Marty. This early section of the film was shot by uncredited cinematographer Barry Sonnenfeld, who also lensed *When Harry Met Sally*, *Big Trouble*, and the Coen brothers' early efforts like *Blood Simple* and *Raising Arizona*. (Sonnenfeld has since become an accomplished director in his own right with films like the *Men in Black* trilogy and *Get Shorty*.)

The pacing is electric and hypnotic as you're immersed in the world of Henry Hill and all the allure that a life in the mob represents. The soundtrack was an instant classic, with wonderful, melodic songs of the '50s, '60s, and '70s, handpicked by Scorsese himself, recollecting what doo-wop jam was blaring out of the jukebox on any given night.

As for the cast, they are uniformly superb. Ray Liotta gives the performance of his career as the lead character, all eyes, as he takes us into this entrancing underworld. Joe Pesci won an Academy Award for Best Supporting Actor as the hair-trigger Tommy DeVito (yes, the same name as the onetime New York Giants quarterback). Pesci had shown his comic range alongside Daniel Stern in the Macaulay Culkin-starring *Home Alone*, but this time, he truly demonstrated killer comedic timing. The scene where seemingly a compliment from Henry ("You're really funny, you know that?"), turns into a deadly serious explosion from Pesci may have won him the Oscar on its own merit, and the scene was based on a story Pesci himself had heard from a friend of a friend (and yes, a made guy).

Scorsese's favorite, Robert De Niro, gets a glorious role as Jimmy "The Gent" Conway, who also could never be a made guy on account of the fact he's half-Irish, but Jimmy is the big brother to both Pesci and Liotta. The scene where De Niro contemplates whacking Morrie, an annoying blabbermouth played by De Niro's real-life landlord Chuck Low, is set to Cream's "Sunshine of Your Love," and as Marty shoots a menacing De Niro, smoking in slow-motion, the uneasy mix of allure and fear is conjured up once again. Paul Sorvino is the mob boss in charge of these ruffians and his presence alone tells us that Paulie is not to be trifled with. He's a father figure to Henry until he finds out the young man has been involved in drug dealing, a no-no in Paulie's world, and eventually their relationship sours terribly.

And not to be discounted among all this testosterone is Lorraine Bracco's remarkable turn as Karen, Henry's Jewish wife, who much like the audience is swept off her feet into this world only to be put through the ringer and all of the emotional upheaval that it entails. The famed Copa shot, when Henry takes Karen to a comedy club but does so through a back entrance, is set to the classic song

"Then He Kissed Me" by The Crystals. Henry is showing off to Karen as he says hello to all the people working that he knows on a first-name basis, but it's also Scorsese showing off as well, a flamboyant answer to his good friend Brian De Palma who also had made a name for himself with elaborate tracking shots. It's one of the most famous shots in the Scorsese canon, and full credit and intrepidity goes to the entire team, including German cinematographer Michael Ballhaus.

It's all fun and games, robbing and hijacking at will, until Billy Batts enters the picture. Frank Vincent, who also played a mobster in *Raging Bull*, this time makes the mistake of insulting Tommy when he sees him at a bar with Henry and Jimmy. He calls him "Spitshine Tommy," a sobriquet for Tommy that harkens back to when he used to shine shoes. Scorsese slowly dollies in on each character, building the tension, until finally, Tommy explodes. Later that night, with Henry and Jimmy's help, they kill Batts and bury him, but the sins of the past will catch up to at least one of those characters.

Another memorable couple of scenes involved future *The Sopranos* cast member Michael Imperioli. Michael told me when I interviewed him for *Cinephile* that Marty and Bob made him feel so comfortable on set and encouraged the ad-libbing of his character Spider, who again makes the grave mistake after being insulted by Tommy of firing back a riposte of his own.

While *Taxi Driver* was born out of Paul Schrader's fevered imagination, and *Raging Bull* was a project that De Niro cared passionately about, *GoodFellas* is clearly Scorsese's show. It's a showcase for his marvelous gifts as a filmmaker as he makes the life of a mobster so alluring and entrancing and then absolutely harrowing. The aftermath of the Lufthansa heist, as bodies start popping up everywhere, including Frankie Carbone in a meat

locker, show the gruesome likelihood of either ending up in the can or winding up dead.

Particularly potent as a cautionary tale against a life of crime is the entire sequence when Henry Hill's drug-addled brain, poisoned by paranoia, is convinced that helicopters are following him (despite those around him thinking he's nuts, he's right). Again, it's Scorsese's mix of music, impactful camera moves, and editing that makes the entire sequence feel like one of breathless anticipation of what's about to happen next—and that's when Lois needs her lucky hat to fly. Eventually, Henry runs out of options. He's served time in the can, where mobsters are actually treated like royalty, eating savory meals every night, including one character slicing garlic with a razor blade. But the drug charge is too much to overcome, so he rats out Paulie and Jimmy, convinced they would kill him until he's left with no other recourse. The movie ends with Henry lamenting he wants authentic Italian food but is stuck with egg noodles and ketchup. One of the final shots of Joe Pesci firing away at the camera is a wonderful homage to the early film classic *The Great Train Robbery*.

GoodFellas was nominated for six Academy Awards, but once again, Scorsese was upset for the Best Director prize in favor of a well-liked actor turned upstart director. In 1980, golden-haired Robert Redford beat Scorsese and *Ordinary People* won Best Picture over *Raging Bull*. History repeated ten years later as Marty's gangster epic, which some had said was even better than Francis Ford Coppola's universally lauded *The Godfather*, instead lost both Best Director to another actor turned upstart director, Kevin Costner, and Best Picture to Costner's well-intentioned revisionist Western *Dances with Wolves*.

Regardless of the Academy not celebrating the picture, the proof is in the pudding. There are countless directors who have cited

GoodFellas as an influence. It was the movie that made me think to myself, at the age of twelve, that maybe I could make a career as a director as well. Such is the power of this film that it can inspire anyone who sees it with the rich power and imagination of this most unique art form.

Cape Fear (1991)

How's this for an all-time trade and an all-time "what if" in the Hollywood annals? Scorsese and Steven Spielberg, longtime pals, agreed to swap scripts. Marty gave Steven *Schindler's List* (imagine Ralph Fiennes's dastardly Nazi being the focus of the film rather than the conflicted Oskar Schindler, given Scorsese's proclivity for focusing on the villain in his stories), while Scorsese received *Cape Fear* in return. Marty was a fan of the 1962 original, and in a lovely homage in his remake nearly thirty years later, cast the villainous Robert Mitchum, who was one of his favorite actors, as a cop, and the righteous and heroic Gregory Peck this time as a defense attorney representing the nemesis of the picture, Max Cady.

This was Scorsese's attempt to make a true popcorn picture, and for years it was his most commercially successful effort, grossing around $75 million, a strong performance for its time. Despite all the critical hosannas that came his way for *GoodFellas*, the movie wasn't profitable on its $40 million budget theatrically (despite finding a huge following on video), so once again, a genuine hit like *Cape Fear* proved Scorsese's bankability and helped him gain funding for his future passion projects. And yet, even in the world of making a so-called genre picture, Scorsese still found ways to subvert the genre, muddy the waters, and inject his own personal themes into the project.

The script, adapted by Wesley Strick, is about a lawyer named Sam Bowden, played by Nick Nolte, who is trying to outrun his sins of the past until Max Cady breezes back into town. The opening titles by the noted Elaine and Saul Bass and ominous score set the tone immediately. Cady, in a performance by Robert De Niro that is most reminiscent of *The Terminator*, first shows up smoking a giant cigar and laughing uproariously and obnoxiously in a movie theater while watching John Ritter's *Problem Child*, annoying Bowden and his family who prematurely leave the movie. Cady, with his Hawaiian shirts and greasy long hair, insidiously taunts Bowden and makes it clear that vengeance will be his. Bowden was his lawyer, but Cady is convinced, and he's right, that Bowden didn't defend his client to the best of his abilities. Cady was convicted of rape and Bowden buried evidence that made it seem that the victim was promiscuous. Again, while the original film is much more black-and-white, here Scorsese presents a morally compromised protagonist. Added to that are problems in Bowden's marriage to his wife Lee, played by Oscar winner Jessica Lange. Sam had an affair with one of his colleagues, played by Illeana Douglas, who Cady targets in one of the more vicious scenes of sexual assault and violence ever witnessed in a Scorsese film. Cady may be a piece of shit, but he's cunning and viciously single-minded in his pursuit of revenge by making Bowden pay for the sins of the past.

De Niro threw himself into the role, visiting with inmates of prisons in the Deep South, specifically talking with rapists and recording their audio so he could mimic their voice patterns and understand the psychology of their thinking. He discovered the primary obsession they shared was one of control over their victims. Scorsese marveled at Bob's dedication to the role, remarking that his favorite leading man would awake at three or four in the morning just to lift weights and appear as chiseled and intimidating as possible. One of my favorite scenes of the film is when Cady first strips down for Bowden and Mitchum's cop, a two-

way mirror supposedly ensuring that the latter two won't be seen. Both men are transfixed by the biblical quotations tattooed all over Cady's body, which leads to the best line of the movie, deadpanned by Mitchum: "I don't know whether to look at him or read him."

It's one matter for Cady to taunt Bowden by perhaps poisoning his dog or raping his colleague and former lover, but he truly makes things personal when he targets Bowden's daughter. The victim in the prison charge he served for rape was sixteen, as is Danielle Bowden, played by Juliette Lewis. She nails the precise rhythms of a girl of that age, and how she'd be seduced by someone like Cady, especially in the cringeworthy scene where he pretends to be her drama teacher and the encounter climaxes, if one can use such an expression, when she sucks on his thumb. The gesture was an ad-lib from De Niro and made many an audience member wince as the reptilian Cady grins with knowing success.

The final third of the film is where Scorsese really amps up the razzle-dazzle when hero and foe fight on a boat in the middle of a monsoon. The movie veers into self-parody, as when Lewis throws a pot of boiling water in Cady's face, and surprised, he remarks, "Are you offering me something hot?"

I found this part of the picture the least successful part of the movie, because this is where the movie feels the most conventional, albeit still loopy, as when Cady puts Bowden on the mock stand and makes comments directly to the camera as if he's speaking to a jury. Finally, Cady is vanquished as Bowden acts with primal rage, but even as Cady drowns to his final breath, he does so speaking in tongues, as Scorsese can't resist even more religious overtones.

Cape Fear is a solid thriller, and at times exceeds the genre, especially in the performances of De Niro and Lewis, who both

received Oscar nominations for Best Actor and Supporting Actress, respectively. Also of note is the hilarious parody of the movie that the Simpsons pulled off, with Sideshow Bob, voiced by Kelsey Grammer, playing the role of Max Cady.

The Age of Innocence (1993)

Scorsese's good friend Jay Cocks told him years ago, upon gifting him a copy of Edith Wharton's *The Age of Innocence*, "When you're ready to make your costume drama period piece, Marty, this is the one you need to make. This is you." It's an achingly romantic and emotionally devastating adaptation of unrequited love.

Daniel Day-Lewis, the only three-time winner of the Academy Award for Best Actor, stars as Newland Archer, engaged to be married to the pretty and polite May, played by Winona Ryder. However, Newland is smitten once he meets May's cousin, the Countess Ellen Olenska. There's a cloud of controversy around the Countess, having emerged from an unfortunate separation from her husband.

This is not a love at first sight situation. Indeed, much as Scorsese allowed his camera to roam almost as a character in the film *GoodFellas*, the first hour of *The Age of Innocence* feels like one of his documentaries, as the narrator voiced by Joanne Woodward explains the social protocols and customs of New York City in the 1870s. Slowly, Newland finds himself falling for Ellen, and despite her initial protestations, and conflicted though she may be, she reciprocates his feelings. But everything in this society is repressed and kept close to the vest. Indeed, when Newland takes off Ellen's glove in a horse-drawn carriage, it feels like the most erotic scene ever, since emotions have been kept so strictly at bay. The most we see, physically speaking, between these two lovers is passionate kissing, which for this time would constitute an X-rated film.

Eventually, the passion builds and it feels inevitable that Newland will leave May. The dialogue is rich and passionate as Ellen tells Newland, "You couldn't be happy if it meant being cruel. If we act any other way, I'll be making you act against what I love in you most. And I can't go back to that way of thinking. Don't you see? I can't love you unless I give you up." Or Newland fighting his emotions: "You gave me my first glimpse of a real life. Then you asked me to go on with the false one. No one can endure that."

It appears the lovers will be together until Ellen suddenly announces her intention to return to Europe. May throws a farewell party for Ellen, and after the guests leave, she delivers her final devastating gut punch to her lovesick husband. Newland is attempting to tell his wife his plans to leave, on an extended absence so he can see Ellen, of course, only for May to inform him politely that he can't. The reason is she's pregnant, and May had told Ellen her news two weeks earlier.

Dutiful Newland realizes he must stay and sacrifice his deep, abiding love for Ellen. But he now realizes everyone around him in their social circle was suspicious of him and the Countess's relationship. It's a revelation that hits as hard as Chazz Palminteri discovering who Keyser Söze is at the end of *The Usual Suspects*. Ruminate on these words from the narrator: "He questioned conformity in private; but, in public, he upheld family and tradition. This was a world balanced so precariously that its harmony could be shattered by a whisper." This is what Jay Cocks had seen would be appealing to Scorsese—the emotional violence in this world and the backstabbing which could be as harmful to the body as Tommy DeVito was stabbing Billy Batts in the trunk of a car.

Twenty-five years pass, and the film shows Newland as an older man, the narrator informing us that he never strayed from May's side and was a wonderful, doting father to their three children.

Even as May eventually died from pneumonia, Newland was her unfailing caretaker. He receives a call from one of his sons who convinces him to travel to France. It's here that the son finally lets the father know that mom knew all along. Ted Archer, played by Robert Sean Leonard, says, "The day before she died, she asked to see me alone, remember? She said she knew we were safe with you and always would be, because once, when she asked you to, you gave up the thing you wanted most." Newland, after a long pause, answers, "She never asked. She never asked me." They walk together a little farther and then Ted reveals that he's taking his father to see the Countess. Newland stops in his tracks and politely refuses. Ted says, "I shall say you're old-fashioned and prefer walking up the five flights because you don't like lifts." Newland gives a sad smile and then responds, "Just say I'm old-fashioned. That should be enough. Go on." Newland looks off to a body of water as Ted walks away, closes his eyes, and as the light from the window catches the water, he's reminded of what a beauty Ellen was in her youth when he loved her. The camera holds a wide shot as Newland, looking as doleful as ever, walks away, and the beautiful music by Elmer Bernstein, who had previously collaborated with Scorsese on *Cape Fear*, swells to a close.

I'm of the belief that Newland can't see Ellen again because it would be too painful for him. He buried his love for her and now, after all these years later, he's accepted that he lived a new life without her and can't bear to deal with the past and the pangs of regret that may ensue. Again, this is a window into Scorsese, the man's soul laid bare through one of his characters. He once confided to Roger Ebert that he couldn't visit certain places or listen to certain music because it would remind him of an ex-lover.

The Age of Innocence may not be Scorsese's best film, but it is in some ways his most daring. For an auteur who will forever be defined by many for his gangster cinema, whoever would've

thought he'd have such a gorgeously refined, subtle picture up his sleeve? Think of Quentin Tarantino, a Scorsese acolyte in some ways, who once said that violence didn't bother him in movies: "It's the Merchant Ivory shit I find offensive." I couldn't disagree more with QT, as I believe the film adaptation of *The Remains of the Day*, produced by Ismail Merchant and directed by James Ivory, is one of the best films of the '90s. But the salient point stays true: most directors don't have the vision or versatility to make something so far removed from what they're known for, especially in Scorsese's case, as he was two decades into his career.

Marty's father, Charlie, worked in the garment business, so it comes as little surprise that the costume design in the picture is on point and Gabriella Pescucci won the Academy Award for Best Costume Design. The film was also nominated for Best Supporting Actress for Winona Ryder, Best Original Score for Bernstein, Best Art Direction by Dante Ferretti, and Best Adapted Screenplay for Jay Cocks and Scorsese. *The Age of Innocence* is about the struggle between an individual and a group, so perhaps it isn't as atypical a Scorsese entry as one might think.

Casino (1995)

Sometimes, it's all about timing. Casino was a successful film for its time and certainly had its admirers, but also had its detractors. Coming just five years after *GoodFellas* and reuniting the unholy trinity of Scorsese, De Niro, and Pesci in another mobster picture— was this just another retread? And yet, with the benefit of time, the picture more than holds its own, even if it's not the masterpiece that preceded it in 1990. Although on the surface it feels like familiar terrain, there are some differences when compared to Scorsese's other gangster pictures. For starters, the setting is not his beloved New York, but Las Vegas. Secondly, as strong as the

male actors are, the showiest performance belongs to a woman, Sharon Stone, playing the role of Ginger. More on her in a moment.

For the third film in a row, Scorsese relies on a (stop me if you've heard this before) documentary-style approach to the first hour of his film, establishing in unerring detail how the Mafia operates and controls the lucrative gambling empire. De Niro is Ace Rothstein, the meticulous, exacting man in charge of this casino operating on behalf of the mob back home. He's always nattily attired, with De Niro wearing an assortment of flamboyant suits that would make Henry Hill jealous. Even in one scene, a rather peculiar detail added by author Nicholas Pileggi, who wrote the book *Wiseguy* and then adapted that into the screenplay of *GoodFellas* with Scorsese, is that Ace wouldn't wear pants when working at his desk—only after his secretary buzzes him about a meeting would he calmly go to his closet and don a pair of dress pants to match his jacket. Ace is such a control freak that he complains to the chef of one of his restaurants that he wants an equal amount of blueberries in each of the muffins being sold. The incredulous answer from the chef: "Do you have any idea how long that will take?" Ace responds that he doesn't care how long it takes—just do it. Regardless, Ace runs an efficient, profitable operation until Nicky Santoro shows up.

Pesci can be accused of duplicating his Oscar-winning role for *GoodFellas* (a hair-trigger hothead) but he's not the first actor who can be typecast and yet be so damn thrilling in the role. Nicky wants to be out in Vegas too, but he's a reckless cowboy compared to the boy scout image Ace wants to project, and it's inevitable these two alpha males will clash.

And what of that showstopping Stone? Three years earlier, she made the smash hit *Basic Instinct*, playing a sexy would-be killer Catherine Tramell, who infamously, while she's being interrogated by the police, opens her legs and reveals she's not wearing any

underwear for a salivating Wayne Knight and others (better known as Newman from *Seinfeld*). Rather than look up her skirt like *Basic Instinct* director Paul Verhoeven, Scorsese gives Stone a star's entrance as a mesmerized De Niro watches her cause a commotion at one of the tables of his casino, joyously making a scene as she tosses chips in the air and then walks away in slow-motion to a transfixed Ace. What a knockout indeed. It's a heady romance, but one, like any, that has to be built on trust, and therein lies the issue. Ginger's a former prostitute who still is under the spell of her former pimp, the slimy, scrawny, mustachioed Lester, played indelibly by James Woods. Lester may be a scumbag, but Ginger's soft spot for him will ultimately lead to the undoing of her and Ace.

So, it's *GoodFellas* in the desert: beautifully photographed by cinematographer Robert Richardson (Oliver Stone's longtime DP), especially a tête-à-tête in the desert between De Niro and Pesci, including the unforgettable shot of Pesci's car pulling up being reflected in Bob's sunglasses. There's another killer soundtrack filled with hits from that era, including the perfect use of The Animals's melancholic "House of the Rising Sun." And there are outsized, fierce performances from everyone, but especially Stone, shrieking and howling at Ace as her drug problems have her spinning out of control. The supporting cast has everyone from Kevin Pollak to Alan King and, truly offering the picture verisimilitude, famed insult comic Don Rickles as the pit boss and loyal friend to Ace Rothstein.

The movie was a financial success. *Casino* opened in fifth place, grossing $14.5 million during the Thanksgiving holiday weekend, and ended up grossing $43 million domestically and $73 million internationally for a total of $116 million worldwide against a $50 million budget—another financial success for Marty and producer Barbara De Fina, one of his soon-to-be ex-wives.

The reviews were mostly positive, but not extraordinary. I remember one of my favorite critics, Owen Gleiberman of *Entertainment Weekly*, penned a fascinating book of his own called *Movie Freak*, saying this was the first time he sensed Scorsese getting off on the violence on screen. He was referring to the watch-through-your-fingers scene of Pesci's Nicky Santoro enraged and looking for answers, putting a character's head in a vise and squeezing until he gets the answer he wants, a brutal bulging eye and all. Gene Siskel of the *Chicago Tribune* added, "*Casino* is hardly a bad film, but it breaks no new ground for Scorsese." The violent climactic scene, involving baseball bats in the same vicious manner as De Niro himself employed as Al Capone in *The Untouchables*, does happily allow Frank Vincent a measure of revenge after being beaten up viciously by his friend Joe Pesci in *Raging Bull* and *GoodFellas*.

Casino received only one Academy Award nomination and that was for Stone, who didn't win the Oscar but did win a Golden Globe for, arguably, a career highlight in terms of prestige acting for her.

I did appreciate the operatic opening and closing of the picture and the titles from the legendary Saul Bass, as the Mafia's hold over *Casino* is equated to the Roman Empire's rise and fall. Ultimately, while highly enjoyable, I don't think it's one of Scorsese's top five, or even top ten films. And that's that.

Kundun (1997)

Almost ten years after his spiritual work *The Last Temptation of Christ*, Scorsese, the high priest of cinema, returned to make another religious work. Rather than Christianity, Marty this time focused his lens on Buddhism. *Kundun* was the story of the Dalai Lama as a young man, scripted by Melissa Mathison (*E.T.*), and released by Disney on Christmas Day, 1997. Told through the eyes

of His Holiness, *Kundun* shows the Dalai Lama's progression from a two-and-a-half-year-old baby boy through to the Chinese invasion of Tibet and his journey into exile.

Sadly, the same could be said of the film when it came to be exiled. While earnest and well-intentioned, the movie is narratively deficient. The two best aspects of the film were both honored; first off, the cinematography, shot by the legendary Roger Deakins who won the National Society of Film Critics Award for Best Cinematography. The Englishman has won this award a record four times. And the other reason to watch the film is to appreciate the score by another notable composer in Philip Glass. I had the CD myself and was struck by its power and Eastern mysticism.

Originally thought to be an Oscar contender, the film did land four nominations but was completely shut out for victories. Left to mumble that it was an honor to be nominated were Deakins and Glass (up for Best Cinematography and Original Score, respectively) along with Dante Ferretti for Best Art Direction and Best Costume Design.

Former Disney CEO Michael Eisner, while apologizing for offending Chinese sensitivities, called the film a stupid mistake. He went on to say, "The bad news is that the film was made; the good news is that nobody watched it." While an amusing quote, I thought it was a classless shot at those who strove to make the picture worthwhile.

Bringing Out the Dead (1997)

Seeking to bounce back both commercially and critically, Scorsese reunited with his favorite screenwriter, Paul Schrader. The film was an adaptation from first-time novelist Joe Connelly describing the hellacious drama of being a medic in New York City's Hell's Kitchen,

based on Connelly's real-life experience. For the first time, Scorsese was working with Nicolas Cage, the nephew of his good friend Francis Ford Coppola. The idea of Cage playing the lead role came to Scorsese after a conversation with his other good director friend Brian De Palma, who had worked with Cage on *Snake Eyes*.

With his burnt-out eyes, hollow expression, and at times manic delivery, Cage gives the performance his all as paramedic Frank Pierce, a beleaguered man seeking some sense of meaning and spirituality in a world increasingly turning chaotic. Joining him for his nightly rides of salvation and witnessing deaths, trying to save these wounded souls in his wailing ambulance, are a rogue's gallery of character actors. It's almost as if they're the ghosts of Christmas past, present, and future. Cage is rolling along with John Goodman, Ving Rhames, and Tom Sizemore. Through the course of a few nights, Frank is desperate to be fired from the gig until he forms a friendship with a victim's daughter, played by Patricia Arquette.

Bringing Out the Dead has all the hallmarks of potential success: a Paul Schrader screenplay, a picture set in Scorsese's preferred turf—New York City at night—featuring an Oscar winner in the lead role. So, why is the movie less than the sum of its parts? It's certainly a good movie, but was neither a critical nor commercial success. Priced at a respectable budget of $32 million, the movie grossed only $16.8 million and received zero awards buzz from the Oscars or elsewhere. Years later, Scorsese remarked to film critic Roger Ebert, who loved the film and gave it four stars: "It failed at the box office and was rejected by a lot of the critics. I had ten years of ambulances. My parents, in and out of hospitals. Calls in the middle of the night. I was exorcising all of that. Those city paramedics are heroes and saints, they're saints. I grew up next to the Bowery, watching the people who worked there, the Salvation Army, all helping the lost souls. They're the same sort of people."

His editor Thelma Schoonmaker added, "It's the only one of his films I think that hasn't gotten its due. It's a beautiful film but it was hard for people to take, I think. Unexpected. But I think it's great. What happened was, that film was about compassion, and it was sold, I think, as a car chase movie. When I saw the trailer, I said, 'Wait a minute! That's not what the movie is about!' I think it'll get its due." As for Cage, he was quoted in 2022 as calling *Bringing Out the Dead* one of the best movies he's ever made.

Gangs of New York (2002)

At last, Scorsese had just the man who could bring his long-gestating dream project to life. Marty had been obsessed with making *Gangs of New York* (GONY) for twenty years, but much like another passion project *The Last Temptation of Christ*, *Gangs* would be marred by controversy (principally a budget which ballooned), delayed release dates, and the colossal presence of controversial producer Harvey Weinstein. Weinstein is a criminal who abused his power over females without remorse or recrimination for years, yet there was a reason why he was so coveted to work with A-list actors and directors alike. Simply put, Harvey got the job done. Even though a violent, nearly-three-hour period piece set in the 1860s was an incredibly tough sell, Weinstein got the financing (the movie had a budget in the $90–$100 million range) and set about the task of getting Marty his long overdue Oscar.

The two filmmaking powerhouses clashed significantly, with Harvey exerting far too much creative input for Scorsese's liking. Weinstein wanted to enhance the love story between Leonardo DiCaprio's hero Amsterdam and Cameron Diaz's pickpocket Jenny Everdeane, lobbied for a more hopeful, optimistic ending, and aimed to reduce the movie's bloated run time (there was a reason he had the derisive nickname Harvey Scissorhands).

The best part of the film is without question Daniel Day-Lewis's towering performance as Bill the Butcher, a monstrous villain bordering on the grotesque, slaughtering pigs and brandishing knives with aplomb. The role couldn't be a further departure from his beautifully restrained work in *The Age of Innocence*. This time, DDL is all in, unleashed and spewing ornate dialogue with relish (a personal favorite is "And which part of that excrementitious isle were your forebears spawned?").

It's a role ripe for De Niro, but Day-Lewis makes it singular from the garish wardrobe to his greasy hair and hirsute appearance. Every time he's on screen he's captivating, and it's an all-time performance in a Scorsese film. *GONY* marks the first Scorsese collaboration with Leonardo DiCaprio, who has now become one of his favorite leading men, but this movie doesn't feature a strong enough Leo role, since he's ill-equipped to hold his own with an acting titan like Day-Lewis ravaging the screen. The aforementioned romance is also one of the weaker parts of the movie, with the scene of Amsterdam and Jenny comparing their scars worthy of ridicule. Still, there's a lot to love about the film beyond DDL. Scorsese was thrilled to shoot at the famed Cinecittà studios where one of his idols, the Italian master Federico Fellini, shot so many of his films. I remember laughing at a scene on the DVD where Scorsese gives his good friend George Lucas a tour of the sets and Lucas remarks, "You know, Marty, I could've built this all for you," referring to Lucas's fondness for cutting-edge CGI.

The heavyweight trio of writers including Jay Cocks, Steven Zaillian (who won an Oscar for *Schindler's List*), and Kenneth Lonergan (who later won an Oscar for penning *Manchester by the Sea*) bit off a sizable part of US history and know their way around the underworld and do so with memorable argot. There are excellent supporting performances including Jim Broadbent as a corrupt

politician, Brendan Gleeson as an honorable one, John C. Reilly, and Liam Neeson.

There are tons of gorgeously orchestrated shots in the bravura direction of Scorsese, along with Dante Ferretti's staggering production design of Five Points. The movie was expected to be the coronation that Scorsese was so deserving of. He won the Golden Globe for Best Director, Day-Lewis won the BAFTA and SAG awards for Best Actor, and the movie received ten Academy Award nominations, including Best Picture. But alas, so much for the Weinstein magic. The movie went zero for ten at the Oscars, including Adrien Brody's stunning upset win for Best Actor, making history as the youngest ever to win the award at the age of twenty-nine. Swept up in the moment, Brody planted a kiss on presenter Halle Berry on stage, which was amusing for some at the time but is less fondly remembered over the years.

Gangs is a sprawling, towering work of ambition and, even if it's flawed, has scenes and moments that rank among Scorsese's most cherished work. I believe film critic Lisa Schwarzbaum of *Entertainment Weekly* put it best: "It may not be the career-defining masterpiece we were all hoping for, but it is most definitely the work of a master."

The Aviator (2004)

Many words could be used to describe Martin Scorsese, and a popular choice would be obsessive. When diving into a project, Marty immerses himself in the entire subject, bringing his encyclopedic knowledge of film to the project. It isn't surprising he'd find a kindred spirit in Howard Hughes, at least the young man showcased in *The Aviator*, before he became an odd, unkempt recluse who kept his urine in jars and suffered a deep descent into mental illness. *The Aviator* portrays Hughes's challenges with

obsessive-compulsive disorder (OCD), of which symptoms include excessive handwashing, fear of dust, germs, and doorknobs, and constantly repeating phrases.

For a director who loves movies as much as Marty does, it was thrilling to see him for the first time showing filmmaking on screen, as Hughes directed the big-budget picture *Hell's Angels*. Hughes cut a dashing figure and this time, DiCaprio is much more suited to the role and fits the casting like a glove. Handsome and charming, Howard is a lover of both Katharine Hepburn (Cate Blanchett) and Ava Gardner (Kate Beckinsale). Blanchett won an Oscar for her performance and nails Hepburn's unique speech pattern and clipped delivery, which are often the subject of broad impersonations. The most memorable scene of the picture for me is Howard's harrowing crash, which is nothing short of spectacular and thrilling in the same breath. Hughes was a risk-taker, but the more he gambled, the more he lost.

The movie was positioned as another major awards contender and fared much better than *Gangs* in terms of reaping them. *The Aviator* was nominated for eleven Academy Awards and won five of them: Blanchett for Best Supporting Actress, Dante Ferretti and Francesca Lo Schiavo for Best Production Design, Robert Richardson for Best Cinematography, Sandy Powell for Costume Design, and Scorsese's secret weapon, Thelma Schoonmaker, was again victorious for Best Film Editing. Leo and Alan Alda for Best Supporting Cast were also nominated, and while Scorsese was nominated for Best Director, he again lost to the late-charging *Million Dollar Baby* and Clint Eastwood.

Eastwood's crowning achievement premiered December 15, which was deemed by some to be too late in the Oscar race, but in addition to winning for Director, *MDB* won Best Picture, Best

Actress for Hilary Swank, and Best Supporting Actor to a long overdue Morgan Freeman.

I believe the Academy got it right. *The Aviator* is a movie you appreciate with your head but doesn't inspire multiple viewings. *Million Dollar Baby* is a top twenty all-time picture for me. It's a movie I've seen multiple times, and every time I see it, it breaks my heart. Scorsese has shown his versatility countless times, but the last thing I was expecting from Clint freakin' Eastwood was to make a Douglas Sirk-type melodrama. Bravo to both men in equal measure.

The Departed (2006)

After grand-scale period pieces, at last Marty returned to the mean streets and a crime drama which finally landed him what had eluded him his entire magnificent career. *The Departed*, from producer Graham King, won Best Picture, Best Adapted Screenplay for William Monahan, another Editing win for Thelma Schoonmaker, and—hallelujah!—a golden guy for arguably America's greatest living director. Scorsese had learned to make peace with never winning an Academy Award. He knew that as a New Yorker and Italian American Catholic, he didn't fit in a conventional manner with the Los Angeles film establishment. It had become a running gag, with even host Jon Stewart once quipping at the 78th Annual Academy Awards, "For those of you keeping score at home, I just want to make something very clear: Martin Scorsese zero Oscars; Three 6 Mafia, one."

In a weak year for film (the biggest threat was probably Alejandro González Iñárritu's *Babel*), it only made sense to honor Marty and his cronies for getting rough and tough again. Speaking of cronies, it was a classy touch from the Academy to have three of his lifelong friends and contemporaries, Steven Spielberg, Francis Ford

Coppola, and George Lucas present Scorsese the Oscar as they all said his name in unison. Upon receiving the Oscar, Marty quipped, "Could you double-check the envelope?" He then added, "I'm overwhelmed with this honor with the Academy and also the honor of being presented by my old, old friends. We go back thirty-seven years. I'm so moved. I'm so moved." Scorsese went on to thank his collaborators on the film before closing thusly: "I just want to say, too, that so many people over the years have been wishing this for me, strangers, you know. I go walking in the street, people say something to me, I go into a doctor's office, I go in a…whatever… elevators, people are saying, 'You should win one, you should win one.' I go for an X-ray, 'You should win one.' And I'm saying, 'Thank you.' And then friends of mine over the years and friends who are here tonight are wishing this for me and my family. I thank you. This is for you."

The victory lap had finally arrived…but what of the film itself? Marty joked this was the first film he directed with an actual plot. His third collaboration with Leonardo DiCaprio was his most successful and a remake of the 2002 Hong Kong film *Infernal Affairs*. It will always irk me that Scorsese finally received his due not for making a movie about New York Italian Americans but Irish Mafia from Boston. But alas, *The Departed* is a joyous, fast-moving ride featuring an all-star cast. Along with Leo, this marked Marty's first time working with Matt Damon; Mark Wahlberg, who scored an Oscar nomination playing Sergeant Dignam; Ray Winstone; Martin Sheen (the shot of him falling to his death in slow-motion is my favorite of the picture); Vera Farmiga, and most notably, acting heavyweight Jack Nicholson.

Nicholson's performance is polarizing; some appreciated his menace and bizarre sense of humor (after shooting a woman, he comments, "She fell funny") whereas others accused him of sporting a bad Boston accent and overacting (I'm not sure we

needed the scene of him wearing a black dildo in an adult movie theater). But Jack is Jack, and I appreciated seeing a movie star relishing being given free rein to ad-lib from Marty and chewing the scenery as mob boss Frank Costello. It's a busy plot, but essentially the movie focuses on the duality of man, and good and evil, as Leo's cop Billy Costigan goes undercover, infiltrating Costello's crew. Meanwhile, Damon's Colin Sullivan is a career criminal who infiltrates the police department and notifies his bosses of who is being investigated. Eventually, both sides know there's a rat and it becomes a cat and mouse game to find out who it is. The last shot induces an eye roll and a groan, but above all, Scorsese maintains a playful atmosphere directing all this A-list talent and the result is a supremely engrossing thriller. Crank up the Dropkick Murphys, slurp back a cranberry juice ("My wife drinks that when she's on her period") and enjoy.

Shutter Island (2010)

Two notable people in my life, my brother and my wife, rank *Shutter Island* as a top five Scorsese movie. I love them both dearly but believe that they are both out of their minds. The movie was clearly a cash grab, and while there's nothing wrong with making a commercial picture, as Scorsese did with *Cape Fear*, it would be helpful if the picture felt torn from the director's soul, as so many of his films are. Instead, this movie is as blunt as the foghorn of music suggests in the early passages and is unnecessarily convoluted, though undeniably creepy and atmospheric. It certainly has its moments and another strong cast—all of which is to say it ain't top five.

Once I heard Scorsese was adapting the picture, I couldn't help myself and immediately read Dennis Lehane's page-turner of a book. Thus, the big twist for me was spoiled, and perhaps that's why my reaction to the film is a little muted. The story involves

US Marshal Teddy Daniels (another collaboration with Leonardo DiCaprio) and his new partner (Mark Ruffalo) traveling to Ashecliffe Hospital, an insane asylum on a remote island, to find the whereabouts of a woman who has seemingly vanished from her locked room. As the two marshals investigate further into this eldritch world, they seem to sense something nefarious going on inside these walls, and Teddy realizes he must confront his own fears and demons before the case can be cracked.

Scorsese imagined the picture as something of an homage to Val Lewton, who was known for his B movie zombie films, and illustrates once again that, while the director may revere the greats, he is far from a movie snob and appreciates directors of all stripes and sizes. Marty was also paying tribute to director Otto Preminger, stating that the main reference to Teddy Daniels was Dana Andrews's character in Preminger's 1944 film *Laura*.

Leo has some strong moments of dramatic anguish and Patricia Clarkson is always a welcome sight, along with first-timers working with Marty including Mark Ruffalo, Ben Kingsley, Michelle Williams, Jackie Earle Haley, Elias Koteas, and Max von Sydow.

The plot becomes so convoluted that at one point Kingsley starts drawing on a chalkboard to explain all the machinations taking place, which must be some of the worst exposition I've seen in a Scorsese movie. A dead giveaway that this would not be one of his prestige projects was the release date; for the first time in forever, no one was courting Oscar in the fall movie season for Scorsese, but instead the movie was hoping for some counterprogramming being released February 19, 2010, which was almost two years after the movie finished filming in July 2008. Originally, Paramount planned to release the film October 2, 2009, but reportedly moved the film in the hope that the economy would rebound enough for an adult picture. The gambit worked, as despite a hefty $80 million

budget, the movie grossed almost $300 million worldwide and *Shutter Island* became Scorsese's fifth movie to debut at number one at the box office, following *Taxi Driver*, *GoodFellas*, *Cape Fear*, and *The Departed*.

Also, the movie was chosen by the National Board of Review as one of the top ten films of 2010, which may be an indication of how treasured Scorsese's name is among critics rather than an actual reflection of the quality of the picture. The movie has a 69 percent approval rating on Rotten Tomatoes, which is the lowest any of his films have received in years.

Hugo (2011)

A kid's picture? From Martin Scorsese?! Whose bright idea was this? *Hugo* was a massive swing, and despite the fact it caused its director Graham King significant agita and lost tens of millions of dollars, it demonstrated more of Marty's range and allowed him to finally present a movie that his daughter Francesca could watch. For his part, King has said the experience was a painful and costly one (the picture made only $185 million against a staggering $150 million budget, which, when you account marketing costs, meant it was estimated to have a net loss of $100 million), but he hopes a movie as extravagant as *Hugo* will stand the test of time and believes it will be viewed as a masterpiece that will be talked about in twenty years. In February 2012, King summed up his experience thusly: "Let's just say that it hasn't been an easy few months for me—there's been a lot of Ambien involved."

The lonely orphan Hugo Cabret (Asa Butterfield) lives in the walls of a train station in 1930s Paris. Hugo bides his time by oiling and maintaining the station's clocks, but what he really is fascinated by is the broken automaton and notebook left to him by his late father (Jude Law). With his friend (Chloë Grace Moretz), Hugo soon finds

himself curious about the backstory of a bitter toy merchant (Ben Kingsley, back again) and seeks to find out what the automaton is really all about. And, lest we forget, the inspired casting of Sacha Baron Cohen in the comic relief role of Inspector Gustave Dasté.

The movie is based on Brian Selznick's 2007 book *The Invention of Hugo Cabret* and ends up being a loving tribute to noted filmmaker George Méliès. This was Marty's first foray into 3D, and he said he found it interesting because "the actors were more up front emotionally. Their slightest move, their slightest intention, is picked up more precisely."

The Academy was greatly enamored with the movie, as it received a leading eleven Oscar nominations, including Best Picture, and won a leading five awards: Best Cinematography for Robert Richardson, which represented some of his best work, Best Art Direction, Best Sound Mixing, Best Sound Editing, and Best Visual Effects. Scorsese may not have won for Best Director at the Oscars, but did win in that category at the Golden Globes, his third win.

Roger Ebert of the *Chicago Sun-Times* wrote, "Hugo is unlike any other film Martin Scorsese has ever made, and yet possibly the closest to his heart: a big-budget, family epic in 3D, and in some ways, a mirror of his own life. We feel a great artist has been given command of the tools and resources he needs to make a movie about movies." Director James Cameron added that *Hugo* was a masterpiece and the film had the best use of 3D he had ever seen, surpassing his own films. And I will add, the scene when Kingsley thanks Hugo for the "kindest magic trick that ever I've seen" is one of the sweetest moments ever in a Scorsese film. Only Marty could ostensibly turn a kid's movie into a deeply affecting look at film preservation and why it's a cause so near and dear to his heart.

The Wolf of Wall Street (2013)

In his seventies, how on earth could Martin Scorsese make arguably the funniest movie of his career? He used a GoodFellas-type arc, except this time rather than wise guys of the 1960s, the subject was charting the rise and fall of wannabe white rich boys of the '80s. They may be obnoxious, but are undeniably funny, and there's a cathartic thrill in watching more men behaving badly—and getting away with it for a long time—before the chickens come home to roost.

Leonardo DiCaprio is having a blast as Jordan Belfort, arguably his most fully realized performance in a Scorsese movie, in his fifth collaboration. Suave and charming, he's blessed with a golden tongue, and whether it's teaching director Spike Jonze in a cameo selling penny stocks or hustling other "pump and dump" operations, Leo is captivating on screen. The scene in which he takes waaaay too many Quaaludes also represents the best physical comedy of his career. His unlikely accomplice in crime is Jonah Hill as Donnie Azoff. The movie represented a huge point in Hill's career, who up until this point had only been seen in popular comedies; now, he was ready for his close-up working with a revered auteur. Hill, with his oversized glasses and large teeth striking a misshapen visage, makes you truly contemplate how many women would find this cretin repellent if he wasn't so damn filthy rich. But Hill has wonderful chemistry with Leo and relished the experience of working with Scorsese on the film and being allowed to improvise with glee.

The script is by the gifted Terence Winter, who was one of the key horses in the writing stable for David Chase on The Sopranos. This black comedy is an adaptation of Belfort's 2007 memoir, and Winter doesn't skimp at all on the crassness of the entire enterprise. Matthew McConaughey is hilarious in a small role as

Jordan's mentor and former boss Mark Hanna, giving him tutelage on how often he should masturbate and involving him in an odd chest thumping ritual, which is something that McConaughey did off-camera and DiCaprio and Scorsese enjoyed it so much they added it to the character. Margot Robbie sizzles on the screen as Jordan's stunning second wife, and Jon Bernthal and Kyle Chandler, and a rare hilarious bit of acting from former meathead turned director, Rob Reiner, round out the uniformly excellent cast.

The three-hour movie was an enormous financial success, making $407 million on a $100 million budget, becoming Scorsese's highest-grossing film. It also set a Guinness World Record for the most instances of profanity in a film, featuring at least five hundred uses of the F-word. The movie averaged 2.81 profanities per minute, and broke the record for F-words previously set by *GoodFellas* and *Casino*. The record has since been broken by *Swearnet: The Movie*, but *Wolf* holds the dubious distinction for the most profanities in a major theatrical release.

I can understand the criticism of the film. There is a lack of sympathy for the victims, it becomes overlong and repetitive, and it could be deemed excessive in its depiction of the debauchery. DiCaprio himself termed it a modern-day *Caligula* and the movie has been banned in several countries abroad because of the graphic sex, drug use, and rampant profanity. Belfort has admitted his actual drug use was much worse than what was depicted; he was on twenty-two drugs by the end of it all. As usual with a fast-paced Scorsese film, the soundtrack is fabulous. More than sixty songs are used in the film, but only sixteen are on the official soundtrack. A personal favorite I enjoyed was the use of "Ca Plane Pour Moi."

The Wolf of Wall Street was nominated for five Academy Awards: Best Picture, Best Director, Best Adapted Screenplay, Best

Actor, and Best Supporting Actor for Hill. DiCaprio lost out on the Oscar but did win the Golden Globe for Best Actor in a Musical or Comedy. It's not a movie for everyone, but for those that love it, it has endless watchability.

Silence (2016)

Following *The Last Temptation of Christ* and *Gangs of New York*, *Silence* was the third in the list of long-gestating projects Scorsese had dedicated years to making. If you substitute *Kundun* for *Gangs*, it also represented his third major religious work, yet another example of the famed filmmaker seeking spirituality and deeper meaning through motion pictures. He was quoted as saying, "*Silence* is just something that I'm drawn to in that way. It's been an obsession—it has to be done." Scorsese wrote the script with his good friend Jay Cocks, and it was based on the 1966 novel of the same name by Shūsaku Endō, which he read after he was invited by the great Akira Kurosawa to Japan to be in his film *Dreams* in 1990. At one point, Daniel Day-Lewis and Benicio del Toro were attached to star, but the film kept getting delayed for one reason or another. Eventually, twenty-six years later, the project came to fruition.

The story concerns two seventeenth-century Jesuit priests (Andrew Garfield as Sebastião Rodrigues and Adam Driver as Francisco Garupe) who travel from Portugal to Japan to locate their missing mentor and spread Catholic Christianity. Garfield is compelling in the lead role, as is the gaunt Driver in a supporting performance (he reportedly lost close to forty pounds for the role), and the movie offers a sobering reality of the tremendous risks and religious persecution these priests faced. They are dismayed when they finally locate their mentor, played by the graceful Liam Neeson, who has renounced his faith and accepted his fate without guilt or regret.

The finale is heart-wrenching as Rodrigues struggles with whether or not to apostatize, seeing five Christians being tortured. He hears what he thinks is the voice of Jesus, giving him permission to step on the fumi-e (a bronze plate with the likeness of Jesus), and he acquiesces in a crushing slow-motion shot. The former priest lives out the remainder of his life in Japan and is given a traditional Japanese funeral. And here, Scorsese saves his best for last: despite opting for a lot of static, contemplative shots, this time he zooms in on the crucifix in his hand, proving that in his heart, Rodrigues never lost his faith.

Along with director Robert Duvall's heroic *The Apostle*, I believe *Silence* to be one of the best movies ever made about religion and the perseverance of faith. I saw the film on Christmas Day in 2016 in a New York theater by myself and was speechless after the two-hour-forty-minute run time had elapsed. It was a profound motion picture experience and even though I've seen it since, I can't possibly match the power of seeing that movie for the first time.

The movie received critical acclaim, with both the National Board of Review and American Film Institute recognizing *Silence* as one of their top ten films of the year. Justin Chang of the *LA Times* named it the best picture of the year and Matt Zoller Seitz of RogerEbert. com wrote: "*Silence* is a monumental work, and a punishing one. It puts you through hell with no promise of enlightenment, only a set of questions and propositions, sensations, and experiences... This is not the sort of film you 'like' or 'don't like.' It's a film that you experience and then live with."

But the movie lived up to its title and was sadly ignored by the Academy, receiving one solitary nomination for Rodrigo Prieto's gorgeous cinematography. Derisively referred to as Scorsese's boring priest movie for those that didn't bother to watch it, the movie failed to ignite at the box office, grossing a paltry $24 million

against a $40 million budget. The lack of Oscar nominations hurt, as did the lack of interest in the subject matter. But I'll take *Silence* over *The Color of Money* any day of the week. Scorsese poured his heart into the film and the passion overflowed, like the blood of a believer being shed.

The Irishman (2019)

For a director synonymous with the gangster picture and with seemingly nothing left to say on the matter, Marty had one more masterpiece up his sleeve. I can only imagine a marathon beginning with *Mean Streets* continuing through *GoodFellas*, *Casino*, and winding up with *The Irishman*, an elegiac, poignant portrait of a mobster haunted by regret. After eight movies together and an extended twenty-four-year absence of being kept apart, Scorsese finally reunited with the estimable Robert De Niro, and Bob seemed revitalized. Accused with some merit of mailing it in through generic thrillers and broad comedies, De Niro here is in virtually every scene of the movie's 209-minute run time and is able to command our attention with just a pensive look or flicker of his eyes.

The movie opens with the evocative doo-wop song "In the Still of the Night" as a camera tracks through a nursing home. Contrast that with Scorsese's other famous tracking shot in a gangster picture (the Copa shot in *GoodFellas*), and it's no coincidence why he's set the movie up this way. De Niro plays Frank Sheeran, who reflects back on his life and how he wound up here. After a chance encounter with Joe Pesci's Russell Bufalino, Frank goes from being a hitman for a mob boss to eventually the right-hand man of a corrupt labor leader, Jimmy Hoffa. The movie is based on Charles Brandt's 2004 true crime biography and has precision and attention to detail throughout. The movie was noteworthy for using the process of de-aging, which is both revolutionary and

Scorsese Stories: Il Maestro

incredibly expensive. Although there were guffaws over some missteps (i.e. the scene of De Niro kicking a man in the street supposedly as a young man but with the movement of a senior citizen), the results are impressive in making De Niro, Pacino, and Pesci youthful and then old. Netflix was incredibly supportive of the project with a budget believed to be around $200 million. Let's get right to Pacino.

The movie is enjoyable in its first act, especially with Ray Romano and Bobby Cannavale popping up, but the enterprise gets kicked up a notch when Pacino shows up as Hoffa. Pacino galvanized the entire production with his electrifying performance and rightfully earned his first Oscar nomination since *Scent of a Woman*, which had been twenty-seven years ago. When casting the part of Hoffa, it was De Niro who suggested Al to Marty and Scorsese readily agreed, having come close to working with Pacino in the 1980s about a movie on the artist Modigliani until they couldn't get the financing together. As for Pesci, his performance was a real revelation for the audience. The veteran actor had been content to smoke cigars and play golf, but eventually he was coerced to join the project by his good friend De Niro, who would not take no for an answer. The result is a stark contrast to the hair-trigger gangsters Pesci had played in the past like Tommy DeVito and Nicky Santoro. Russell Bufalino is phlegmatic, serene, and thoughtful. Later in Russell's dotage, he becomes wan and frail, almost an object of pity as his bark has lost its bite—he's toothless and desperate just to munch on a piece of bread. *The Irishman* marked Marty's fourth collaboration with Pesci, fifth with Harvey Keitel; it was the fourth collaboration between Pacino and De Niro and the first between Pacino and Pesci.

There are critics who question the veracity of the picture and the big topics the movie is tackling, such as the long-unknown murder and whereabouts of Hoffa. The entire buildup to his murder

is handled so restrained and artfully by Scorsese, taking a cue from his work in *Silence* to not hurtle the plot ahead but to do so at a quiet, deliberate pace, yielding an ultimately devastating impact. I saw *The Irishman* at its world premiere at the 57th New York Film Festival on September 27, 2019, with Scorsese, De Niro, Pacino, and Pesci on hand, and you could feel the crackling energy throughout the theater from beginning until end. I watched the movie again the next day with my wife, and a month later again in theaters. I was not deterred by the lengthy run time, and never felt the movie drag, or had my energy flag, while being enveloped by the experience. I've watched certain scenes multiple times, such as when Sheeran is being honored with a special dinner, seeing Pacino and Pesci lock horns together followed by Bob and Al. Quite simply, I couldn't get enough. Scorsese said, "What you see in their film is their relationship as actors, as friends, over the past forty, forty-five years. There's something magical that happens there." Also worthy of mention from the cast is Stephen Graham as gangster Tony Pro and his hysterical scenes matching wits with Pacino's seething Hoffa. The production itself was a massive undertaking. All told, it had 117 filming locations, 319 scenes, 160 actors, in a story spanning fifty years.

The National Board of Review named *The Irishman* the best picture of 2019 and the American Film Institute (AFI) had the film in its top ten. Ten is the number of Oscar nominations *The Irishman* received, yet sadly the movie went 0-fer, just like *Gangs of New York* had done back in 2002. *The Irishman* was nominated for Best Picture, Best Director, Best Supporting Actor for Pacino and Pesci, Best Adapted Screenplay for Steven Zaillian, Best Production Design, Best Cinematography, Best Costume Design, Best Film Editing, and Best Visual Effects, yet frustratingly went home empty-handed. Owen Gleiberman of *Variety* called it a "coldly enthralling, long-form knockout—a majestic mob epic with ice in its veins" and called Pacino's performance "the film's most extraordinary." Other

filmmakers also loved the movie, including Guillermo del Toro, Bong Joon Ho, Paul Schrader, and Quentin Tarantino, who said the movie was his favorite of the year. Dubbed by some critics as Scorsese's *Unforgiven*, this was a perfect assessment of *The Irishman*. It was a director closing the chapter on movies he'll forever be known for but doing so looking back with the heavy, melancholic eyes of an old man.

Killers of the Flower Moon (2023)

This is another rich, contemplative epic as Scorsese again tackled a new genre: a Western! He loved the genre as a kid and the influence of *The Searchers* is keenly felt in *Taxi Driver*. Just as John Wayne saves Debbie from the Comanches, Travis similarly saves Betsy from her pimp, Sport. *Killers* is a beautifully realized, quietly despairing film about the slaughter of the Osage in Oklahoma, an underreported era of American history brilliantly brought to life by author David Grann which was then adapted into a screenplay by Oscar winner Eric Roth (*The Insider*) and cowritten with Scorsese. The movie is set in the 1920s, when the Osage nation was targeted after oil was discovered on tribal land. A corrupt local political boss played by Robert De Niro plots to steal their wealth at all costs, and he hides his true motives behind an avuncular smile and an alleged generosity of spirit toward the Osage.

This was another massive project with a budget north of $200 million, so again, Scorsese had to resort to a streamer to primarily foot the bill and Apple was only too happy to do so, while Paramount handled the theatrical release. This marked the tenth collaboration between De Niro and Scorsese, sixth for DiCaprio and Scorsese, and first for all three in a feature film. (They had made a short film called *The Audition* together in 2015, and Leo had worked on *This Boy's Life* with De Niro, who was impressed by the young man's work and told Scorsese offhandedly that he should work

with DiCaprio someday.) Also, this was the eleventh collaboration between Scorsese and his dear friend Robbie Robertson, the brilliant musician who passed away two months before the film premiered and was Native American (his mom was a member of the Mohawk nation).

As for the story itself, DiCaprio plays Ernest Burkhart, a World War I veteran, home and looking for work. He pays a visit to his uncle, William "King" Hale, who immediately takes Ernest's temperature on the kinds of women he likes and encourages him to marry one of the Osage women. Ernest ends up being a driver for Mollie Kyle (Lily Gladstone) and the two end up taking a shine to each other, getting married, and having children. The main difference between Grann's book and Scorsese's movie is that Grann diligently explains the murders, but then goes on to explore how J. Edgar Hoover used those murders to shape the FBI. Marty's focus was narrower, eschewing the origin story of the FBI and instead focusing on the rapacious individuals and their cunning ways. The original script had DiCaprio playing the FBI agent and was a straightforward adaptation of Grann's book. However, during their research and conversations with the Osage, Scorsese and Roth realized the heart of the story needed to be told from the inside out, and focus on the relationship of Ernest and Mollie. Thus, Leo traded the role of the agent Tom White for the coward Ernest Burkhart while Jesse Plemons stepped into the role of White.

Killers of the Flower Moon is a fascinating depiction of the insidious nature of evil and De Niro again rises to the occasion, working with his favorite director, making Bill Hale a villain to remember. Editor Thelma Schoonmaker said she thought De Niro's work in this film ranked among his best-ever performances. Bill Hale is a reminder that the killer wears sheep's clothing, and while he may outwardly profess great respect and admiration for the Osage people, in his

heart, King is ruthless, manipulative, and has zero regrets about their mass slaughter in favor of his own financial gain.

The movie may be drawn out for some, but I found it thoroughly engaging. DiCaprio does a superb job of portraying how a man could genuinely love his wife, yet simultaneously take part in her own personal, and her entire tribe's, ruin. Lily Gladstone as Mollie Kyle is nothing short of a revelation. Lily was unknown to mainstream audiences, but renowned casting director Ellen Lewis recommended one of her indie films to Scorsese. Marty was impressed and they clearly made the right decision to cast her. Gladstone has an expressive face that wouldn't be out of place in the silent era, and her primal scream when she hears of the death of loved ones is one of the highlights of an emotionally devastating movie. Her grounded, authentic performance gives the movie considerable gravitas. Scorsese even offers some remarkable creativity to the film's denouement after King and Ernest have been brought to justice. Marty stages a radio play explaining what happened to all of the principals and gives himself the role of the final voice who tells the tale of what truly happened. The message is clear: we are all implicated in this most American tragedy.

I loved a review from one of my favorite critics, Justin Chang, who incidentally was also enamored with *Silence*. Chang wrote that *Killers of the Flower Moon* was both like and unlike anything its director has ever done. "Scorsese doesn't just achieve a sense of place; he also pulls off, not for the first time, a passionate and meticulous feat of cultural anthropology. He brings an entire bygone era to rich, teeming life, just before he chokes it off with an all-consuming stench of death." The movie grossed just under $160 million worldwide and was showered with praise. It captured the Award for Best Film from the National Board of Review and was named one of the top ten films by AFI. Just like with *Gangs of New York* and *The Irishman*, *Killers* was nominated for ten Academy

Awards, such as Best Picture and Director. Notably, at the age of eighty-one, Scorsese earned his tenth nomination for Best Director, more Oscar nominations for that category than anyone else alive (besting his good buddy Steven Spielberg). Scorsese also became the oldest Best Director nominee, eclipsing John Huston, who was seventy-nine (William Wyler has the all-time record of directing nominations of twelve, with three wins). Schoonmaker earned her ninth nomination for Best Editing, a new record in that category. And finally, Robbie Robertson earned his first Academy Award nomination (for Best Original Score), albeit posthumously.

But disappointment again reigned supreme for the Martin Scorsese fan club as the movie was completely blanked. Gladstone won the Golden Globe and the SAG Award for Best Actress but was not able to top now two-time Oscar winner Emma Stone for *Poor Things*. As was expected, De Niro came up short for Best Supporting Actor, losing to the heavy favorite Robert Downey Jr. for *Oppenheimer*. The Academy Awards ignoring the movie remains inexplicable, but anyone who watches *Killers of the Flowers Moon* knows it's another crime marvel from its master, exploring through what happened to the Indigenous people, the true heart of darkness.

CHAPTER 24

Scene Study: Random Thoughts for an Aspiring Film Critic

I love a great sad movie; my favorites are Eastwood's *Million Dollar Baby* and Bahman Ghobadi's *A Time for Drunken Horses*. You know all about Clint's knockout of a boxing drama, but Ghobadi's movie is an unflinching tragedy. The youngest of a destitute Kurdish family has a terminal illness, and his young siblings struggle to pay for a life-saving operation. In desperation, the eldest sister agrees to marry an Iraqi willing to care for the boy. At the border exchange, however, the family of the man rejects the sick boy, putting the siblings in a crushing race against time. A truly unforgettable, heartbreaker of a film.

★　★　★

Planes, Trains and Automobiles is my favorite comedy. The conceit by John Hughes and the performances by Steve Martin and John Candy are lights-out, but the movie is also genuinely moving. A movie that makes you laugh riotously (those aren't pillows!), it's a gut-buster that also hits you in the heart. Also receiving votes for the best comedy ever are *The Naked Gun*, with its unrelenting gag-a-minute style, and the sheer originality of Charlie Kaufman and Spike Jonze's *Adaptation*.

Big Night is a succulent dish of a comedy drama. I love everything about that film, from the entire irresistible soundtrack (especially

Louis Prima) to the chemistry between Stanley Tucci and Tony Shalhoub. And who can forget that sublime final scene when the brothers wordlessly reconcile over making some eggs? I interviewed Shalhoub on the red carpet at the 2019 Critics' Choice Awards and was delighted that he's as fond of the film as I am.

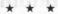

Adnan Virk (AV): *Big Night* is one of my favorite movies. I love that movie so much. I think it's the best movie about food and it's the best movie ever about brothers. Tell me any anecdotes you have about working with Stanley.

Tony Shalhoub (TS): Well, Stanley has been a friend for a long time. I did theater with Stanley even before, years before *Big Night*. And that was kind of a game changer, working on that movie. He and his cousin who wrote it were first-time screenwriters. He and Campbell Scott directed it, both first-time directors. So, we just didn't know how it was going to track out there in the world. People just seemed to love it, and it's held up over the years. And it was great playing brothers.

AV: The music, the food, and I love that last shot. Sometimes directors are so busy, but this time just a wide shot, two brothers making eggs. It's such a beautifully wrought scene.

TS: Yeah, it is. Although, I have to tell you, the only funny part of that was we did one long take, maybe about six times, and those eggs were really, really hot because they were coming right out of the pan. You know, usually in normal life, you put something on a plate, you get a chance to cool, but we had to just dig the forks in there. And after about the sixth take, our mouths were pretty much, you know, shredded.

★ ★ ★

My favorite movies about romantic anguish are Neil Jordan's *The End of the Affair* and the Merchant Ivory adaptation of *The Remains of the Day*. I love the Graham Greene novel and Jordan did a masterful job adapting *The End of the Affair*. Jordan's film which put him on the map, *The Crying Game*, still has one of the most unexpected twists ever and is one of the most deserving winners of the Academy Award for Best Original Screenplay. But back to *The End of the Affair*: Ralph Fiennes is a tortured romantic detailing why he is "a man of hate," and in recapping his torrid affair with the beautiful Julianne Moore, the movie transports you back to that time and place, war-torn England, when the idealized love of a couple was equal to the bombs and ballast going on outside their windows.

As for *The Remains of the Day*, it's a beautiful dance done by Anthony Hopkins as Stevens the butler and his love interest Miss Kenton, played by Emma Thompson. It's sophisticated storytelling, depicting a man so steeped in indentured servitude that he turns himself off to his own thoughts and passions to the point that they have become deeply repressed. A truly gorgeous film to watch and contemplate.

★ ★ ★

My favorite documentary is Terry Zwigoff's *Crumb*, a bizarre, hilarious, and profoundly moving argument for the salvation that can be found in art for a perverse man. A close second is Andrew Jarecki's *Capturing the Friedmans*, an absorbing tale of a Long Island family dealing with allegations of the worst type of human behavior possible—child molestation.

★ ★ ★

My favorite Western is probably Clint Eastwood's *Unforgiven*, but my oh my, did Sam Peckinpah's *The Wild Bunch* blow me away the first time I saw it. Peckinpah's often imitated, never duplicated slow-motion balletic violence directly influenced John Woo, whose movies like *Hard Boiled*, *The Killer*, and *Face/Off* are among the most kinetic action movies of all time. *The Wild Bunch* featured a group of amoral criminals, but the performances by William Holden, a cackling Ernest Borgnine, and Robert Ryan are uniformly excellent in showing us different shades of wounded masculinity. Overflowing with bravado and the tinged sadness of a bygone era, Peckinpah's movie still kicks some serious ass.

★ ★ ★

If you're scared of foreign films and subtitles, don't be. I recommend two of my favorite filmmakers, Federico Fellini and Akira Kurosawa, whose films were beloved in Italy and Japan, but were also able to translate their cinematic language to countries worldwide. Fellini's *8 ½* is the finest movie ever about creative expression, while *La Strada* is the height of Italian Neorealism. As for Kurosawa, there's a reason why he was revered by the likes of George Lucas and Francis Ford Coppola. *Rashomon* is brilliantly layered and *Seven Samurai* has the epic sweep, but I'll take the gentle, poignant humanity of *Ikiru* as my favorite Kurosawa film.

If you want a movie that's an event, try Krzysztof Kieślowski's *Dekalog*. Originally made for Polish television, it's ten one-hour parts, with each chapter based on one of the Ten Commandments. It's unsurprisingly a top ten movie for me of all time. Relentlessly bleak and gritty, set in and around a Warsaw apartment complex, it's also wholly compelling. *Dekalog* has thoughtful subject matter and it achieves what the best movies are often seeking—a way to illuminate and shed light on the human condition.

Scene Study: Random Thoughts for an Aspiring Film Critic

★ ★ ★

My favorite silent movie isn't with Charlie Chaplin or Buster Keaton but F. W. Murnau's *Sunrise*. It is the definition of exquisite.

★ ★ ★

As for the best family movie of all time, there's nothing that will top *Back to the Future*—1.21 gigawatts! Zemeckis brings all the inventive science fiction, but along with the brains, it's got plenty of heart. What's not to love about a son trying to teach his dad how to fall in love? Great Scott!

★ ★ ★

Sometimes, I tailor movies to the seasons. I always try watching the Coen brothers' *Fargo* in the middle of the winter. It was one of the late film critic Gene Siskel's top ten favorite movies of all time. Gene's reasoning, and I completely agree with him, was that *Fargo* was masterful at combining so many different genres and thus felt completely original. This movie is a comedy, drama, thriller, detective story, and has such a distinct locale and genuinely rich characters. Frances McDormand is one of my favorite actresses and I think her work here is nothing short of remarkable, while William H. Macy's loser of a car salesman is something only he could perfectly capture. *Fargo* also has one of my favorite taglines for a movie ever, for its sneaky simplicity: "A lot can happen in the middle of nowhere."

The best summer movie for me is Spike Lee's incredible *Do the Right Thing*, which becomes more prescient with each passing day. Every character is a winner and Spike's creativity and vision pop off the screen as a neighborhood in Bed-Stuy is a microcosm of America. The controversial ending was hotly debated and generations from

now, cinephiles can still argue if Mookie did indeed do the right thing. And that's the triple truth, Ruth.

★ ★ ★

Nothing is harder to do in movies than stick the landing, which is why I appreciate the perfect ending of Carol Reed's *The Third Man*. Steven Soderbergh said, "So many classic films aren't as good as their reputation, but *The Third Man* is the opposite. It's even better than you realize." Along with *Casablanca* and *The Godfather*, *The Third Man* features my favorite finale; the wide shot of Joseph Cotten forlornly smoking a cigarette while Alida Valli walks right on by. Added Soderbergh, "Every time I watch the ending, I hope she stops." The movie is a cagey thriller featuring a showstopping performance by Orson Welles, whose speech about democracy yielding a cuckoo clock is uproarious. I hope I get to Vienna one day just to see some of the sites where the movie was filmed, including the city's underground sewer system made famous by that elongated chase sequence as the cops finally hunt down and kill Harry Lime.

The final film on the Mount Rushmore of movie endings is the 2009 Academy Award winner for Best International Film, Juan José Campanella's *The Secret in Their Eyes*. I'll use Gene Siskel's argument for how much he loved *Fargo*: both films do an amazing job of blending so many genres. This Oscar winner from Argentina is a grisly murder mystery, a detective procedural, and most memorably, a love story. Ricardo Darín—who looks like he was born with a beard—and Soledad Villamil make sweet music together, and Campanella picks the perfect ending to capture their story. The poster of Darín in the foreground in silhouette at his typewriter with Soledad in the background is also a personal favorite.

★ ★ ★

David Mamet is my favorite writer. *Glengarry Glen Ross* is his masterpiece (I've seen three different iterations on Broadway) and his scripts for *The Verdict*, *The Untouchables*, and *Hoffa* have his unmistakable staccato gutter dialogue. One of my favorite jokes is when a homeless man asks a rich man walking by for some change. The rich man pauses and gently chides him, "Neither a borrower nor a lender be. William Shakespeare." He walks away and the bum thinks for a second before firing back, "Oh yeah? Fuck you. David Mamet." An under-seen gem of Mamet's is *Homicide*, starring his favorite leading man, Joe Mantegna. It's the story of a cop who undergoes a crisis of faith as he confronts his long dormant Judaism, and has always stayed with me, especially that drop-the-phone haunting ending.

When I worked at ESPN, while hosting a college football halftime show, I remarked about a Dak Prescott touchdown to John Ross: "More like *Glengarry Glen Ross*. Always Be Closing." My friend Gabe Oppenheim was watching and in a staggering, intrepid act of kindness, somehow relayed that sentiment to Mamet. I almost collapsed when I saw the email pop up in my inbox which read, "Dear Mr. Virk, the compliment you gave me on ESPN referencing my play *Glengarry Glen Ross* is just about the nicest thing anyone's done for me. Please pass along your address so I can offer a token of gratitude." Suffice to say, I wrote back an incredibly long, effusive email, to which Mamet didn't respond. But a week later, I received a book called *Tested on Orphans: Cartoons by David Mamet*. On the second page, he had drawn a self-portrait and signed it. Mamet has taken a hit in some quarters with his strong political takes after he wrote an article March 11, 2008, entitled "Why I Am No Longer a Brain-Dead Liberal." Regardless of his political views, I deem him to be a writing genius and will always savor his gift to me, along with Gabe's notable assist.

★ ★ ★

You can argue film critics don't matter like they used to, but I'll always be indebted to them for enriching this art form. Geoff Pevere of the *Toronto Star* is a personal favorite, and I still quote his line about Nick Nolte: "A voice like a talking ashtray."

I once had lunch with Owen Gleiberman after I messaged him about how much I loved his book *Movie Freak*. He was warm, receptive, and funny. His longtime colleague at *Entertainment Weekly*, Lisa Schwarzbaum, was so pivotal in making me appreciate the marvelous Iranian new wave of the late '90s, especially the movies of Abbas Kiarostami, who became a personal favorite (*Taste of Cherry*, which won the Palme d'Or in 1997, is truly life-affirming). And to this day, I'm still subscribing to Ty Burr and his newsletter for his incisive reviews of current movies, and especially his unparalleled knowledge of classic cinema.

Of course, Roger Ebert is in a class of his own. I devoured his reviews and still watch clips of Siskel and Ebert when I'm tempted to go down the YouTube rabbit hole. I owe this man an immense amount of gratitude for how much he taught me about film, especially his reviews of the great movies. I finally donated a few of Ebert's annual yearbooks to my local library, but Roger's book on Scorsese remains a treasured tome in my collection. This influential film critic's final gift was allowing himself to be the subject of Steve James's poignant documentary *Life Itself*, which moved me to tears in the theater when I saw it and was my favorite film of 2014.

★ ★ ★

The best book about moviemaking is Sidney Lumet's *Making Movies*. It is practical advice from one of cinema's finest practitioners. The best book about movies, period, would be Peter Biskind's *Easy Riders, Raging Bulls*. My favorite film biography would be the remarkable *Robert Mitchum: Baby, I Don't Care* by

Lee Server. Mitchum is my favorite old-school actor and Server makes a compelling case for how Mitchum's understated charisma became the definitive signature of film noir. *Out of the Past, Cape Fear,* and *The Night of the Hunter* all hold up incredibly well today (I love that Spike Lee paid homage to *The Night of the Hunter* in the opening of *Do the Right Thing* with Radio Raheem). Plus, there are the legendary tales of Mitchum's partying as the first bad boy of cinema, getting popped for the now antiquated idea of carrying pot.

And yet, *Double Indemnity*, which did not star Robert Mitchum, might be *the* definitive film noir. Barbara Stanwyck is the queen of all femme fatales, Fred MacMurray is the sad sack who gets duped, and lording over them all is the tiny, squat Edward G. Robinson as Keyes ("Know how I know? Because my little man tells me"). I can get behind any movie when the two leads are so morally bankrupt, and Keyes has the funniest moment in a killer thriller: "I picked you for the job, not because I think you're so darn smart, but because I thought you were a shade less dumb than the rest of the outfit. Guess I was wrong. You're not smarter, Walter... You're just a little taller."

<p style="text-align:center">★ ★ ★</p>

Best current filmmaker to never win an Oscar? That's easy. Paul Thomas Anderson, who's as gifted as they come. Just look at his first three movies: *Hard Eight* featured a stunning lead turn for career character actor Philip Baker Hall, *Boogie Nights* had its gonzo, *GoodFellas*-inspired filmmaking along with a remarkable breakout cast, and *Magnolia* had the chutzpah to have frogs falling from the sky and the audacity to have Aimee Mann sing along in a true homage to a Robert Altman ensemble film. *There Will Be Blood* might be the finest movie of this century, starring Daniel Day-Lewis in perhaps his best performance ever (and that's

saying something). And while you can drink milkshakes with that devastating critique of the American Dream, there's no resisting the impish charm of *Phantom Thread*, a pitch-black comedy wrapped up in a beautifully realized costume drama.

★ ★ ★

How did *Mad Max: Fury Road* not win Best Picture? It won four Oscars for Best Costume Design, Editing, Sound Mixing, and Production Design, but should have won the biggest prize of them all as the movie event of the year. George Miller's opus is nothing short of the best action movie of this century and on the short list of the best action movies of all time.

★ ★ ★

The movie I love that nobody seems to give a rip about? Danny DeVito's *Hoffa* starring a blistering Jack Nicholson as the union leader. I loved DeVito's fluid direction, the film's evocative sets, David Newman's soaring score, and especially David Mamet's script, which is a pungent earful.

Speaking of Mamet, as I mentioned earlier, I've seen *Glengarry Glen Ross* on Broadway with three different casts and the movie is a symphony of scheming cleverness and creative profanity. You can close your eyes and just savor the musicality of the dialogue in the film. Al Pacino, Jack Lemmon, Alan Alda, Alec Baldwin, Ed Harris, Jonathan Pryce, plus David Mamet equals perfection.

Another sleeper for you, especially around the holidays, is *29th Street*, starring Danny Aiello and Anthony LaPaglia and directed by George Gallo. Famed film critic Jeffrey Lyons, father of Ben, once described it as a "cross between *GoodFellas* and *It's a Wonderful Life*." Bang on.

★ ★ ★

You want an overrated actor? How about Harrison Ford? I admit he's an icon for Han Solo and Indiana Jones, but I don't see much range throughout his filmography, and *Regarding Henry* is one of the most cloying, painful experiences I've ever had to sit through, cinematically speaking.

As for the worst movie ever? Harmony Korine's *Trash Humpers* is truly detritus and takes a run at that ignominious prize, but the dishonor of the worst of all time is bestowed upon Sylvester Stallone and Estelle Getty's *Stop! Or My Mom Will Shoot*. Seriously, just shoot me.

Don't get me started on Robert Zemeckis's saccharine *Forrest Gump*. It's criminal that claptrap won Best Picture over *Pulp Fiction*, *The Shawshank Redemption*, and *Quiz Show*. I would even take the fifth nominee, *Four Weddings and a Funeral*, over that silly Tom Hanks movie and its allegedly homespun wisdom which was actually just hokum. A turgid dud.

★ ★ ★

Somehow, some way, I've made it this far without having to watch a single minute of the *Fast and the Furious* franchise.

★ ★ ★

I loved seeing the original sets of *Psycho* when I took the Universal Studios tour in 2024 and Hitchcock deserves all the props for having the chutzpah to kill his leading lady halfway through the movie. *Strangers on a Train*, hilariously referenced by Danny DeVito in his Hitchockian homage *Throw Momma from the Train*, is also a personal favorite of mine, especially the extended tennis

scene and the deceptively simple storyline: "You do my murder, I do yours. Criss cross."

But my favorite movie from the master of suspense is *Vertigo*. The movie that came closest to Hitchcock's twisted heart, it's the best story I've ever seen about obsessive love. Director David Fincher said in a documentary that part of why he loved *Vertigo* so much is because it was so perverted he laughed, but amidst the perversion is an auteur baring his soul. The scene where Jimmy Stewart's John "Scottie" Ferguson has finally remade Kim Novak into his long-lost love is my most treasured scene ever in a Hitchcock film, akin to Montgomery Clift gazing at a stunning Elizabeth Taylor in George Stevens's *A Place in the Sun*.

★ ★ ★

My wife Eamon and I went with Ben Lyons to an Oscars afterparty the second year Ben and I worked the Academy Awards, a party that was hosted by none other than Jimmy Kimmel. We got to meet Jimmy, Matt Damon, Jon Favreau, Ray Romano, Jennifer Aniston, and I talked hockey with two-time *Cinephile* guest Will Arnett. But the most memorable moment was when, while lining up to get some french fries, Eamon and I were desperately brainstorming to think of something clever to say to the actor in front of me. When Michael Keaton turned around and said "Hi Adnan," I almost fell over. We had a nice conversation about Pittsburgh sports teams, which have fallen on hard times, and he ended the friendly chat by noting, "I was in a much better mood before I started talking to you." I also told him how much I loved his baseball movie *Game 6* and he nodded and said, "Man, we made that movie for nothing." From *Batman* to *Birdman*, Keaton blows me away. He's also given us two despairing portraits of addiction; his lead turn in 1988's *Clean and Sober* and award-winning role as a doctor in the

absorbing miniseries *Dopesick*, which took a sledgehammer, and rightfully so, to the wanton greed of the Sackler family.

* * *

There was no actor more influential than Marlon Brando. His method acting greatness was first witnessed on stage and then adapted to the screen in *A Streetcar Named Desire* by Elia Kazan in 1951. Three years later, he gifted us with *On the Waterfront* and the unforgettable "Charlie, I coulda been a contendah" speech. *The Godfather* marked Brando's riveting comeback as Vito Corleone, stuffing his mouth with cotton balls and playing a mobster with benevolence. But the truly mesmerizing Brando performance for me is his star turn in Bernardo Bertolucci's *Last Tango in Paris*. The scene of Brando excoriating his dead wife is as pure as acting gets and Marlon hasn't showed that type of vulnerability since. And then there's the butter scene.

* * *

I'll never forget the moment when I heard Philip Seymour Hoffman was dead of a drug overdose. He's on my personal Mount Rushmore of favorite actors along with Pacino, De Niro, and Paul Giamatti. I think Seymour Hoffman's best performance is opposite the greatest actress of all time, Meryl Streep, in John Patrick Shanley's *Doubt*, an adaptation of his own play. PSH was incapable of striking a false note in any movie. His work with Paul Thomas Anderson alone is testament to his versatility and talent. I'm so grateful I saw Seymour Hoffman on Broadway, giving a titanic performance as Willy Loman in one of the most revered American plays of all time, Arthur Miller's *Death of a Salesman*.

* * *

The Apostle is the finest performance Robert Duvall has ever given us. He poured his heart into the tale of a preacher being tested as he starred, wrote, and directed the picture. The story of an eccentric Pentecostal preacher seems to have sprung deep from Duvall's soul. Religious movies that don't mock faith are hard to find, but this is a spiritual experience and an uplifting one—you can marvel at an acting great working at the peak of his powers in this labor of love. It was nice supporting work from Billy Bob Thornton and a young Walton Goggins.

What was the biggest reason *The Godfather Part III* didn't work? No Robert Duvall. Tom Hagen is the secret sauce. Sofia Coppola may have been dreadful, but nothing can taint the first two classics.

★ ★ ★

George Clooney might be a modern-day icon, but he and I are in agreement on his finest achievement: *Good Night, and Good Luck*, which is in many ways a tribute to his broadcaster father Nick. I also saw the Broadway show and George and the entire production were simply marvelous, chain-smoking their way through denouncing McCarthyism and extolling the virtues of veracity. *Good Night, and Good Luck*, the movie, features a standout performance from David Strathairn as Edward R. Murrow, and is an important film about ideals overcoming mendacity, deftly executed by Clooney.

★ ★ ★

What's better than Gloria Swanson playing a faded screen star in Billy Wilder's *Sunset Boulevard*? The only thing more memorable than a funeral for a chimp is this exchange: Joe Gillis (Joseph Cotton): "You're Norma Desmond; you used to be big." Norma

Desmond (Gloria Swanson), with eyebrows raised: "I *am* big. It's the pictures that got small."

★ ★ ★

Why can't we have co-Oscar winners like how sports leagues have co-MVPs? Pacino had to win for Best Actor in 1992 for *Scent of a Woman* because it was so long overdue, but Denzel Washington gave the performance of his career in *Malcolm X*, which is one of the finest biopics I've ever seen.

Speaking of Denzel, I'm partial to *Platoon*, but my favorite war movie is *Glory*. James Horner's score is my number one and the campfire scene is what the word "pathos" was invented for. Denzel won the Oscar but worthy acclaim is due to Morgan Freeman, Andre Braugher, Matthew Broderick and Cary Elwes. By the way, Broderick was a gigantic pain during and after the filming of the movie, which director Ed Zwick detailed in his richly entertaining autobiography. Broderick has since apologized to Zwick, but the facts remain.

Another co-Oscar winner would be for Best Supporting Actor in 1994. I know Samuel L. Jackson hit a career peak with his inventive and unforgettable work as Jules in *Pulp Fiction* and should've been recognized, but I will always be captivated by Martin Landau's touching turn as Bela Lugosi in Tim Burton's best and most personal film, *Ed Wood*.

And, while we're on the subject of awards, I think they should be renamed in honor of some of the most influential people to work in the movie industry:

- The Sandy Powell Academy Award for Best Costume Design

- The John Sayles or Mike Leigh Academy Award for Best Original Screenplay
- The Bernard Herrmann Academy Award for Best Original Score
- The Thelma Schoonmaker Academy Award for Best Editing
- The Daniel Day-Lewis Academy Award for Best Actor
- The Meryl Streep Academy Award for Best Actress

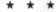

A question I'm often asked is, if I could make a movie about any subject, what would it be? For a fiction film, I'd make a movie about the late great baseball star Roberto Clemente. I interviewed basketball star Carmelo Anthony about Clemente years ago, and Melo told me his production company had a story in development but didn't know what happened to it. I asked Pulitzer Prize-winning author David Maraniss who wrote the definitive bio on Clemente and he didn't know what happened to the movie either. Clemente was a Hall of Fame player, and more importantly, a Hall of Fame person, and I would market the film to the underserved Hispanic audience and be confident we could pay tribute to Clemente's monumental legacy.

As for a nonfiction film I'd love to make, I'd like to tour the most famous religious sites of the world's major religions and call the documentary *Places of Worship*. I would finish this supreme spiritual journey by making the pilgrimage to Mecca, fulfilling one of the articles of my faith as a Muslim.

CONCLUSION

The Future Is Now: What's Next for Cinema

If you're an avid moviegoer, you may be an endangered species. Studios and exhibitors estimate that between 15 and 20 percent of moviegoers stopped going to cinemas after the lockdown ended. According to *Variety*, ticket sales in 2024 fell to $8.7 billion, a 23.5 percent drop from pre-pandemic levels. This is an industry that was bringing in $11 billion before the COVID crisis. North America has 5,691 fewer screens compared with pre-COVID times, according to research by media consultancy Omdia. 2024 was the first year since the pandemic that overall returns didn't improve upon the last.

Now, it's not enough to just offer movies. B&B Theatres offers at their multiplex the option to bowl, play pickleball and arcade games, or grab an alcoholic beverage. Brock Bagby, the company's president, said, "It's harder to run; it's more like you're overseeing a cruise ship than a movie theater. It's also a bigger risk; they're much more expensive to build. But we need to create a better mousetrap to get people to come."

It's not just attendance and the box office—there's a general feeling that movies aren't as relevant as they once were. There's been the advent of prestige television, second-screen experiences, unlimited streaming services, the rise of social media: *Have you seen this video of a three-legged ballerina juggling while on a unicycle...*

So, what to do? Better snacks, spruce up the theater experience (recliner seats for all!), even variable ticket pricing—a steep demand for the latest *Jurassic Park*, but how about the latest indie movie for just $5? The shrinking of the theatrical window has certainly hurt theaters as well. Before, you had to wait ninety days after a movie opened; now it can be as little as seventeen days, as when I watched Jonathan Majors's towering performance in *Magazine Dreams* the other night on DirecTV, just after it was finally released in theaters two years after earning rave reviews at Sundance.

People still come out of the woodwork for the tent poles with master filmmakers like Christopher Nolan, making IMAX a must for any of his pictures. But with so many other movies, you can just tell yourself, *Meh, I can wait, right?*

What can be done? On the topic of getting more butts in the seats, I vote for less trailers! I love a good trailer and have spent hours watching my favorites, but if a movie is listed at 1:30 p.m., then it should start ten minutes within that time. Now, when I go to the movies, it's almost twenty-five minutes after that. Bless Nicole Kidman, but please have mercy on all of us.

William Earl of *Variety* also had more ideas for getting people back in movie theaters. Among his provocative ideas included "lighting up profits." With weed now legal in some states, why not sell pot to customers rather than having them go to their local dispensary first? Gummy bears for kids and "adult gummies" for those eighteen and older. He also suggested having certain screening being "free to text" for those who just can't turn their phone off for two hours.

Earl's idea that I most responded to with regards to the movie theater experience was improving accessibility. According to the nonprofit Autism Speaks, one in thirty-six children and one

in forty-five adults have autism. Regal and AMC are among the theaters offering sensory-friendly screenings, which dial down the volume, turn up the lights, and permit quiet chatter for those on the autism spectrum.

Furthermore, a 2022 New York City law mandates that open captions be shown for at least 25 percent of all screenings. An estimated 48 million Americans have some level of hearing loss. Subtitles are clearly essential for the deaf or hard of hearing. I also know some people who don't have hearing loss but simply prefer having the subtitles on.

Movies are under attack, but honestly, I don't worry as much as others may. Cinema is still a relatively nascent art form—it's only been around for about a century. Perhaps people won't return to the theaters in droves. But honestly, that's on the power brokers in Hollywood. Think of *Field of Dreams*: if you build it, they will come. If better movies and different kinds of movies are produced, then I would think attendance would improve. Instead of offering a diverse array of movies, it's just mega blockbusters; the executives put all their eggs into that one basket. Gone are those beloved indies of the '90s or kitchen sink dramas. But those movies still exist. They're just harder to find because they aren't being produced and made with the same frequency. As Barry Jenkins said to me, "The budgets are either $2 million or $200 million. There's no middle ground."

Cinema isn't what it once was, but maybe it will evolve into something else once all the superhero movies die out. Or maybe that's what Hollywood will become—just a factory of IP, recycling sequels, and a bloviating sea of detritus. In that case, I'll just return to the movies of the past and of my youth. They are the priceless uncut gems that keep me company, awake in the dark, and I'm fully content to do so.

Acknowledgments

I thank Allah for his guidance and mercy. I can't thank my editors, Hugo Villabona and Naomi Shammash, from Mango Publishing Group enough for agreeing to publish and support this work. The entire team was terrific. To my friend Scott Spinelli, an author himself, who offered his help and guidance in publishing and his friend Lutfi Sariahmed who first planted the seed of Mango in my head. To my literary agent Josh Getzler, for believing in my writing. To my broadcast agent Matt Olson, for being more than an agent and more importantly a friend.

To my parents, for nurturing my fondness for cinema, and to my big brother Zeeshan, who was my companion through so many seminal films of our youth. To my cousins, the Cheema boys, for discovering *Dog Day Afternoon* together and giggling inappropriately during *Platoon*.

To all of my friends who ever had to endure my babbling about cinema and doing so with patience and good humor, I appreciate you so very much. To all the devoted listeners of *Cinephile*, words can't express how grateful I am to each and every one of you. To the producers of *Cinephile*—especially the OG Dan Stanczyk, Joe, Chris, and Harry—thanks for your hard work and humoring me. For the guest bookers, from Katie to Laura, you made so many dreams come true. To all the guests I was able to interview on the podcast, I can't thank you enough for your generosity.

To the film critics who enriched my passion for this most special art form.

To Ben Lyons who catapulted *Cinephile* to sights unseen and moved mountains for a mortal, J. K. Simmons, Miles Teller, Josh

Acknowledgments

Duhamel, Dan Le Batard, John Ortiz, Jeffrey Lyons, Ben Mankiewicz, Keith Olbermann, Bob Costas, Nick Khan, and Scott Rogowsky—thank you for the blurbs and I'll continue to support your work with fervor in appreciation.

To my favorite teacher, the estimable Peter Peart, who told me I reminded him of a young Pacino.

Lastly, to my wife Eamon, who passed *The Godfather* quiz I gave her when we first met (with slight hesitation, nailed McCluskey), and has given me the gift of our four wonderful boys: Yusuf, Adeen, Shazz, and Maaz. I love you boys more than words can say.

To quote the final words of the Coen brothers' *The Man Who Wasn't There*, as Ed Crane faces his final breath: "Maybe there I can tell them all those things they don't have words for here."

About the Author

Adnan Virk is an Emmy Award-winning broadcaster who is currently a host on MLB Network, NHL Network, and Amazon Prime Canada. Virk has been on television since September 2002 and worked almost nine years at ESPN, where he was a host primarily on their baseball and college football coverage, while also filling in on ESPN Radio. Virk's podcast *Cinephile* ran for eight years, totaling 336 episodes from 2016 to 2024. A graduate of Ryerson University and a Toronto native, Adnan lives with his wife Eamon and their four boys, Yusuf, Adeen, Shazz, and Maaz, in New Jersey.

Mango Publishing, established in 2014, publishes an eclectic list of books by diverse authors—both new and established voices—on topics ranging from business, personal growth, women's empowerment, LGBTQ studies, health, and spirituality to history, popular culture, time management, decluttering, lifestyle, mental wellness, aging, and sustainable living. We were named 2019 *and* 2020's #1 fastest growing independent publisher by *Publishers Weekly*. Our success is driven by our main goal, which is to publish high-quality books that will entertain readers as well as make a positive difference in their lives.

Our readers are our most important resource; we value your input, suggestions, and ideas. We'd love to hear from you—after all, we are publishing books for you!

Please stay in touch with us and follow us at:

Facebook: Mango Publishing
Twitter: @MangoPublishing
Instagram: @MangoPublishing
LinkedIn: Mango Publishing
Pinterest: Mango Publishing
Newsletter: mangopublishinggroup.com/newsletter

Join us on Mango's journey to reinvent publishing, one book at a time.

www.ingramcontent.com/pod-product-compliance
Lightning Source LLC
Jackson TN
JSHW030025080725
87254JS00001B/1